A NEW ART FROM
EMERGING MARKETS

A NEW ART FROM
EMERGING MARKETS
IAIN ROBERTSON

LUND HUMPHRIES

First published in 2011 by Lund Humphries

Lund Humphries
Wey Court East
Union Road
Farnham
Surrey GU9 7PT
UK

and

Suite 420
101 Cherry Street
Burlington VT 05401-4405
USA

www.lundhumphries.com

Lund Humphries is part of Ashgate Publishing

A New Art from Emerging Markets © The Author

Edited by Alison Hill
Designed by David Preston Studio
Set in Minion Pro and Scala Sans
Printed in the United Kingdom

British Library Cataloguing-in-Publication Data
Robertson, Iain (Iain Alexander)
A new art from emerging markets.
1. Art, Modern--20th century--Economic aspects.
2. Art, Modern--21st century--Economic aspects.
3. Art, Asian--20th century. 4. Art, Asian--
21st century. 5. Art and society--Asia.
6. Art and state--Asia.
I. Title
701'.03'0905-dc22

Library of Congress Control Number: 2010941394

ISBN: 978-1-84822-019-5

Contents

The Beggar

A little of thy steadfastness,
Rounded with leafy gracefulness,
Old oak, give me,
That the world's blasts may round me blow,
And I yield gently to and fro,
While my stout-hearted trunk below
And firm-set roots unshaken be.
— *James Russell Lowell*

To Max and Hermione

Preface

This book sets out to show that fundamental economic and political forces have combined with a revival in ancient beliefs to change our world and drive a paradigm shift in cultural perception and value. For over a hundred years the Western market for international contemporary art has held sway. A system that has successfully sold imagery to an energetic, restless and socially insecure middle class in an age dominated by the Capitalist states of Europe and America, has reached its apogee.

The art traders' intuitive sense for 'good' art and for what images best represented the spirit of the age became internationally accepted taste. When aestheticians and the Museum of Modern Art in New York (founded in 1929) rubber-stamped the market's selections by hosting exhibitions and collecting examples of the art that retailed commercially, a new system of value was born.

But today this system and the art that it has validated are being questioned by the increasingly sceptical ethno-cultures in areas of the world that I have defined as Greater China (the People's Republic of China, Taiwan and Hong Kong), the Persianate world (Iran, Iraq, Pakistan and Afghanistan) and Hindustan (India). In its place increasingly confident Chinese, Iranian, Arab and Indian patrons are making judgements of taste based on their understanding and appreciation of their own traditions. These traditions have deep cultural, social and religious roots and the forms and images with which the new patrons are most comfortable are inspired by these conventions. In place of the international market there is ample evidence of self-sustaining national markets operating systems that not only differ from those of the mainstream market, but have dissimilar ambitions. It is not surprising therefore that the art that is a product of this change in thinking is also very different in character from international contemporary art.

This new art from emerging markets, which is supported as much by an ideological shift as by the economic and political rise of East Asia, China and India, is forcing the international cultural scene to address not fragmentation so much as polarisation. Visible changes to the international art market landscape can already be seen in the meteoric rise of Hong Kong, which is now one of the

world's most important art conduits, but the transformation is best illustrated by the rise of an emerging market consensus that favours commonality and tradition over individualism and 'originality'. The emerging market societies are choosing to re-examine and reinvigorate their past, which has led them to question the purpose of globalisation and the application to their civilisations of an international cultural standard. Their assessment of this developing cultural accord will determine, ultimately, the fate of international contemporary art.

Acknowledgements

Lucy Myers commissioned this book and I am grateful to her for her confidence in me. I am thankful for the intelligence and enthusiasm of the other editors at Lund Humphries, in particular Alison Hill. Jos Hackforth-Jones and Megan Aldrich, the Director and Academic Director of Sotheby's Institute of Art respectively, were generous in the time they allowed me to research and write this book. I have learned an enormous amount about ancient civilisations in the last three years and have been greatly stimulated by a wonderful series of exhibitions at the British Museum examining these cultures. The connection made between the past and present by many of today's cultural institutions and in particular the British Museum strengthened my belief that a new art from emerging markets would draw its inspiration from tradition.

The book has profited enormously from conversations and readings by any number of friends and colleagues. The most influential by far is Chang Tsong-zung, whose thoughts, writings and observations I have been digesting for years. I am also grateful to have known the Taiwanese sculptor, Yang Ying-fen, who was wise and kind. I would like to pay special thanks to Zhao Neng, Anne Farrer, Edward Gibbs, Reggie Baxter, Claire Brown, Natasha Degen, Marcus Verhagen, Anthony Downey, Aqdas Tatli and Neha Jaiswal. It was a great privilege to meet and talk with the artists: Ye Fang, Jiang Shanqing, Luo Kuo-sung, Gu Gan, Cao Fei, Ai Weiwei, Li Jin, Lee Jaehyo, Lee Myeongho and Han Tao.

Miranda Harrison helped in the proofreading and I greatly appreciate her attention to detail. I would like to thank those who have introduced me to interesting artists: Janet Oh, (Vivianna) Xu He, Tom Woo and Lili Zhong. My thanks to the galleries who have kindly tracked down artists who have granted me permission to use their images: Roxanne Zand and Ruba Asfahani of Sotheby's Middle East and India Department, Michael Goedhuis Gallery, Lisson Gallery, Larasati auction house, Sundaram Tagore Gallery, Pace-Wildenstein, Suum Project and Mary Boone Gallery. Finally I am delighted with Laura Harris' book cover design and with her illustrative drawings for each chapter.

— *Iain Robertson, March 2011*

1

Introduction:
All change in the art market

On a stiflingly hot day at the height of a Hong Kong summer, a year before the Crown territory was returned to China, Mei Yang and I arrived at the ground floor entrance of one of the giant skyscrapers in Central. We had flown from Taipei with a precious cargo and a clear objective. The gaudy brashness of Hong Kong's mirrored and gilded high rises wrapped in serpentine, and aerial walkways reminiscent of ivy clinging to trees, was in sharp contrast to Taipei, which had begun work on its massive urban infrastructure project. Much of Taipei city would be a construction site for the next decade. In the summer months, the only parts of town that offered any relief from the searing heat were the meandering lanes of Ximending, home to massage parlours (referred to as 'Barbers' shops), wholesale retailers, small fabric vendors and specialist snack bars, where the arcades of the Japanese quarter provided shade to shoppers and thrill seekers. Otherwise locals were forced to the city's edges, which had yet to feel the full impact of development. So, the sea breeze and air conditioned malls of Hong Kong were actually very welcome. Once inside the building's icy cold reception, we asked for the offices of T.T. Tsui.

Stepping out of the lift onto a level halfway up the tower, we were led into the interior. Behind an imposing desk in a large, light room

with views over the harbour sat Mr Tsui. He had a summer cold, the downside of air-conditioning, and two assistants stood on either side of him proffering tissues. He smiled broadly, stood up and moved over to capacious chairs beside his desk gesturing for us to join him. We settled down, accepted his offer of tea and admired the Chinese antiques and brush paintings that filled his office. At the time T.T. Tsui's star shone very brightly indeed. He was extremely wealthy and had donated a substantial sum of money to the Victoria and Albert Museum in London. His eponymous Museum in the Bank of China Building housed one of the world's finest collections of privately owned Chinese art. There was even a rumour that he would be the first post-colonial Chief Executive of Hong Kong. Mei Yang reached for the bundle beside her chair, placed it on the table that separated us, and pushed it in front of Mr Tsui. An assistant bent down to unwrap the package and reveal a large bronze buffalo head engraved with archaic symbols. The gift was quietly acknowledged and spirited away. It was only then that I noticed three other bronzes in the room very similar to the one that we had brought. The Hong Kong oligarch was a collector of the work of the sculptor, Yang Ying-feng, Mei Yang's father, and we had just made a gift to him of one of the most impressive examples from the artist's middle years.

It was only weeks later that I understood the reason for the visit and the gift. We received a fax, which simply said that Mr Tsui would be happy to contribute to the success of an exhibition of Mr Yang's sculptures in London by offering his (financial) assistance. An art transaction can often be quite oblique, and this is particularly so in Asia. A year later, at the beginning of the market for Political Pop oil painting in China, trading was more straightforward. A collector or dealer from Hong Kong, Taiwan, Europe or America might be introduced to a community of artists, dine with them and afterwards visit their studios, often based in an art academy. Within the hour the visitor left with half a dozen canvases rolled up under his arm and the artist pocketed a bundle of dollar bills.

The early years of the Chinese market illustrate how the sentiment of exchange in Asia has dramatically altered since the introduction of open-cry auctions to Japan in the mid-1980s and a few years later to Taiwan, China and South Korea.[1] Asian art, in common with Western art, now has a precise monetary value and in addition, anyone, including artists, can see what something or someone is worth. Such a system was an anathema to the conservative and protective Tokyo Arts Club, which since the beginning of the century had shielded dealers, artists and even

collectors from the market's inequities. The traditional Japanese connoisseur expected to make a loss on any art he sold back to his dealer, and it was thought to be distasteful to seek financial gain from one's collection. This feeling extended to contemporary art, especially the world of the Japanese dominated *Nihonga*[2] community. Taiwan's Qing Wan Society, a latter-day Society of Dilettanti, also operates behind closed doors, and some of its members are avid collectors of contemporary art. Prices are never revealed. In South Korea, until very recently, art dealers had to agree to honour the high, gratuitous prices that senior artists invented for their work. It was their responsibility as the intermediary to carry the loss which resulted from the differential between the artist's valuation and the price a collector was willing to pay.

Indonesia's market for art was ignited by the Dutch auction house, Glerum, and India's by an American who sold his vast collection through Sotheby's in New York. The post-revolutionary Iranian market for art came to life with the aid of Western style galleries and art fairs operating out of the Gulf states and the intervention of the two largest international auction houses. China's oil painters, the most successful of all, rode a wave of American and European art speculation for half a dozen years. Wherever you cast your eyes, a different part of the world reveals its 'treasures' to the international community, where they are priced, categorised and digested before being, very often, cast aside.

But today the mood of those societies has changed, and this is reflected in the work of some of their most interesting artists. A sentiment that could not have been expressed with any degree of confidence before is now openly voiced. Societies as large and influential as China's and India's are today declaring their cultural independence from the international art market. The international standard by which their 'unclaimed'[3] artists are judged is being questioned. The universally accepted gold standard which judges the aesthetic properties of international contemporary art and measures those judgements by a market price may not, in future, be the yard-stick by which the value of core[4] art from emerging markets is determined.

Two developments over a relatively short period have contributed to this fresh mindset in the societies that comprise the emerging art markets. The first is economic. The city-states of Hong Kong, Singapore and most recently Dubai are highly efficient conduits for the world's commodities. The Asian Tigers, South Korea and Taiwan are now very wealthy, advanced communities. China and

India have been growing their economies at a rapid pace for 30 years and China, in particular, is now an engine room for international growth. Many states in the Middle East, in common with Asian countries, have accumulated vast reserves of foreign capital, which they are now investing in overseas assets and in their own cultural and urban infrastructures. Japan, which is clearly not an emerging market but an extremely rich and sophisticated nation, sits propitiously close to some of the world's most dynamic economies.

The second development is political. China's government has little desire to shoulder the world's responsibilities. It has, it argues, enough of its own problems to deal with. More pertinently, the brittleness of the country's polity dissuades any Chinese government from extending its political influence beyond its current borders. This condition has, despite the country's tremendous economic success, given rise to political insularity. It has also allowed, nay encouraged, nationalist sentiments to surface. India has also begun, at its political fringes, to entertain ideas of nationalism, although its chauvinism has a religious character. Iran has effectively cut itself off from the international community and pays little heed to the West's admonishments. Three of the world's oldest civilisations have, in short, elected to adopt nationalist stances.

The twin forces of a dynamic economy and the disengagement of rising economic powers from concomitant global responsibility are leading towards cultural protectionism. China's art market is reversing its internationalist policy and this is most evident in the contemporary art market, which is directing its energies towards national development. China's primary concern is to funnel the international market's supply of exceptional Chinese works of art to Beijing. It is also becoming less tolerant of foreign art dealers who trade within China. India already makes it very difficult for the international market to operate within its borders. Its recent flirtation with the speculative world of international contemporary art ended badly and there is little reason to suppose that it will embrace it wholeheartedly again. Iran, meanwhile, has remained resolutely outside the international art market fold. Smaller emerging art markets like Indonesia's and Taiwan's are more interested in regional expansion and Japan, still a relatively impenetrable citadel, has joined its neighbours in directing its energies towards China via that country's main external conduit, Hong Kong. South East Asian nations, including Indonesia and India, use Singapore as a central exchange for the art from their countries while Iran and the Arab world trade

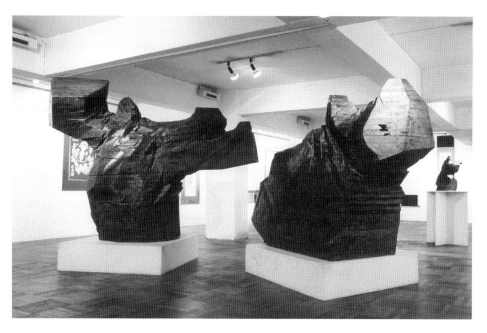

1 Ju Ming,
Taichi pair, 1996

their artists' work in the United Arab Emirates, specifically in Dubai. The axis of exchange for art from emerging markets has changed quite dramatically over a relatively short period. But the most far-reaching change is in the art that is being created for new audiences in national and regional marketplaces.

The greatest barriers for an unschooled Western audience to an appreciation of Chinese and Arabic calligraphy, for example, are the inability to draw meaning from the characters or script and the lack of sufficient historical or literary knowledge to make sense of the content. These factors are much less significant when the artist introduces a narrative or objective element into the work of art. A landscape, architectural or urban scene in which people are depicted speaks a universal language. The responsiveness to the artistry of the work is still hampered by the lack of familiarity with the technique. It is also hindered by a lack of cultural and philosophical comprehension of the viewer. The epigraphic bronze sculptures of the Iranian, Parviz Tanavoli (*b.*1937), and the repetitive character exercises of the Chinese artist, Qiu Zhijie (*b.*1969), require a visceral understanding of meaning and practice in Persian and East Asian cultures.

The Korean painter Lee Dong-youb's (*b.*1946) minimalist canvases require a prolonged experience of the act of meditation to reveal their fundamental purpose. The Taiwanese sculptor Ju Ming's *Taichi pair* (1996) **(fig.1)** series is admired by an

international audience for its sculptural form and the principal of the importance of the flow of energy (*chi*) (*qi*). But the practice of *Taichi* is inextricably linked to the formation of Chinese characters and ultimately to calligraphy. A great Chinese brush painter will ensure that the 12 regular meridians that correspond to the body's main organs are free from obstruction, so that his full energy can be transferred into the formation of his calligraphy.

What does the international market make of a work like *Ya rahim (Oh Merciful)* (2000) (**fig. 2**) by the Chinese Muslim, Haji Noor Deen Mi Guangjiang, in which *ya rahim* and *asma' al-husna* (Beautiful Names of God) are written in the style of Arabic known as *sini* (Arabic script written by Chinese Muslims). The script appears to resemble *cursive* style Chinese characters, but is in fact Arabic. To the left of the script the artist has inscribed in Chinese the date 'Winter month 2000'. He has signed his name in Arabic and added his personal seal which bears his name in Chinese. There are examples of *sini* script on Ming dynasty porcelain and metalwork and they exhibit, like this scroll, a cultural conversation and exchange between two ancient and sophisticated forms of expression that lie outside the compass of the international market.

The Japanese painter Hiroshi Senju's (*b*.1958) paintings of waterfalls can certainly be admired as re-enactments of the wonders of nature, but behind their transient, universally esteemed beauty lies the very Japanese concept of continuity and change that draws its lifeblood from the deep reverence for the spiritual qualities of nature. The powerful force that propels this art is the shared experience of the artist and his audience; both of whom draw sense and value from the past.

The idea expressed in calligraphy made of wood with black lacquer, gold and mother-of-pearl inlay has hung for nearly a century over the Asian galleries in the Museum of Fine Arts in Boston, the United States. It reads in four large characters '*yu gu wei tu*' (keeping company with the past). It was created by the Chinese painter-calligrapher Wu Changsi (Wu Changshuo, 1844–1927). The artist's avowed aim was not to embalm the past or feel encumbered by tradition but to bring new meaning to antiquity. Ink painting, the world's oldest painting tradition, provides for increasing numbers of Chinese artists a counterweight to the rapid changes in their lives today, but it is not the only medium in which artists can respond to history.

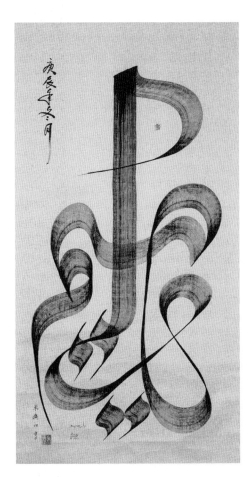

2 Haji Noor Deen Mi Guangjiang, *Ya Rahim (Oh Merciful),* 2000

In 2006 The Boston Fine Arts Museum invited ten Chinese artists to examine and create a work in direct response to a painting or object in the museum's Asian art collection. Xu Bing (*b.*1955) chose the *Mustard Seed Garden Manual of Painting* (first published in 1679) – a compilation of stock motifs drawn from the painting of past masters. Xu photocopied each page of the manual onto transparent sheets, cut out the motifs and pasted the elements into a landscape design of his own imagination. The collage was then carved onto woodblocks which were used to print the final scroll. In the same way that he challenged received assumptions in his installation, *Tiansu* (1988) (*Book from the Sky*), which has 4,000 false Chinese characters suspended in scrolls above the viewers heads, so in *Mustard Seed Garden Landscape Scroll* (2008–10) he asks his audience not to take anything for granted and to avoid complacency and cultural stasis, but at the same time to learn from the past and seek meaning in their lives from antiquity.

Two artists, Liu Xiaodong (*b.*1963) and Li Jin (*b.*1958), whom we will encounter in chapter 3, responded in very different artistic ways to Xu, but with similar intentions. The self-taught artist and epicurean, Li Jin, chose an ink on silk painting *Northern Qi Scholars Collating Classic Texts* (eleventh century) by the Northern Song master, Yan Liben (*c.*600–73); Li's *A New take on Scholars Collating Classic Texts 1–2* (2008) depicts, in diluted ink and colour, one figure from the original painting, a scholar writing with a brush. With his back to this figure the artist paints a contemporary man tapping his script onto a laptop keyboard. To his left stands a disconsolate Daoist wild man and beside him the twentieth-century giant of Chinese literature, Lu Xun (1881–1936). At the extreme left of the composition stands a bald-headed Buddhist monk. The two handmaidens in the original painting are replaced by a couple of gaudily clad, contemporary metropolitan ladies who sit beside their male companions. In the background a pug dog

looks on quizzically at the louche, morally lax scene. Prominent traces of Li's portrait can be found in each of the characters he represents. The artist is saying that there is a commonality between each of the people on the scroll, now fractured, which he shares.

Liu Xiaodong's approach to his subject, the fifteenth-century hand-scroll, *Erlang and His Soldiers Driving out Animal Spirits*, a 5m long narrative painting depicting a series of violent encounters between deities, mythological beasts and fearsome animals, is in one respect the same as Li's albeit on a much larger scale. Liu also drew inspiration from contemporary subjects, in this case Boston students. The artist was intrigued by reports, particularly in the Chinese media, about teenage violence in America. Each student in his painting is clearly characterised in acrylic and charcoal on paper over the 7m long work. The violence in Liu's *What to Drive Out?* (2008) is not expressed as overtly as it is in the scroll, but it is implied, coiled and ready to erupt at the slightest provocation. It is a pointed reference to America's great expectation of individual freedom and wealth and the potential for an explosion of violence should those presumptions be compromised.

While it is certainly true that some artists from emerging markets feel the weight of tradition to be a burden, there are others who regard the achievements of civilisation to be something that should be built on. The Chinese artist Ah Xian (*b*.1960), who moved to Australia in the wake of the Tian'anmen Square demonstration in 1989, creates European style busts in porcelain, decorated in designs typical of Ming and Qing dynasty imperial ceramics. The portrait *China China, Bust 36* (2001) shows a red dragon design encircling the head of a man. The dragon is the symbol of male potency, but the fact that the beast is quite literally suffocating the man suggests that Ah himself feels smothered by his great cultural inheritance. Not so the artist and garden designer, Ye Fang (*b*.1962), who has created a traditional Chinese garden behind a terrace of five modern houses in the ancient city of Suzhou **(fig.3)**. In the construction of his masterpiece Ye has adhered to archaism. His garden follows traditional Chinese rules on geomancy,[5] *feng shui* and proportion, but serves at the same time as a functional space, used on occasion for performances of Chinese Opera thereby further deepening our engagement with the past.

In a very clever and amusing work, *Born Yesterday* (2007), the Iranian artist Farhad Moshiri (*b*.1963) depicts a lurid, Pop Art-like two-layered pink wedding cake inscribed with the words 'born yesterday' in sugary sweets. In this painting Moshiri has subverted

both this commercial, Western symbol of celebration and the international art market in which his own commodity is traded. By contrast the Persian wedding feast has its origins in antiquity. In Iran a wedding *sofreh* (spread of food) is still laid out on the floor and each item of food has a symbolic value: flatbread represents prosperity, a tray of spices acts as a guard against the evil eye, decorated eggs and nuts are symbols of fertility and pomegranates and apples tokens for a happy future. Honey and sugar, meanwhile, act as the glue that seals the couple's love for one other.

The food that the Chinese artist, Li Jin, depicts so lovingly in his colourful scrolls has great symbolic resonance for today's Chinese especially at festivals. Fish is a symbol of abundance and an essential, often untouched, dish at the Chinese New Year feast. Dry bean curd, rather than the white, fresh variety, is selected because white is a colour that the Chinese associate with death and misfortune. Mint condition notes are inserted in *hong bao* (red bags) in carefully considered amounts, ensuring that the number four (a homophone for death) never appears, depending on the relationship between giver and recipient. The use of fireworks to frighten off evil spirits is given a free rein in Taiwan at this auspicious time of the year, to a degree that is a little unnerving for the uninitiated. The 12 signs of the zodiac, which characterise each year and in terms of your birth carry more significance than your birthday, have a great hold over the Chinese imagination. This superstition certainly helped to push the price of a small eighteenth-century spinach-green jade buffalo or ox to over £4 million, eight times its high estimate, at a small English auction house in the summer of 2009.

Koreans share many of the traditions that endure amongst Chinese communities at their own *sut dal kum mum* (New Year's Eve) celebrations. They, like the Chinese, clean their home in order to receive the new year afresh, but they also keep the lights on throughout the house in order to stay awake otherwise, so legend has it, they fear that their eyebrows will turn white. Ducks are often served at Chinese weddings because they represent fidelity and sticky rice cakes, an acquired taste, are synonymous with a rich and sweet life, the layers symbolising rising abundance and the round shape, family reunion. In Korea a glass of *gui balki sool* – a strong liquor that is meant to sharpen your hearing for the year ahead – is imbibed.

On the altar table of food that Koreans offer to their ancestors at New Year, food is placed in a strict hierarchy. At a stage in the

day known as *sebe*, the younger members of the family pay their respect to the elders and the youngest receive gifts of money, which would have originally gone towards the purchase of a calf and today teaches them the importance of thrift. The Chinese *yue bing* (moon cake) eaten traditionally during the Mid Autumn Festival is steeped in symbolism. The salted egg in the centre denotes the moon and an imprint of the characters for longevity or harmony appear on the top of the rich and heavy comestible which may also have a surround of rabbits, a symbol of the moon. In metropolitan, modern Taipei at the time of year set aside for ancestor worship or tomb sweeping, it is thought imprudent to whistle in case you upset the ghosts. To this day, it is not uncommon for the body of the deceased to be laid to rest outside the family house for days until the spirit of the dead person is deemed to have left their body. In what might be regarded as a metaphor for protectionism, the night before the important Korean festival of *Chuseok* (Mid Autumn Festival), women in traditional *hanbok* costumes dance the *ganggangsullae*. This circular dance requires one of the dancers to stand in the centre to act as a look-out for the group, offering them protection and reassurance.

India has a strong affinity with tradition and the past. The *Mahabharata* – a poetical history of mankind, at the heart of which lies *The Bhagavad Gita*, Hinduism's most profound holy text – is kept alive for millions in the sub-continent by itinerant and illiterate bards. Between the first and third centuries it was composed into 2,685 verses. When it was televised in 93 episodes on the state-run network in the early 1990s, viewing figures rose to a high of 600 million or 95 per cent of the population. At the core of the *Mahabharata* is the *dharma,* a concept which 'calls upon widely dispersed cultural assumptions about psychology, concepts of the body, sex relationships between humans and animals, attitudes to money and material possessions, politics, law, caste, purification and pollution, ritual, social practice and ideals, world renunciation, and worldly aims' (Doniger 2009, p.201).

Today, more in the breach than the observance, the goal of renunciation is integrated into the life of Hindus. Women throughout rural India create transient designs with coloured rice powder on the earthen floors of their homes, which Doniger (2009, p.682) explains are their equivalent of the Vedic sacrificial hall which is also demolished after sacrifice. They carry the designs in their head. In the Mithila region in the north of India the gods are depicted on fragile wall and floor paintings in vivid dyes, fading soon after they are made.

The Vedic idea of a non-violent sacrifice, Doniger asserts (2009, p.657), affects contemporary Hindu attitudes to cows which are allowed to roam free throughout India and are decorated with garlands, fruit and paint at festivals. It is against the law to kill cows in several Indian states because in early Sanskrit texts the animal came to symbolise the Brahmin. Kill a cow and you kill a Brahmin. During the Tantric worship of Shiva in his aspect as Bhairava even the humble dog is venerated and statues of the god astride a large white dog can be found at the Kal (or Kaal) Bhairava in Varanasi. Dogs wander freely in the temple compound and worshippers will decorate them with garlands and doughnuts. A statue of Shiva dancing (*Nataraja*), which had entered the Norton Simon collection in the United States and was repatriated after a court case in the early 1970s to its temple in Tamil Nadu, was deemed by a state official to have been the *Nataraja* itself appearing before the courts in the form of an idol.

A cultural commonality and shared symbolic order are much harder to imagine in the West than in the societies that we will encounter in this book. The international art market certainly threatens the judgements of taste that are often, in the parts of the world that we are examining, intuitive and second nature. It also denudes a culture of its variety and gives rise to a formulaic cultural Esperanto which speaks only to institutionalised cultural apparatchiks. This does not mean that the market *per se* is unhelpful, or destructive to the creative process. In its regional and national forms it can be a vital element in the salvation of a craft, skill or uncalculated and brilliant piece of inspiration. In the following chapters we will encounter art that identifies with its community, enjoys a shared language, acknowledges the importance of the past, rather than defying rules for the sake of singularity, and above all is created by artists who are highly trained and therefore skilful in their field.

Notes

1. Taiwan's most influential auction house, Ching Shiun, was founded in 1994 in the southern city of Taichung, although the territory's oldest house is Chuan jia yi su, established in 1990 in the same city. International auctions did not come to Taiwan until the arrival of Sotheby's and Christie's in 1992. South Korea's Seoul auction house was established in 1998. Est-Ouest auction house in Tokyo was set up in 1984 and Mainichi Art Auction, also in Tokyo, in 1989.

2. Japanese-style paintings made in accordance with traditional Japanese conventions, techniques and materials.

3. Those Indian and Chinese Modern and contemporary artists who have profited from the international market in the past will stay within the system.

4. Core in this case refers to work that is representative of the culture or civilisation in which it is made.

5. Divination by figures or lines.

2

The East Asian Democracies: Taiwan, South Korea and Japan

Aligning traditions and modern economies

Mustard-coloured food steamers are stacked two dozen high outside the Lin Tien Cooperage in downtown Taipei. The family firm has been making barrels, tubs, pails and steamers since 1928. Lin Tien was one of many small artisan businesses threatened with extinction at the height of Taiwan's bubble economy of the mid 1990s, a time when a thin film of gold leaf accompanied each serving of shark fin soup in upmarket restaurants. In the same street as the cooperage the Taiwan Handicraft Paper Manufactory Co, which was opened under Japanese ownership seven years later, continues to sell hand-made Chinese paper. Both businesses survived but the economic upheaval changed Taipei's landscape and turned a rough, dishevelled city into a modern Asian metropolis.

Artists like Lu Hsien-ming (*b*.1959) recorded Taipei's modernisation in paintings such as *Stroll* (1996) in which he draped a canvas portraying the partially completed Mass Rapid Transport project over a portrait of an elderly man on crutches negotiating the perils on a tarmac road. But Taiwan, and indeed all the societies of East Asia, is instant and so by the time Yuang Goang-ming (*b*.1965) photographed *Ximen by Day* and *Ximen by Night*[1] in 2002, Taipei boasted tree-lined streets, parks and a first rate transport system. Yet despite these dramatic changes Taipei feels like a

traditional Chinese city. *Chou-doufu* (stinky tofu) sellers fight for
space beside dumpling vendors and purveyors of snake-blood soup
in dozens of specialist food night markets. It is still the best place
to drink oolong tea, to eat beef noodles and to experience high
Chinese culture in the everyday. The naming by the Kuomintang
(KMT) [2] of four principal roads in Taipei [3] after four of Confucius'
12 principles reflects, if not a sensitive application of tradition
onto modernity, then certainly an assumption that classical
precepts have a meaning and a place in a modern Chinese city.

In quite an astonishing way, Taiwan has negotiated
modernisation and uncovered in the process its cultural essence.
The *de-facto* state has invested heavily in its arts infrastructure,
which culminated in the complete refurbishment of the magnificent
National Palace Museum. The objects housed in the museum came
to the island with Chiang Kai-shek's retreating Republican army
in the winter of 1948 and the collection is the personification of
power, politics and symbolism. It represents the roots of Chinese
civilisation and sits like a colossus over Taiwan's culture, which was
for many decades a safe haven for Chinese culture and customs.

As the mainland slipped into cultural anarchy during the
1960s, Taiwan provided a home for the great brush painters, Zhang
Daqian (1899–1983) and Pu Hsin-yu (1896–1963) and held onto
many of the customs and values rejected by China's Communist
leaders on the mainland. So the Republican enclave retained
many of the 'old' traditions but allowed the social and artistic
legacies of Japan, a country which had been its colonial master
for 50 years, to persist. In 1991 Taiwan became a constitutional
democracy under the Japanese educated President Lee Teng-hui,
and the stirrings of Taiwanese identity, called Nativism, were
allowed to surface. Nativism, like Ho Lo, the Taiwanese language,
may prove to be cultural and linguistic cul-de-sacs such is the
regional omnipresence of China, but their very existence, like that
of the Lin Tien Cooperage, gives hope of a rich, cross-cultural
pan-Asian culture that leans towards salvaging what remains of
local traditions. Taiwan's journey has been truly unusual and its
poly-cultural society with its many contradictions will be a great
influence on China in the future. But Taiwan owes more to Japanese
cultural foresight than it cares to admit. In many ways Japan
has set the cultural tone for the future of both its neighbouring
societies, lessons that Taiwan is transferring to China today.

Japan is by the far the most mature of the region's economies.
It is not an emerging art market, but it is of paramount importance

to emerging art markets in part because of the internationalist example it set other Asian states at the outset of global modernism. It was then the only non-Western state that effectively performed economically as a Western state. Today Japan is one of the world's core industrial nations. The modernisation of the country began with the restoration of the Meiji Emperor in 1868. This soon resulted, Ropner and Hirakawa (Goodwin 2008) explain, in the formation of a modern Japanese art market at a time when the international community elected to hold a series of world expos. The expos drew Japanese art and craft to the attention of important collectors in America and Europe and created a craze for all things Japanese. In one of Van Gogh's (1853–1890) last paintings – *Self-Portrait with Bandaged Ear* (1889) in the Courtauld Gallery in London – the artist paints on the right side of his composition a Japanese woodblock print that shows an idyllic view of Japan. The original print was published by Sato Torakiyo between 1870 and 1880, and Van Gogh must have owned a copy. The market for Japanese art was vibrant, Ropner and Hirakawa explain, right at the beginning of the development of the international trade, with 85 Japanese companies involved in the export of Japanese artefacts between 1892 and 1921.

The formation of the Tokyo Bijutsu (Arts) Club in 1906 drew together a great network of professional dealers within Japan, while the prestige of Tokyo University as an educator in the technique of modern Western (oil) painting attracted some of the most highly regarded Korean and Taiwanese artists to study in Japan. An art dealer's entry into the Tokyo Bijutsu Club depended on him securing the backing of more than two financial dealer-guarantors. The very need for an art club in the first place was down to the refusal of banks in Japan to lend money to those who traded in art and antiques – a situation that their successors may have wished still existed when the market opened up in the 1980s[4] and Japanese art businesses and international corporations borrowed money from banks against the future value of their stock.[5]

The 'closed' Japanese market for contemporary art, which was partially prised open in the 1980s, has sought to develop into a mainstream art market centre since the return of international celebrities such as the artist Takahashi Murakami.[6] So far the experiment has been relatively unsuccessful and it is to be hoped, for the good of Japanese art, that the formerly 'protected' Japanese art market, an antidote to the international one, fails in its attempt to align itself with other global centres.

But it is not Japan's 'closed' art market model nor its world-class cultural infrastructure that should be seen as its most significant gift to the contemporary arts of East Asia and beyond throughout emerging markets, but its highly developed and prized crafts, which in cities like Kyoto have been instrumental in the revival of something as grand and meaningful as traditional house building.[7] Japan has taken its 'artistic', as opposed to industrial, crafts very seriously and has been consistent and assiduous in maintaining traditional skills and practices since the Meiji era (1868–1912), raising craft to the status of art in 1927.[8] Four distinct tendencies were identified as worthy of special attention; two were revivalist, one concerned with the simple vigour of Folk Craft (*Mingei*) style and one that concentrated on those who strove to transform themselves from artisans into artists.

There is a distinction made in Japan, according to Faulkner (1988), between *Shokunin* (one who pursues a skill) with little scope for creativity and *Sakka* (one who makes) which implies originality. It is the *Sakka* category that is of the most interest to the development of the arts in emerging markets. The Association of Modern Artist Craftsmen, which was established in 1961, tilted the balance firmly in favour of creativity over tradition by changing the emphasis away from 'crafts for use' to 'crafts for contemplation' (Faulkner 1988, p.15). The promulgation of a Law for the Protection of Intangible Cultural Property from 1952 to 1954 identified skills of a particularly high value and skills which, if they were not supported by the government, were in danger of disappearing, as the deciding criteria. Enshrined in the preservation of the craft tradition was the philosophy encapsulated in the Haiku verse of the poet, Matsuo Bashō (1644–1694); *fueki ryūkō* (continuity and change).

Bashō's dictum was invoked in the 1959 Nitten[9] exhibition catalogue to explain the true meaning of the word *dentō* (tradition) in contemporary Japanese artistic production, a tradition which embraces without contradiction both continuity *and* change. 'The continuation of an artistic tradition must allow for and even encourage change, to keep that art form vibrant' explains Rousmaniere (2008, p.12).

Continuity, unlike a fractured tradition, summons up the image of a fast flowing river in which the waters are in a constant state of transmutation while the source remains immutable.

Three important criteria are attached to the very best exponents, which became known as 'Living National Treasures', of art/crafts in Japan: their technique must be of the highest artistic value,

it must occupy an important position in the history of Japanese crafts and it must have distinctive regional characteristics. The last requirement is in many ways the most interesting because it dictates that in order for a craft to be of the highest quality, its creation should be tied to the original source of its inspiration and the materials employed should also be procured locally. In the modern world, and notably with materials like lacquer, [10] this is a difficult demand to fulfil in Japan, but there are many examples of Japanese art/crafts people who have either remained or moved to the regions to work. This move by practitioners away from metropolitan and art market centres is mirrored in the isolation from the commercial world that many of today's Chinese brush painters seek and secure for themselves in their walled (garden) enclosures.

The tradition of passing on the secrets of the craft from the master down through the family or to an apprentice is another key element in the process because the daily observation and transference of the master's skills, knowledge and technique to trainees and the gentle evolution of their experience are essential to the retention of the spirit of the craft. Miwa Jusetsu (b.1910), who comes from a dynasty of art/potters who lived and worked in Hagi on the western tip of the island of Honshu, was made a 'Living National Treasure' in 1970 as reward for reviving the tradition of Hagi ware[11] typified by his rugged, asymmetrical tea bowls. His third son, Miwa Kazuhiko (b.1951), has followed his father but is free from any formal constraints and has developed remarkable sculptural works based on traditional techniques and glazes. Miwa Kazuhiko's approach to his craft is echoed in the entreaty of Nishizawa Tekiho (1889–1965) in the first issue of *Japan Crafts* (*Nihon kōgei*) on 1 October 1955, when he says that work should be based on the special character of the Japanese people with its roots in tradition. They should be unique objects whose aesthetic properties are based on strong beliefs and not swayed by fashion. There should, he continued, be a connection to the present and to new techniques and materials because the Japan Arts Craft Association is not about hidebound tradition. 'Tradition' Rousmaniere (2007, p.32) concludes is not simply 'preservation. It is that element in creative art which does not change at its core but which changes constantly in its expression'.

Ōnishi Isao's (b.1944) round tray in 'hoop built' (*magewa-zukuri*) technique (2000), made of black translucent lacquer (*tamenuri*) on wood, is infinitely more accomplished in every respect than the wares produced in the Lin Tien cooperage. The four gold circles

that surround the rim and base of the artist's rich, green-tinged lacquered dish bring to mind the nine rings of Saturn. But the self-taught artist begins the process by bending strips of wood just like the owners of the cooperage and then fitting them into a tight ring. He works from start to finish on all of his large dishes and bowls, even making his own tools and the surfaces on which he works.

The Japanese approach to the protection and encouragement of dormant or endangered crafts has influenced South Korea. Korea set up its own Cultural Assets system in 1962 and soon after the government recognised (usually elderly) masters in a particular craft, referring to them as 'human cultural assets'. One of the obligations placed on the holders of this title, which is rewarded with a monthly stipend, is to train and examine apprentices. The system has created objects and materials of a consistently high quality but with significant variations, noted, Jane Portal explains, (2000, p.148) for their 'directness, ruggedness, spontaneity, naivety, charm and vitality'.

There is a substantial body of Japanese, Korean and Taiwanese contemporary art that builds on the respective traditions of these societies. This work, a selection of which we will look at next, is not by any means the largest sample of art and creativity in East Asia. It is in fact dwarfed by ubiquitous international style contemporary art, but does offer an alternative to the mainstream production of images, which can at times appear contrived and flamboyant. Its aesthetic properties are attached to ancient beliefs, customs and mores. It is an art that is tangible, often functional, considered and very well made.

The work of the self-taught Korean painter Pak Su-gun (1914–65) whose depiction of peasant women, usually based on the artist's wife, grinding grain, walking or sitting with a child tied to their waist or selling fruit in a market, are some of the most compelling examples of understatement and artistic honesty in art. Pak will often include a simple Korean homestead in his painting with, as Portal explains, the thick impasto texture of the oil paint that is applied to his canvases resembling the earthen walls of Korean cottages. The figures too are painted in a muted palette of browns, greys and creams and the forms traced in thick black lines. The directness and simplicity of Pak's painting describes his unequivocal relationship to the natural rhythms of life in Korea, while his art, as West and Suh (2001) explain, is a fusion between Western nineteenth-century Realism and native subject matter. It is rendered in a unique style that captures the essence of rural

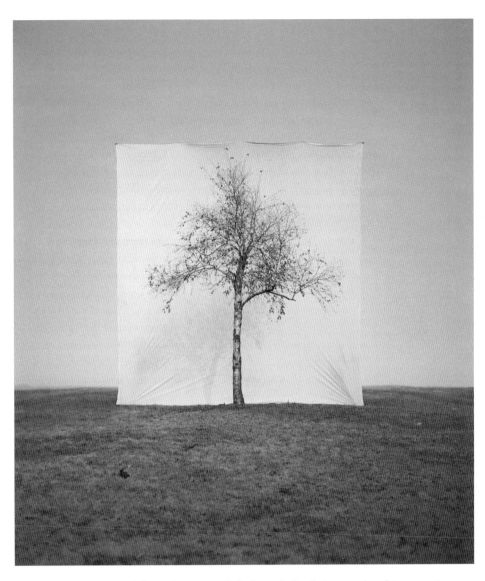

4 Lee Myeongho,
Tree Number 1, 2006

life on the peninsula before wholesale international intervention. In this way, Pak is a starting point in the investigation into an art that underlies the enduring values in East Asian art.

The contemporary Korean artist Lee Myeongho (*b.*1975) takes photographs of trees. In preparation for each shot, he employs a crane to suspend a giant cloth behind the tree, creating a silhouette and sharp delineation of its trunk, boughs, branches and foliage (**fig.4**). The artist lives in a traditional single-roomed house in central Seoul which has been refurbished, as so many traditional properties in Korea have, to reveal the natural beauty of the internal

wooden beams, roof and structural supports binding him to his country's heritage. The internationally successful Kim Sooja (b.1957) has also acknowledged the importance of tradition in Korean life and culture. Her patchwork *bottari* bags, which were conventionally used by Koreans to carry their worldly belongings, are the key element in her installations. *Pojagi* (wrapping cloth) made from scraps of brightly coloured left-over material that is sewn together, is traditionally used for wrapping gifts and covering food, but it can also be enlarged to form a wedding blanket. So Kim's work also refers to the quilt that formed part of the dowry that accompanied a bride to her new family.

Vivid colours play an important role in traditional Korean society. Within the Korean Buddhist tradition, old temples are re-painted to enhance their beauty. The work, as Jane Portal explains, is carried out by monk painters supported by teams of disciples who paint designs onto stencils which are then pricked with small holes. A white powder is then applied to the stencil in the area intended for decoration leaving an outline for the monk painters to apply one of up to ten colours to fill the patterns. In Bongeun temple close to Ewha University in Seoul the abbot, Lee Chiho (b.1909), creates works exclusively for his temple. His highly coloured and detailed paintings of the life of Buddha, his vital and energetic renditions of animals that represent the signs of the zodiac and his gold-point sketches of minor gods accomplished in a few deft strokes of the brush, keep an ancient tradition alive. The work has a primarily religious purpose and on important occasions it provides an iconic reference for the multitude of believers. On festival days crowds of people ascend the temple hill in order to receive the Buddha's blessing amidst the swirling, painted flags and pendants and temple decorations that the abbot and his monk painters have made for the occasion.

The Japanese artist Hiroshi Senju (b.1958) shares the abbot's concern for the spiritual in art. Senju paints waterfalls. He applies white and, most recently, fluorescent coloured paints to paper backed by board. The colour resonance of these latest works replicates the neon night-time that we experience in our cities today. Senju's waterfalls, like our cities, come alive at night. They are in every respect contemporary artistic visions created out of ancient techniques. In his earliest works he used oyster shells, coral and semi-precious stones to form *iwaenogu* (Japanese natural pigments) which he attached to rice paper with an animal hide glue. Senju's use of natural and traditional materials is driven

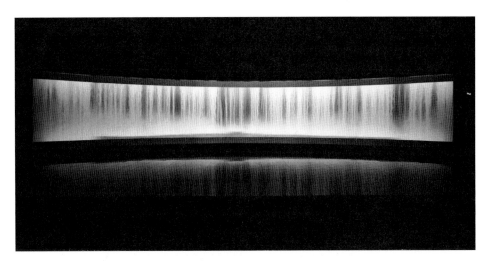

5 Hiroshi Senju,
Falls, 2004

by the sustainability and versatility of well-tried practices and the
beauty of *iwaenogu*. It is never a slavish revision of tradition for
tradition's sake. His work is the embodiment of Bashō's dictum
of continuity and change. *The Fall* (1995) is a large-scale 14 x 3.4m
high installation which received an honourable mention at that
year's Venice Biennale. The series of paintings, arranged in the
manner of a traditional Japanese screen, contain the natural force
that is expelled from a raging waterfall. The depiction of streaks
of frothy foam and droplets of spray has an energy and power that
exceed the limitations of the picture frame. Senju has achieved
his great effect by expertly pouring white, industrial paint at
intervals down each of his interlocking picture panels. He has
then applied black paint with a traditional brush to delineate the
white lines and so enhance the dramatic impact on our senses
of cascading water.

Senju's inspiration is supported by the long and arduous training
he received in *Nihon-ga* painting at Tokyo National University.
His is an art rooted in Shintō, the prehistoric Japanese belief, at
the heart of which lies the worship of nature. Shintō is represented
by two ideograms that have been translated as 'the way of the
gods'. And the gods (*kami*) of Shintō have very strong feelings for
nature: 'Nature's power', Victor Harris (2001, p.14) explains, 'may
be felt in beautiful scenery, a sense of awe, recognition of nature's
beneficence in providing human wants, or fear of the dangers it
can unleash in storm, flood, earthquake, and volcanic eruption.'

The 100m high Nachi waterfall is one of the three *kami* of
Mount Kumano which represents intellectually comprehensible
Buddhism (*taizo-kai*) as opposed to the void (*ku*). 'Since Amida

Buddha was held to be the Buddhist equivalent of the *kami* of the mountain, the mountain itself became synonymous with Amida's Pure Land paradise' (Harris 2001, p.38). The crashing falls of Nachi appear to have been transported magically to terminal 2 in Tokyo International Airport. In a giant curvilinear form suspended over the modern shiny terminal interior, Senju has brought the spirit of the mountain to the heart of modern Japan **(fig.5)**. In another installation, his monochrome, predominantly dark, falls create great theatre in Tokyo's Grand Hyatt Hotel and, in yet another, act as the walls to reconstructed temples in the Tokyo National Museum.

The photographer Hiroshi Sugimoto (*b*.1948) shares Senju's fascination for nature's power. His attraction to the element of light, which is the artist's pivotal interest, in his studies of the sea and cinemas dissolves the structures and objects in his photographs. A perfect example of this effect is the images he shot of the Richard Serra sculpture, *Joe* in the grounds of the Pulitzer Foundation. One still, *Joe 2026* (2004) **(fig.6)**, renders the sculpture in tonal, architectonic shapes that are formed by and pulsate with the light emanating from an aperture at the top of the composition. Sugimoto, like Senju, has captured the essence of the elements and drawn deeply from the well of Japanese belief in the primacy of nature over man-made structures.

At the time that the Italian critic, Germano Celant, used the term *Arte Povera* to describe the changing physical states of objects; instead of representing things, artists like Susumu Koshimizu (b.1941) started making works like *From Surface to Surface* (1971, remade 1986) in which 14 cut and sawed planks of wood were stood up against a wall. Koshimizu, who grew up next to a timber mill, intended the work as a meditative aid. Other artists, notably from Korea, also became interested in a contemplative art that had at its core a belief in the significance of materials. The *Mono Ha* (School of Things) has since become an important part of the art landscape. The Japanese word *utsukushii*, Kawakita (1986) explains, 'implies feelings of tenderness towards a certain object that inspires feelings of affection and good will'. An affinity with natural

6 Hiroshi Sugimoto, *Joe 2026*, 2004

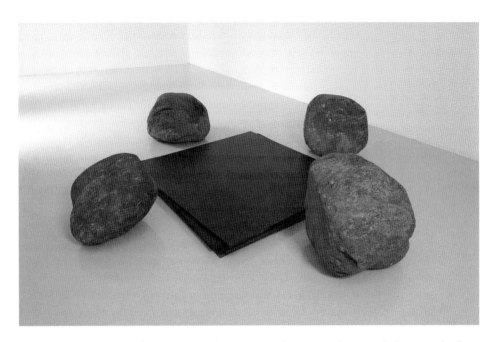

7 Lee-U-Fan, *Relatum – Discussion*, 2003

phenomena such as snow or flowers can be extended to a work of art that leaves the viewer, in the words of Kawakita, speechless.

The work of the *Mono Ha* engages with nature in just this way. The Korean, Lee U-Fan (*b.*1936), is one of its most eminent practitioners.[12] Lee established himself in Tokyo in the 1970s, creating an installation of boulders and metal planes in his garden in Kamakura. His works of art, which highlight the relationship between river rocks and flat steel planes, emphasise the physical tension between manmade materials and nature's own. In a work like *Relatum – Discussion* (2003) **(fig.7)**, the four rocks really do appear to be engaged in a conversation with the four stacked black iron plates. The rough hewn boulders encircle the precision manufactured metal sheets, manipulating the interior space and acknowledging the void that exists beyond the sculptural island. Lee's work is directly influenced by Zen or Ch'an Buddhism, in which the power of meditation and embrace of 'nothingness' as a way towards Buddha-hood is a central tenet. The artist's paintings are made up of horizontal, often blue and white, vertical and gestural paint stripes, small squares or scattered marks, which act as surrogate rocks and plates.

Lee Dong-youb (*b.*1946) works in the manner of the *Mono Ha* artists, and his concept of a 'zone of nothingness' is similar. Although Lee uses oil paint his work is very Eastern in flavour and can perhaps be best explained with reference to the notion

of painting/drawing (known in Korean as *hwaehwa)*, which sidesteps the need to acknowledge the picture plane but thinks instead in terms of 'flats' and marks or brush strokes. The canvas to Lee is the space in which he displays a rigorous self-discipline characterised by repeated stroke making. The depth of vision that the viewer experiences when gazing into the works from Lee's *Interspace – Musing* cycle from the early 1990s is the void apprehended as a field of thought. He likens his notion of space to the sound of the *moktak* (Buddhist, wooden bell), which has a very particular physical resonance. The fact that his brush creates subtle fissures on the surface of his paintings draws a physical connection between the artist and the outside world, and provides the viewer with the means to enter his 'zone of nothingness'.

The natural beauty of the Korean artist, Lee Jaehyo's (1965) 'icicle & thread variable installation' (2001), which he created out of the snow and icicles on the overhanging canopy of the Vermont Studio Center, demonstrated the artist's particular affinity with nature. The *hwaehwa* that he subsequently made of the installation captures the fleeting beauty of his expertly cut fan of transparent vertical ice daggers. His later work maintains his close relationship

8 Lee Jaehyo,
0121-1110=1080713,
2009

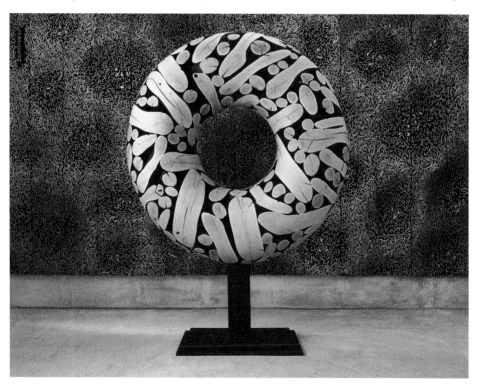

with nature. In the sculpture, *0121–1110 = 1080713* (2009) **(fig.8)**, the planed wood of a chestnut tree is manoeuvred into the shape of a donut. In another series, thousands of nails are hammered into charred blocks of wood after which they are bent and flattened. Lee's work has a great physical presence but his enduring concern is with nature's fragile beauty, best expressed in the icicle installation and in a work such as *Fallen Leaves of Oak* (2005) in which he suspended thousands of dried leaves from lengths of wire, allowing the leaves to rustle at the slightest movement of air.

The late *écriture* (or *myo* = drawing *bop* = method in Korean) works of the painter Park Seo-bo (*b*.1931), which he began in the early 1980s, also adopt the principles of *hwaehwa*. In these works, Park repetitively marks vertical lines of water-based paint in sections the length of a piece of *hanji* paper (a highly absorbent Korean paper made from mulberry tree bark). The lines are painted in alternately different shades and tones. The artist also marks the spongy paper with pencil strokes which leave a furrow and raise the paper on either side of the indentation. By allowing his water-based paint and pencil marks to be 'regulated' by the physical properties of the paper, in Park's words letting the paper speak for itself, the artist is *offering* his modern grammar to the traditional brush painter's material. The Zen principle that it is better to have nothing than something finds its pictorial representation in the mixed media *écriture* works of art. The rectangular strip(s) of monochrome paint applied to the *hanji* paper act, like the steel planes of black iron in Lee U-fan's *Relatum-Discussion*, as pools of emptiness. They also illustrate the essential relationship between something and nothing.

Suh Se-ok (*b*.1929) shares the concern with the spirit and form that lies at the heart of the art of both Lee Dong-youb and Lee U-fan. Suh is the leader of the *Muklimhoe* group of abstract brush painters. His elegant brush work, *People* (1980), comprises three forms divided by one horizontal and one vertical line into 12 compartments. In the construction of his loosely defined grid, the artist makes the viewer aware of the significance of line in the construction of form while at the same time creating emptiness rather than substance out of his linear structure. In a figural work like *Dancing People* (1990) **(fig.9)** the artist refers, obliquely, to a Shamanist ritual – an ancient form of worship that is commonly practised today in Korea. Suh's people are lost in primordial frenzy, summoning up powerful spiritual forces that defy a modern, rational explanation.

Some of the best works by the Taiwanese sculptor, Yang Ying-feng (1926–1998), are the wood and stone animals and Chinese

9 Suh Se-ok,
Dancing People, 1990

deities that he created in the late 1950s and 1960s, culminating in the semi-abstract sculptures of the 1970s which encapsulated the artist's fascination with nature's silent *chi* (*qi*) (energy). Yang was educated in art at Tokyo University and later, when he returned to Taiwan, received instruction from the great brush painter Pu Hsin-yu. He developed his affectionate and humorous woodcuts of rural Taiwanese communities and farmyard animals (which were printed on paper made out of compressed sugar cane) into ritualistic bronze totems such as *Buffalo Head*, which were traced with hieroglyphics and symbols that reflected the artist's interest in early Chinese bronzes. His move to the spectacular limestone Taroko Gorge in the mid-1960s gave rise to his sublime stone Buddhas, but the works which followed were his lifetime achievement. *Mandarin's Sleeve* (1972) **(fig.10)**, which is a stylised representation of a *Taichi* player, shows how the artist invented a shorthand sculptural vocabulary for expressing the ancient Chinese belief in a cosmic energy which reverberates throughout the universe and which can, through regular and correct practice, notably through the exercises in *Qigong* and *Taichi*, be channelled into the human body. The folds of the arching sleeve can as easily be interpreted as a mountain's ridges.

Yang had an enduring influence on his pupil, the sculptor Ju Ming (*b.*1938), whom he encouraged to practice *Taichi* in order to develop the younger man's physical and mental discipline, and

whose own *Taichi* sculptural series shares the same concerns as Yang's work from this period. Both artists have rooted their art on Taiwan. Ju, who learnt to carve temple sculptures under the guidance of the wood-carver Lee Chin-chuan, is himself a virtuoso. He now works on the island's wild east coast and is once again sculpting wood into human figures – brightly coloured wooden icons that form an important part of the artist's *Living*

10 Yang Ying-feng, *Mandarin's Sleeve*, 1972

World series. This new body of work appears to be inspired by the Austronesian mortuary effigies (*tau tau*) that are still made in the highlands of the Indonesian island of Sulawesi. The *tau tau* figures are uniquely personal portraits of the deceased, to the extent that the clothes in which the sculptures are dressed are changed by family members long after the burial of the remains.

One of Yang Ying-feng's daughters became a nun, something which is not uncommon in Taiwan, and established a temple order. Temples (and gods) proliferate on the island, many little more than a means of avoiding tax, but a good many more perform genuine acts of charity. One such temple, Long Fa Tang, in the southern city of Kaohsiung, is part Buddhist temple and part psychiatric hospital and chicken farm. The temple's patients are part of a radical experiment to 'cure' or at least improve their ability to behave 'normally'. Pairs of inmates (because that effectively is what they are) are chained together at the waist 24 hours a day. The lead person in the pair is deemed to be the most rational and it is reasoned that his behaviour will slowly raise the standards of his companion. The Taiwanese photographer Chien Chi-chang (*b.*1961) has visited the temple since 1993 and in 1998 he took a series of black and white photographs, *The Chain*, of the fettered pairs of men bathed in the light from an open door. The photographs are extremely sympathetic and dignify his subjects, but the harsh realities of the remedy are transparent.

In another series, *Double Happiness* (2003), Chien captures the faces of Taiwanese men and their Vietnamese brides as they request Taiwanese visas for their new spouses in his home town of Taichung. Chien's point is that as the educational attainment of Taiwanese and other East Asian women advances so do their material and intellectual aspirations, leaving a significant number of local men to seek marriage from women in poorer parts of the world.

If Chien deals with some of the uncomfortable social consequences of economic development, then Hsu Yu-jen (*b.*1951) looks wistfully at the changes that industrialisation has wrought on Taiwan's beautiful landscape, which has been physically blighted by the years of modernisation. The response to the detritus that now litters Taiwan's once pristine coastline, and the unregulated and often abandoned factories that mark its verdant hills and valleys, finds a remarkably restrained response in the artist's work since 2000. Hsu draws the modern world in pen and ink but his forms conform to a strict geometry. It is the geometry of a modern, industrial world which now shapes nature that the

artist depicts in the finest and lightest of short stroke brush works, *Sea Surrounded by Cement Dykes* (2006). The delicate effect that Hsu achieves with his brush, so that the image appears as in a haze, has been likened by Chang Tsong-zung (2007, p.5) to 'light leaking through the brushwork' or by the artist as like 'looking at daybreak through doors and windows'. The primacy of space and light is heightened by the shifting horizons in a painting like *Water Flows to Remain Empty. A Thousand Mountains Disappear* (2001), so that the viewer sinks into the work's white void, the depth of which is defined by the ink marks on *xuan* (mulberry bark) paper. The 'reality' that Hsu depicts in the vertical ink on silk painting, *Leafless Trees Hang Upon the Cliff, Looking Thirstily Towards the Valley* (2006), is a man-made world sucking at nature's lifeblood.

Hsu has a studio on Taiwan's scenic east coast, and shares a fascination for the dramatic topography of this part of the island with Ju Ming and Yang Ying-feng. His geometric, linear studies of mountains, cliffs and rocks are close in sense and intention to the stylised lines and 'spontaneous' carving that Yang and Ju apply, respectively, to their sculptures. The Chinese term for landscape is *shan* (mountain) *shui* (water) and Daoists maintain that there are good and evil mountains. Out of this belief came Chinese geomancy or *feng shui* (the study, literally, of winds and waters). Hsu's sliced and geometrically ordered mountains have been altered and wounded by man. His faint, barely perceptible brush marks represent mankind's imprint on nature; scar tissue that can never be erased.

In spite of the authoritarian rule of their governments, particularly on Taiwan and in South Korea, the last decade and a half of civil society has enabled their communities, through social force, to reclaim elements of their past. They have begun to establish structures and develop trains of thought and modes of practice that seek to preserve but not embalm their cultural traditions. By and large they are successful in marrying a modern world to a traditional one, and the lessons in evolutionary change that Taiwan especially can teach China, but also other transitional societies with a rich and living cultural heritage, are seminal. China's contemporary culture will be strengthened beyond measure if grassroots communities on the mainland are encouraged now gradually to reclaim their pasts.

The risks of an internationalist approach to the art market

The reason the world's international dealers line up to be included in the Korean International Art Fair (KIAF) today, until now an almost exclusively national event, is the same reason that they once made the journey to Taiwan for the Republic of China's (ROCs) International Art Fair in the mid 1990s – exploiting, however briefly, a new market. Having just begun the process of salvaging their indigenous cultures from international cultural homogenisation, South Korea and Taiwan have invited powerful commercial competition from Europe and America to dictate the cultural agenda. It is patently not in the interest of Asian states to put their neophyte art markets and indigenous cultural recovery in jeopardy by opening themselves up to the international market at this stage of their development. It is within their interest to be partially protectionist, to encourage the participation of regional, pan-Asian dealers at their fairs and not to seek to upgrade the event by buying into a Western brand keen to offload the goods it finds hard to sell in Europe and America.

South Korea has been perhaps the most 'successful' exponent of the three in internationalising its art market. Seoul embarked on a concerted cultural offensive in preparation for the country's World Cup in 2002, although the 'opening' of the Republic started with the Olympics in 1988.[13] Since this time and in the intervening years the country has also passed the 'two turnover test'[14] which is the mark of a consolidated democracy. As a consequence of its compressed industrialisation and late democratisation Im (2010, p.103) explains, 'The traditional governance of the sedentary Confucian society has coexisted with the modern governance of the industrial society and even the post-modern governance of the "neo-nomadic society".'[15]

This governance is no more apparent, according to Im (2010), than in the resilience of regionalism and a clan-like loyalty to the hometown, which reaches down into the family and emphasises the value of education, a secular life, the importance of the family, an elite paternalism and righteousness (Kwon & Cho 1994, p.8 in Im, 2010).

'Citizens', Peerenboom explains, (2010, p.218) 'elect imperial presidents with wide discretionary powers whom they can trust to exercise sound judgement because of their moral character – the modern-day equivalent of the sage and virtuous Confucian *junzi*.'

Confucianism, Kim tells us (1996, in Im, 2010), saturates people's lives and is at the core of Korean culture. It is at the heart of each one of the rights-based states in this chapter, which are opposed to the majoritarian democracies of the West and favour collective rights over individual freedoms. The particular character of Korean politics and society has had a great impact on the country's arts, for while Korea's cultural framework appears very modern the forces which determine its direction are hierarchical, illiberal and elitist and the content traditional.

Korea has developed an arts infrastructure and art market that, with Japan's, is the region's most effective.[16] A key to its swift success has been the great sums of government and corporate money that have been pumped into its museum building programme and into the training of its multi-media artists. Both the National Museum of Contemporary Art and the Samsung owned Hoam (renamed Leeum in 2004) were established in the 1980s. The other important factor has been the single-minded intent with which Korea has set about perfecting its internationalist model. The speed of international success enjoyed by the peninsula's artists has only been made possible by the importation of Western codes of art market practice. The tight-knit group of Seoul-based alpha dealers each focus on different artists and concentrate on distinct client bases. When these dealers appear at international fairs, for which Choi & Choi (2008) confirm they receive financial support from the Ministry of Culture, or open premises outside Korea, they are careful not to trespass on their (Korean) rival's territory. It is easy and cheap to cross-border trade art in and out of Korea, which makes it relatively straightforward for the powerful dealers to export their national stars overseas.

The Korean Cultural Centres that have opened in major Western cities, and which perform a similar function to the Japan and Daiwa Foundations, assist in the process of validating the art of their countrymen and women by exposing their work to an international cultural elite in the world's cultural capitals. Although the stimulus package for hard-to-sell art, Art Bank, that the Ministry of Culture has operated since 2005 is a bridge too far. When a government starts to buy commercial art for no other reason than that it cannot be sold on the open market or by commission, a crisis in confidence can spread from these ultimately worthless assets to the mainstream market.

But this initiative aside, Korea's internationalist cultural model has been carefully constructed. Seoul is its epicentre, Gwangju,

home to its biennale,[17] while Gyeongju is the archaeological and historical heart of the country. Scattered liberally around the rest of the peninsula are Zen monasteries, newly constructed churches and sprawling cities comprised of numbered tower blocks. A consequence of the low-ceilinged, Western-style box apartments that were built in South Korea in the 1960s and in Taiwan in the 1970s and 1980s is that they do not lend themselves to the hanging of traditional scroll paintings, and so Western-style art in rectangular and square frames has found favour with an urban elite. The new town plazas have sprouted huge numbers of public sculptures, which also pay no heed to tradition. One of those satellite towns that grew out of Seoul is Cheonan, home to the eccentric collector/dealer, Chang-Il-Kim and his Arario Small City. The Arario art gallery has long outgrown Cheonan and expanded into Seoul, New York and Beijing although the nondescript town is still home to the company's flagship enterprise and the bulk of its international collection, notably the work of the Young British Artists (YBAs).

It was an Arario artist, Lee Hyung-koo (b.1969), who represented Korea at the 2007 Venice Biennale and the next year appeared in an exhibition at Arario in Chelsea, New York.[18] Arario is in so many ways a metaphor for the South Korean art market, which has expanded aggressively beyond its domestic core and in the process harmonised, as best it can, its pricing structures with that of the international community. Until relatively recently, Choi & Choi (2008) assert, prices were set by artists rather than market forces. This situation meant that Korean dealers often had to sell works for a loss pushing small businesses, with little in reserve, to the brink in an economic downturn. The established Korean galleries, Hyundai (f.1970), Gana (f.1983) and Kukje (f.1982) have been joined by PKM (f.2001) and Hakgojae (f.1988). There has also been a proliferation of new and smaller galleries throughout Korea since the new millennium, but this core group situated in an area known as Sagan-dong has, for decades, set the market's tone for both Korean and imported art.

The Korean market is finely balanced. If it opens itself to internal competition from overseas, and there are very few legal restrictions preventing this from happening, the edifice may well crumble. Seoul is not an international art market centre like Hong Kong, and it faces marginalisation if it challenges the city-state over its premier international status. If the country has growth aspirations, then a regional art fair that focuses on Asian contemporary art as represented by the select group of international

dealers and a wider body of new Asian dealers would be the foundation on which to build a much more sustainable policy.

The benign tax regime that exists for Korean art collectors strengthens the national art market. A wealthy group of collectors patronises primarily Korean art, the most visible of whom is the Lee family who owns the Samsung conglomerate. The Leeum and Rodin museums are testament to their patronage. Important Korean collectors are already buying on the international market and it makes little sense, at this stage of the country's art market development, to actively encourage mid-range collectors to look elsewhere as well. This will undoubtedly happen if Seoul pursues a strategy of open competition.

If Korea needs a lesson in the perils of rapid over-expansion then it need look no further than Japan in the late 1980s. For a brief period at the height of the 1980s Tokyo property bubble, the Imperial Palace and its extensive grounds in the centre of the city were reputed to be worth as much as the state of California or a medium-sized European economy. During this time Japan imported more art (by value) than the United States. Its corporations acquired second tier Impressionist art at international auctions at prices that have yet to be matched in real terms. When its overheated economy collapsed, Japanese banks were left with bad debts while the corporations and collectors themselves had storehouses of art now worth a fraction of its purchase value. Exposure to the international art market, even for an art economy the size of Japan's, is fraught with risk. The first sign that Korean art may have to face up to the perils of price inflation happened in 2006 when the painting *Marilyn Monroe vs. Chairman Mao* by Kim Dong-yoo (b.1965) exceeded its high estimate 25 times at Christie's in Hong Kong.

There are many aspects of the Korean art world (and Taiwan's) that adhere to an older tradition, such as the Confucian notion of a gentleman. A gentlemen or educated man should not, Confucius advises, concern himself with the pursuit of wealth but instead develop his good character. There are many Korean artists of whom it can be said that their artistic calling and cultivation of a good character outweigh their desire to profit from their art. These artists are an important link to the past and to a time when only the very lowliest itinerant dauber would charge money for his work. Another aspect of Confucianism which is apparent in both Korea and Taiwan is a respect for one's elders. A Confucian paternalism and rigid age hierarchy operates throughout Korean society and infiltrates the art market in an explicit manner. An artist over 65

years of age is referred to as *Wonro* (which translates as respect for an individual who has mastered a skill and contributed to society). These artists are traditionally the ones who enjoy the greatest representation and most exhibitions in alpha Korean galleries.

Japan has, after an extended interregnum, cautiously returned to the international market and auction houses like Shinwa now hold auctions in Hong Kong. The country is fortunate that the great size and diversity of its domestic market has steered it through two difficult decades and also lessened its need to compete so aggressively in overseas arenas. Taiwan, through the aegis of its Art Dealers Association and particularly when it was under the chairmanship of the Lung Men Gallery, has been hampered by its diplomatic isolation and forced to attract competition onto its home soil. When Sotheby's and Christie's started to sell from upmarket Taipei hotels Chinese and Taiwanese Modern and contemporary oil paintings to Taiwan collectors and dealers in the early 1990s, the island's strategy appeared to have paid off. But the two international houses left shortly after Taiwan's economy began to falter at the end of the decade. Taiwanese collectors, meanwhile, resolutely refused to buy from foreign dealers, even those from Hong Kong, so the primary and secondary markets remained the exclusive domain of Taiwanese dealers.[19]

As a result of its failure to develop Taipei into East Asia's art market capital, Taiwan looked in on itself. The territory's poly-culturalism is not unique, but perhaps more evident than in other parts of East Asia. Its composite culture which, at the 'high end' is still predominantly Chinese, is vital and uniquely expressive of the great diversity of life in contemporary East Asia. It has assimilated a huge range of the region's traditions and emerged the stronger and more vital for so doing. Its major cultural institutions are rigid and inefficient, but the scope of the sector's cultural explorations has shone light on topics as diverse as Miao costumes from south-east Guizhou and Taiwanese traditional folk and flower arrangements.[20] Taiwan's cultural evolution is therefore a much stronger and more fertile conduit for the transfer of a pan-East-Asian lifestyle to China than the West, South Korea or Hong Kong.

Japan is a different matter and its *anime* and *manga* cultural phenomena, a variant of American animation and Pop Art has had, through the works of artists like Takashi Murakami, an immediate impact on the China art scene.[21] The close cultural ties that endure between Japan and Taiwan have meant that the

11 Huang Chin-Ho, *Fire*, 1992

latest art trends out of Japan tend to be adopted first on the island. The Taiwanese artist Hung Tung-lu (*b*.1968), well known for his 'Taichi' holograms, introduced his first *manga* style characters to the art world in the late 1990s. Lee Tzu-hsun (*b*.1973) managed to amalgamate Japanese Pachinko arcade culture with the overtly materialistic temple life of Taiwan in *The Temple of Love* (1999). There is also a clear reference in this work to the 'love hotel' which is a feature of cities and towns throughout Taiwan and Japan. Perhaps the most iconic work of art to be made during Taiwan's 'decade of greed' is Huang Chin-ho's (*b*.1956) *Fire* (1992) (**fig.11**), which records one of many incidents in the 1990s in which subterranean night clubs, most of which flouted all safety rules, burnt to the ground and incinerated revellers. Mechanistic half-naked hostesses flee the glass-clad structure, which billows smoke from its core. The rich tropical fauna which surrounds the building suggests that it is an out-of-town, unregulated club that also serves as a discreet 'short stay' hotel. Once again the cultural anchor is Japan.

The artist Wu Tien-chang (*b*.1956) was the most successful at amalgamating the Chinese, Japanese and Taiwanese cultures. His *Dream of a Past Era* (1994) presents a *qipao* clad woman with a bobbed hairstyle playing a mandolin and seated on a wall with a pagoda in the background. Her eyes are covered by a glittering mask and she is framed by a mirror and artificial, gaudy flowers. The flowers could have been taken from a Taiwanese funeral cortege, the glass surround from a Japanese pachinko parlour, while the *qipao*, hairstyle and nonchalant pose are very reminiscent of 1920s Shanghai beauties.

Taiwan has come a long way since Chin Hsiao-yi, the former Director of the National Palace Museum in Taiwan, refused to acknowledge as late as the mid-1990s the existence of the Peoples Republic of China. He was a relic from a 38-year period of martial law that ended in July 1987, during which time the Kuomintang (KMT) and its army of informers undertook extra-judicial executions, recounted in Yon-fan's film, *Prince of Tears* (2010).[22] The role of voluntary associations and artist groups in the erosion of authoritarianism, the awakening of regional and ethnic consciousness and the creation of a poly-cultural society – and the speed with which it was accomplished – is one of the most exhilarating political journeys in post-war East Asia.

The *minchian shehui* (civil society) changed the nature of government, which had marked the beginning of its rule with the massacre by soldiers of Taiwanese civilians on 28 February 1947.[23] With the expulsion of Taiwan from the United Nations in 1971, Hsiao and Ho (2010) explain, the KMT's international standing was undermined and it was forced to look for legitimisation from its citizens. Artists' groups such as the Cloud Gate Dance Group and indigenous literature and social science clubs began to explore local cultural identity. By 1986 these Taiwanese cultural concerns found expression in the Democratic Progressive Party (DPP). Shortly afterwards, once-marginalised groups such as the Hakka marched to demonstrate in recognition of their specific culture and mother tongue. At the same time the aboriginal movement demanded ownership of its ancestral lands. The arrival of democracy in 1993 and the passing of the 'two turnover test' in 2008 with the re-election of the KMT has resulted in the raising of environmental consciousness, a heightening of local and ethnic awareness and produced, as a consequence, a rich and diverse culture.

Internationally beleaguered Taiwan has emerged as the most robust regional cultural entity. It is the best positioned to play a key role in influencing and changing China's cultural direction. The way to really get to the heart of Chinese contemporary culture is through Taiwan. The export-driven, Western-style approach adopted by Korea which sets about infiltrating China's national art market will not succeed, whereas the subtler approach of Japan, leading by cultural example, is tactically much more effective. Taiwan's importance lies in the transmission of its cultural ideas to China by stealth rather than by force, combined with a self-confidence born of hard-fought social and cultural

victories. It is a potent cocktail that is no longer threatened from within, although may still face threats from without.

There are important differences which separate Taiwan and Korea from other emerging art markets. The first is that both states are, as Thompson (2010) explains, 'late democracies' – economic modernisation was followed by democratisation. Secondly, both experienced a sustained period of recent colonisation by the Japanese, and thirdly their respective democracies owed much to religious groupings; Christian in Korea, Daoist and Buddhist in Taiwan. In Taiwan this revival of interest in local gods like the sea goddess Matsu was, according to Thompson (2010), primarily amongst middle-class ethnic Taiwanese. The revival of interest in traditional beliefs and ceremonies in the largest social group has allowed Taiwan's civil society to grow relatively smoothly.[24] The resurgence of interest in Daoism and Confucianism in China, and its sanctioning by the state, suggests that the Taiwanese 'approach' to the revival of tradition and cultural plurality is already underway on the mainland.

China shows little sign of emulating Korea's export-driven cultural initiative. Its aim is to modernise and at the same time revitalise tradition, but to stay within its borders. Whether, as a result, there will be incremental change in the political landscape is harder to predict. In the end, China's cultural model may owe as much to Singapore's 'Asian values' as to Taiwan's poly-culturalism. What is certain is that the region's contemporary art will increasingly be informed by the past.

A politics of distrust is holding back cultural development

Japan's forceful projection of its culture across the region (and greatly beyond) in the first half of the twentieth century is well documented, and the enduring legacy of distrust between it and Korea (both North and South) and China is often reasserted by Pyongyang, Seoul and Beijing. The fact that the Tokyo National Museum holds huge stores of Korean art and artefacts, acquired during its period of occupation of that land from 1910 to 1945, rankles Koreans.[25] The enduring tensions between North and South Korea that are a fact of daily life in Seoul cast another shadow over South Korea. The post-development democracy that came to South Korea has, on many estimates, reduced political tension on

the peninsula and given rise to pacific and positive nationalism (Acharya 2010). But the succession of North Korea's leader, Kim Jong-il by his youngest son, Kim Jong-un, might present a threat to internal security in such a hierarchical Confucian society and a desire to legitimate his rule by military action. The threat of all-out war between the two states, and its deleterious effects on the region, is ever-present. At the same time, over the prospect of national reunification, looms the spectre of economic ruin.

Cross Straits relations between the two Chinas is another legacy of the period of internecine struggle in East Asia. The flames of separatism that Chen Shui-bian[26] fanned for ten years have been doused by the current president of Taiwan, Ma Ying-jeou, to the extent that his government accepted the gift of two giant pandas from Beijing, whose names in Chinese characters translate as 'reunion' – making Ma's acceptance the equivalent of a *kow-tow*. Unlike in Korea, democracy in Taiwan has tended to heighten tensions, most notably in the missile crisis of 1995–6 when China reaffirmed its 'right' to use direct force to annex Taiwan. Greater economic cooperation has dampened the warlike rhetoric. There are now direct flights between Taiwan and China and even limited numbers of Chinese tourists on the island. Taiwanese businesses are meanwhile active on the mainland. The auction house, Ravenel, is in joint venture with a mainland operation. The level of political anxiety between Taiwan and China will be decided either by a military *force majeure* or more likely gradually by a process of cultural integration.

Japan's relationship to both Korea and Taiwan is problematic, but as has been shown in the case of Taiwan, can also be remarkably positive. Numerous Taiwanese artists, including the celebrated painter Chen Cheng-po (1895–1947),[27] whose paintings now command millions of dollars on the international market, studied in the Academy of Fine Art in Tokyo. Taiwan, Japan and South Korea are the trump cards in China's hand and it is how China plays this hand that will have the furthest reaching consequences for its own future cultural direction.

Currency is the key instrument in the art trade and in the dissemination of art. The art world's reserve currencies are currently split between dollars, Euros and sterling. One of the keys to East Asia's rise will be the acceptance by emerging art markets of the Chinese Renminbi (RMB) as its reserve currency. The Hong Kong Dollar which is pegged to the United States dollar is, at the moment, the region's most international currency

but the Chinese government, with its huge holdings of United States dollar denominated reserves, is already taking steps to increase the international role of the RMB.[28] This will lead to greater pricing autonomy in emerging art markets. It will mean that the value of Asia's art will be calculated in RMB, a currency which by that time will have to be fully convertible.

The politics of distrust can of course infect cultural relations. But there is a sense that with so much to lose in the event of conflict, China and its neighbours will grow closer together rather than further apart. China is unlikely soon to adopt democracy, argues Peerenboom (2010), aware of the plight of the dead-end, corrupt democracies of South and South East Asia. If ever it did decide to do so, it would subscribe to the non-liberal and elitist form of democracy that exists in Singapore or South Korea. But the flow of contemporary culture and lifestyles from East Asia's Tigers to China will continue to be tolerated, even welcomed, by Beijing and China will be transformed by the experience, awaking to become the senior partner at the centre of an art world structured around increasingly nationalist, communitarian societies.

Notes

1. The full titles of the two large photographs were *City Disqualified: Ximen by Day* 120 x 150cm and *City Disqualified: Ximen by Night* 120 x 150cm.

2. The Nationalist party formed in China in August 1912 to replace other revolutionary groups.

3. Ba de Rd (Chinese education), Zhong Xiao [bei] Rd (loyalty and filial piety), Ren Ai Rd (generous heart) and He Ping [dong] Rd (harmony and peace).

4. Est-Ouest was the first open, public auction house in Japan. It set up business in 1984. Mainichi Auction house was the second: established in 1989 at the height of the Japanese art boom.

5. The international market for art collapsed in 1990 slashing the value of works of art held by Japanese corporations, collectors and dealers.

6. Fairs like Murakami's own GESAI (Art Festival), the rebranded Art Fair Tokyo and its satellite, Tokyo Contemporary Art Fair, as well as a host of triennials and biennales, aim to internationalise Japan's art market.

7. *Kyo machiya*, literally translated as 'city craftsmen's houses', dating from the Edo period (1603–1867) to the Showa (1926–1989).

8. At the Teiten exhibition in 1927 a specific art crafts (*bijutsu kōgei*) section was established. The beginnings of individual artistic craft production occurred in 1920–21 when Tomimoto Kenkichi (1886–1963) started to exhibit his work, also Kusube Yaichi (1897–1984) and the Sekidosha Society began to hold exhibitions of their work (Kenji in Rousmaniere, 2007).

9. Government sponsored craft exhibitions.

10. There are currently only 20 *Kakiko* sap gatherers for lacquer production in Japan, so 90% of the liquid lacquer used to produce finished products in Japan today is sourced in China (Rousmaniere 2008, p.20).

11. Hagi ware was known throughout the Edo period for its straw ash glaze, distinctive body and Korean influence. It went into eclipse in the first half of the twentieth century.

12. The Informel Movement in the 1960s and the Monochrome Movement in the 1970s, both led by Park Seo-bo (*b*.1931), drew on Western Abstract Expression and Minimalism respectively, despite Korean artists' assertions that they were home-grown Movements. *Mono Ha* is, on the other hand, demonstrably Eastern in flavour.

13. General Park Chung-hee (president from 1961–1979), like Deng Xiaoping in China from 1979, shifted the country's policy from an inward-looking economic growth model to one based on exports.

14. Huntington, S.P., *The Third Wave: democratization in the late twentieth century*, Norman: University of Oklahoma Press, 1991, pp 266–7.

15. Im (2010, p.113) refers to the nomadic army of internet aficionados who have paradoxically taken Koreans back to their pre-settled horse-riding itinerant roots.

16. Japan has a huge number of museums nationwide, with many of them showcasing local artists and crafts.

17. The Gwangju Biennale was inaugurated in 1994, many Koreans believe, as 'compensation' for the massacre of 1,000 civilians from 18–27 May 1980 by the military government of General Chun Doo Hwan. The *Minjoong* (People's) art movement, which rejected the status quo and what it saw as a poisonous Western influence, grew out of the social and political fall-out from the 5.18 Massacre.

18. Like the West's alpha dealers, Arario pays a salary to each of the artists in its stable.

19. Johnson Chang set up Hanart (Taipei) in the late 1980s and remained the only foreign gallery in Taiwan until he passed his business on to the Taiwanese, Joanna (Chi-wen) Huang of the now eponymous gallery.

20. National Museum of History, 1996.

21. The origins of the *manga* and *anime* craze in East Asia can be traced back to the outsourcing of design work by American animation studios, first to Japan and then to South Korea and Taiwan, establishing the region as the world centre for animation.

22. The artists Chen Cheng-po (1895–1947) and Huang Jung-tsang (1918–1952) were two of the most prominent victims of this period of martial law.

23. As many as 21,000 people were killed in the 2:28 incident and a further 5,000 during the martial law government between 1954 and 1955. (Silvard, R.L., *World Military and Social Expenditures*, 1996, p.19, Washington DC: World Priorities Inc).

24. It can also be argued (Acharya, 2010) that much of the Taiwanese identity agenda was driven from the top down by the Chen Shui-bian government.

25. Choi & Choi (2008) estimate that the Tokyo National Museum holds more than 1,000 gold, bronze and celadon artefacts: a total of 35,000 Korean objects, 30,000 rare books and 80% of all Korean Buddhist art.

26. Chen Shui-bian (*b.*1950) was the 10th and 11th president of the Republic of China from 2000–2008 and leader of the Democratic Progressive Party (DPP). Ma Yin-jeou (*b.*1950) is the 12th president of the Republic of China and chairman of the Kuomintang.

27. The market for the art of Chen Cheng-po has moved from Taipei to Hong Kong, although the collectors are still Taiwanese.

28. China has been growing its bilateral currency swap deals with some of its trading partners. In the future China will be able to conduct its trade, particularly with emerging markets, in RMB.

3

Greater China

China is intent on rediscovering its past

Look at any number of contemporary works by Chinese artists and you will encounter walls. The young, red-scarfed Communist pioneer represented by Cui Xiuwen (*b*.1970) is trapped between the ochre-red walls of the Forbidden City; the school child by Weng Fen (*b*.1961) sits astride a wall looking at the new Chinese city from the old, while the naked Ma Liuming (*b*.1962) is photographed running along the Great Wall. The artist, Zhang Dali (*b*.1963), was made infamous by the portrait silhouettes he smashed out of walls and those graffiti adorned palisades bearing the insignia AK-47. *The Red Wall – Coca Cola* paintings (1997) of Wei Guangqing (*b*.1962) are the most literal examples of barriers but other works, such as the *Memory* series (2006) by Sheng Qi (*b*.1965), the *Tian'anmen* works in the early 1990s by Zhang Xiaogang (*b*.1958) and, most recently, the giant woodcuts of the Gate of Heavenly Peace by Han Tao (*b*.1979) depict the ultimate walled enclosure – the Forbidden City.

The bloodlines of Zhang's *Tian'anmen 1* (1993) act like the light darts of a stigmata, attaching the viewer to the yellow gateway and by association to Chairman Mao. The bloodlines became the umbilical links between family members in the artist's next and best known series, *family,* a body of work that highlighted the impact on Chinese society of the country's one-child policy, depicting as

55

it did an only child presented as a trophy to the onlooker by his expressionless mother and father. But the Tian'anmen paintings had already defined Zhang and the group of artists that became known as the Political Pop generation as, ironically, apolitical artists who wholeheartedly embraced Deng's dictum, 'It's good to be rich'. These artists were never outside the fold; on the contrary, they worked with the establishment.

The significance of walls in Chinese art

There are many other themes in contemporary Chinese art, but the wall is one of the most pervasive. Walls play after all a seminal role in Chinese life. They form a protective shield around the conventional Chinese homestead. The traditional Chinese garden is a walled enclosure, a world within a world; in fact the Chinese pictogram for garden is in the shape of a square within which sits a phonetic symbol. Today, in cities all over China, new-build housing developments are constructed with walled perimeters. The extraordinary reading room of the National Library of China in Beijing has at its centre a square chasm hundreds of feet deep. Walls operate today as information censors on the internet and as moral censures in the wider community, but with particular application to artists. They are the squares on a page that provide the grid on which the written language is practised by young children. The square wall is dismantled in the course of the game of *majiang* (*mahjong*). And so it is unsurprising that metaphorical walls surround social conduct and interaction from the niceties of human communication to the protocol of official encounters.

There are ways in which China's government moderates the behaviour of its artists whenever they do stray outside the political boundaries. A small army of 'informers', known colloquially as 'the people who go to everything', report their suspicions to the authorities. Those who desire to be confrontational have to be subtle. The uncompromising treatment by the government of petitioners and opposition party representatives is probably widespread in China, and artists present some of the most visible targets.

The recent reforms to China's censorship laws, which have extended to technically criminalising artists such as the controversial Gao brothers,[1] for creating and displaying overtly political images, especially those of Chairman Mao, give warning of a hardening stance in government towards satire, although

the levels of enforcement are often overstated. The Gao brothers famously made a limited edition sculpture entitled *Miss Mao* (2006) in which a bust of the *Great Helmsman* depicted him as a hermaphrodite. The brothers cleverly circumvented the censors at a group exhibition in the Shandong Museum in 2007 in which they substituted their Mao figurine for a young girl who was asked to sit on a high stool and hold a kitten. On her T-shirt was written 'Miss Mao is not in' and on her leg the brothers' web address.

A more troublesome incident surrounds the fate of artist Ai Weiwei (*b.*1957), the artistic advisor for the so-called 'Birds Nest' stadium constructed for the Beijing Olympics. Despite his high international profile and seeming favour amongst the Chinese political establishment, Ai's lobbying on behalf of the victims of the Sichuan earthquake resulted in his hospitalisation (in Germany) with suspected brain damage, after allegedly being set upon by Chinese policemen.[2] Zhao Bandi (*b.*1966) has recorded in photographic stills his own lawsuit during the SARS crisis against two newspapers for printing one of his images without obtaining his permission or crediting him as the author, thereby highlighting copyright infringements in China. He is shown sitting forlorn beside his trademark giant panda toy throughout the proceedings, getting up at the end of the trial to read a letter from his girlfriend saying that their relationship is at an end. So, the artist asserts, reality becomes fiction and returns to reality.

At times reality seems like fiction in the world of Chinese arts censorship. At the 2010 Shanghai Expo, a 'performance' of the *Yijing* by the artist Huang Rui (*b.*1952), which demanded an audience of 64 people for 64 minutes (64 being the number of symbols in the *Yijing* – *The Daoist Book of Change*) was prohibited by the censors because of its imagined connection to the Tian'anmen Square incident on the 4 June 1989.

The tradition of calligraphy

If the division of a page into squares best fits Chinese characters, then it is also true to say that the character itself forms a self-contained (walled) thought or concept. It is an apparently short although in essence giant step from literacy in Chinese to *bona fide* calligraphy, but it is important to know that a great part of Chinese art is expressed in calligraphy, which requires its audience to be literate. Ai Weiwei even referred to his search for the names of the

Sichuan earthquake disaster victims in calligraphic terms; strokes on white paper.[3] A tradition in the appreciation of this art form dates back to the Tang Dynasty (618–907). The work of the sage of calligraphy, Wang Xizhi (303–361) was collected, cut into stone and circulated throughout the empire. These works became known as model letters (*fatie*) and were later transcribed into ten volumes in the Qing dynasty (1644–1911).

Over three-quarters of the domestic Chinese art market is made of calligraphy and works on paper and, according to He (2009), there is a noticeable shift in taste amongst young Chinese collectors towards cutting-edge calligraphy.[4] Today, up to half the domestic Chinese auction market comprises calligraphy and brush painting (Hao, 2007) and, according to the Chinese art database Artron, the turnover of calligraphy and works on paper now exceeds that of antiques and international contemporary art.

Calligraphy in China carries the weight of government and tradition. Mao Zedong, who disseminated his own calligraphy in giant words on banners, posters and signage, explains Gordon Barrass (p.105), to a greater extent even than any Chinese emperor, moulded the art of calligraphy into a potent instrument of political will. There are three tendencies in contemporary calligraphy that feed off the 'Grand Tradition': modernist, neo-classical and avant-garde.[5] The neo-classicists are essentially pure revisionists and the avant-garde is closer to abstraction than calligraphy, but the modernists, and three artists in particular, offer an intriguing insight into the future direction of this ancient art form.

The classical Chinese brush painter Zhu Qizhan (1892–1996) sums up the essence of great Chinese painting and calligraphy in the following declaration:

> The ultimate requirement in Chinese painting theory is to bring out the 'artistic conception' in one's work. The highest state of artistic conception pursued by artists for a thousand years is the vitality of changes and geneses of the universe. I am particular about spirit, strength and momentum. I am in search of thickness, simplicity and un-skilfulness ... there comes from un-skilfulness the real flavour of vitality, and that is the point. The pen is valued for its strength, while strength is valued for its momentum. Strength is the expression of the spirit while the idea is the root of the spirit. The spirit is a power that grows out of our thoughts and feelings. (Zhu Qizhan Art Museum, Shanghai, 2010)

Eminent Chinese artists
and the roots of Chinese art

To an artist like Zhu the importance of an artist's nature or spirit is fundamental to the artistic conception of his work. A great artist, according to the first principle of the sixth-century art historian and critic Xie He's *Six principles of Chinese painting,* is expected to nourish his noble spirit to enable him to express himself unskilfully, in the sense of painting without artifice or pretence. The eminent modernist brush painter, Wu Guanzhong (1919–2010), echoed this fundamental sentiment when he referred to the brush (*bi*) and ink (*mo*) as 'nothingness', by which he meant the essence of great painting lay in the spirit of the artist not in the tools of his trade. It should never be forgotten, however, that both artists had mastered the technical aspects of brush painting through years of practice.

Yang Yanping (*b.*1934), perhaps better known today for her evocative colour fields which depict water lilies, such as *Autumn Wind* (2010) (**fig.12**), once searched for the roots of Chinese painting. This quest resulted in her complex, composite ideograms in which a dominant emotion expressed in an often archaic written character would be accompanied by other feelings represented by different characters. The composition of the picture was always harmonious. In the 1990s the artist sometimes simply used the brush to create a free-flowing *cursive* character on gold-flecked rice paper. *Wind* (1999) is an excellent example of just such a character, one that expresses movement within the form.

12 Yang Yanping, *Autumn Wind,* 2010

13 Gu Gan, *Extending in All Directions*, 1990

The single character, boldly committed to the paper, was a characteristic of Wang Dongling (*b.*1945), whose classical training and 'big character' experience during the Cultural Revolution are combined with a strong desire to experiment. Wang is a Daoist and accomplished practitioner of *Gongfu*. He is a grounded, self-assured man and as he crouches over giant sheets of paper wielding his great brush, there is a sense that the work and he are one. The artist's most stunning works are often his most simple, such as *Dragon* (1993) – a perfectly balanced wild *cursive* script character that nevertheless retains what the Chinese call *yun* (artistic flavour). Another even looser work, *Breeze* (1989), has the same sense of lightness, and is just about intelligible. It is drawn on heavily patterned paper, which works rather well. But the composition is muddled and the clarity of the image muddied when he uses newspaper and multicoloured backgrounds.

A Book from the Sky or *A Book from Heaven* (*Tian shu*) (1987–1991) (in Chinese the character is the same for both sky and heaven) in which the artist Xu Bing (*b.*1955) carved 4,000 invented Chinese characters onto wood-blocks, takes the concept of the character onto a conceptual level. The characters, set in movable type, were printed onto books and scrolls which were then

displayed on the floor and suspended from the ceiling. A later version of this project in which the artist laid his nonsensical square word calligraphy on top of newspaper cuttings, many featuring pictures of real events, while perhaps successful at introducing subject matter, did muddy the image. Xu wished to relay to his audience the notion that politics and economics are as meaningless as his invented and pointless language.

The artist Gu Gan (b.1942) is a great modernist who stands beside Wang Dongling and Yang Yanping. He has investigated the potential for the development of calligraphy more than the other two. He has, as Barrass points out (2002, p.183), experimented with the outer shape of the character, elongating or widening it into a new form, shown in *Extending in All Directions* (1990) **(fig. 13)**. He has, in short, deconstructed the character, writing each of the elements of a work in a different script: seal, grass and regular. Finally, in his use of coloured ink, employing warm colours for autumn and cool for winter, the artist has added a rich and evocative tonal hue to his paintings. *The Mountains are Breaking Up* (1985) draws inspiration from a poem of the great iconoclast Li Bai (701–762). It depicts in the upper left-hand corner a large character for mountain (*shan*) overturned by the force of the other main character, destruction (*cui*). Li Bai's verse is strung across the ridge of *shan* and two colophons on the bottom left and top right of the picture, frame the writing and balance the composition. The artist has continued to push the boundaries of expression with his work on unusually thick *xuan* (mulberry bark) paper, the highly textured surface of which leads to unpredictable shapes – in the manner of ceramic 'kiln accidents'. Gu Gan has, more than any other modernist calligrapher, stretched the limits of the classical tradition to breaking point, but stopped just short of unintelligibility. He has preserved, like Wang and Yang, its essence and form.

In spite of the industrialisation of China in the twentieth century, it is remarkable how resilient the artist's affiliation to the spontaneous rendition of nature in ink and wash has been. It appears almost, at times, to be anachronistic. And yet in an extraordinary series of works entitled *The Pond* (2006–2009) **(fig.14)**, Beijing-based artist, Jiang Shanqing (b.1961), has focused all his creative energies on capturing the essence of nature in the pond outside his house. His large washes, often delineated to reveal the skeletal structure of a leaf, form seas of ink that end in serrated borders, highlighted by sprigs of colourful foliage. In a second approach to his subject, Jiang trails the ink around

14 Jiang Shanqing,
The Pond, 2006–2009

the paper, sometimes pausing the brush to create puddles of ink in various degrees of density. In each and every work he demonstrates remarkable control over his freedom of expression. The Guangdong-born, but now living in Taiwan, experimental brush painter, Liu Kuo-sung (*b.*1932), addressing his own 1999 *tour de force Universe in My Mind* (**fig.15**) which represents the peaks of a mountain range across four giant panels, explained to me that the work was an expression of himself through his calligraphy. And that is Jiang's aim too, to understand his inner self in every instant. For Liu and Jiang, John Masefield's observation that 'Time's an affair of instants spun to days' holds very true.

There is a tactile quality to the work of great contemporary brush painting. In Lui Kuo-sung's *Universe in My Mind* it is clear that the ink-stained, hand-made paper has in places been peeled

off to suggest snow atop the mountain range, and in Jiang's giant lily leaves the plants seep into the paper. The expression of the seasons in a work like *Sunshine after Autumn Rain* (1997) by Yang Yanping conveys in a *xieyi* (free) style, in which the paper has been crumpled and layers of inked paper have been pressed onto the already painted surface, the melancholy she experiences when autumn passes into winter. Yang chooses to express her pensiveness through the lotus. The rich and burnished colours in this work suggest an eternal feeling and mood while at the same time capture a single, irretrievable moment.

The symbolism of the natural environment

There is a tradition amongst brush painters to cocoon themselves. Zhang Daqian (1899–1983) lived in sheltered seclusion next to the National Palace Museum in Taiwan, where he produced some of his most powerful work; giant pictures of lotuses[6] and a 1.8m x 10m panorama of Mount Lu.[7] Li Huasheng (*b*.1944) lived in one of the last remaining courtyard houses in Chengdu and the Taiwanese, Yu Peng (*b*.1955), in an idiosyncratic dwelling inspired by a traditional Chinese habitation. In what other environment would he have been able to create his fantasy gardens or *Pure Exotic, Archaic, and Strange Series: Living Room and Courtyard* (2000). In the latter work Yu breaks his living space into four uneven compartments; one shows him seated before a *bonsai* tree, and the other three depict a tree and mounted *lingbi* stones. His courtyard

15 Liu Kuo-sung, *Universe in my Mind*, 1999

is presented as a complex arrangement of walled spaces, rocks and foliage. The artist's immediate environment, out of creative necessity, envelops him, and acts as a protective shield against twenty-first century life. Huang Rui, whom we encountered earlier, falling foul of the censors, constructed his traditional style homestead in Beijing out of the bricks he scavenged from houses in recently demolished *hutongs*. This act challenged the destructive instincts of China's modernists and, by implication, the government.

The most impressive demonstration of artistic insulation amongst contemporary Chinese artists is the walled garden that the brush painter, Ye Fang (*b*.1962), created for himself and his four neighbours in the ancient city of Suzhou. If one enters the house from the rear, one passes through a pair of wooden doors and sees on the right a circular opening with the five characters for the five elements carved in running script (*xingshu*) into a stone tablet. To the left another blank plaque awaits a poet's inspiration. In the centre of the two stone panels, a round window affords the visitor a view of the three 'companions': the prunus, bamboo and pine. A running stream in the shape of a carp links the various elements of the garden together. The garden's waterfalls allude to the legend of carp jumping the dragon-gate (*long-men*) in the Yellow River and becoming dragons themselves. Ye's garden has *feng shui*. The flow of the water travels through a small pond before passing into the larger lake, ensuring that those who live next to the garden will keep their money and spend it wisely. In a mountain cave that rises above the 10m high walls the character for mirror is cut into the rock, urging the visitor to picture his true self in his mind's eye.

A garden, Ye believes, should provide city dwellers with the essential elements of nature rather than add further to its man-made architecture. This particular garden has become an oasis for the families who occupy the adjoining properties and a sanctuary for some notable collectors from Taiwan's famed Qing Wan Society. By creating the environment to enjoy tradition within an historic city like Suzhou, the artist has successfully revived other traditional cultural pursuits such as poetry recital, opera and banqueting. Ye, who grew up in Suzhou amidst the classic gardens for which the city is famed, brings spirit and vitality to his garden in the same way that Zhu breathed life into his paintings of the four seasons.

In June 2009 the Chinese collector, Liu Yiqian, acquired the Northern Song Emperor Huizong's masterpiece *Rare Birds painted from Life*, despite doubts surrounding its authenticity, against furious bidding from China's largest auction house, Beijing Poly,

for RMB 61.7 million (£6.17 million) ($10 million).[8] This price was exceeded in June 2010 when an 11m calligraphy scroll by Huang Tingjian, written around 1095, was auctioned at the same auction house for RMB 438 million (£44 million) ($66 million). Beijing Poly is now one of the largest auction houses in the world[9] and its business is being driven from within China. The auction house is owned by the state, which suggests that China's art market is essentially an arm of government.[10] This has sent out a strong signal that the market for China's indigenous art will form another enclosure to the exclusion of the international community.

The principles of Confucius and their influence on Chinese art

The foundations of Chinese history rest in an etymological and anthropological unity, and on the ethical precepts of Confucius (552–479 BC). Confucianism was born of the State and unlike the world's principal religions was not conceived in opposition to the State. The four Confucian principles of *Li* (propriety), *Yi* (equity), *Lian* (integrity) and *Chi* (humility) were adopted by Sun Yat-sen (1866–1925) and later used as the philosophical basis of the New Life Movement inaugurated in 1934 by Chiang Kai-shek (1887–1975). Despite the Maoist interregnum, it is hard to imagine a China in which these principles are absent.[11] Indeed in 2003 the Communist government of China inaugurated a Public Morality Day in order to encourage Chinese to behave better. There is a strong intellectual, neo-conservative movement in today's China which imagines a quasi-Confucian, extra-legal, egalitarian apparatus in which a neutral civil service impartially enforces laws, overseen by judges who would be the guardians of the Chinese Constitution. How government is actually to be separated from law remains unclear. It is difficult at the moment to imagine a China without a strong paramount leader and an omnipresent state. The primary concern of the Communist government is to maintain the integrity of the country's national borders, which has led to a rise in nationalism. Nationalism is seen by the Chinese as a virtual fortification against cultural interference from the outside, with the country's borders serving as the physical limits of national consciousness.

Today's New Left Chinese intelligentsia have at their core a notion of China that inhabits, once again, a 'Walled World' (Leonard 2008). The key twin beliefs of the New Left are that they

support market reforms, but oppose the socially and economically divisive affects of 'Pearl River Capitalism'. To that end, Leonard (2008) recounts, the New Left adopted a model village (Nanjie) situated in the heart of China, the spiritual opposite to Shenzhen, which attempted to synthesise the market with collectivism and welfare, giving rise to the term 'Yellow River Capitalism'. Crony government is one of the key elements that the New Left wish to see reformed. They estimate that it costs China up to 15% of its annual GDP and, most importantly, once eradicated will vastly increase the propensity of Chinese consumers to spend. They argue for a 'social dividend' to be paid to the state by China's corporations, which can then be channelled into welfare and allow potential consumers to feel less insecure and more likely to consume material goods.

Hu Jintao's *tuanpai* (Chinese Communist Youth League) is certainly much more receptive to the New Left philosophy than Jiang Zemin's 'Shanghai set'. In place of the free market, China's use of foreign investment and public money to build up capital intensive industries and push to protect public property is influencing the development of many emerging markets. China's notion of 'walled worlds' preserving their economic, legal and political independence while coming together to exchange goods in a global market place flies in the face of Fukuyama's belief that we have entered the age of 'the universalization of Western liberal democracy as the final form of human government'. The problem with the philosophy of China's New Left lies in the practice rather than the principle. The process of *guojin mintui* (the state advances as the private sector recedes), which is the actual result of recent increased government investment, has also resulted in a rise in crony local government (Anderlini/Dyer 2009).

Deng Xiaoping famously described China's shift towards Capitalism in the 1980s as crossing the river by feeling for the stones, and China's *ad hoc* approach in the post-Mao era has characterised many of its decisions. The current policy has been determined by past failures of government. Sun Yat-sen's prescriptive vision of a democratic China did not extend to supporting the groundroots 4 May (1919) movement against the increasing power of foreign concessions, when a more courageous, self-confident leader would certainly have done so. Sun tied China's destiny to Moscow's by allowing Communists to join the Kuomintang (KMT), a legacy that bedevilled its government, arguably, until the collapse of the Soviet Union. His three principles, adopted by a KMT congress in 1924, of nationalism,

democracy and people's livelihood carried little weight and had little impact on China's traditional autocratic polity. Democracy in today's China according to Leonard (2006) conjures up images of the collapse of the Soviet Union, the so-called People's Democracy of the Cultural Revolution and the risk of an independent Taiwan – in short, chaos. The New Left's 'Walled World' idea is a captivating concept for China and the emerging world.

There is another significant cultural legacy that Sun has left his nation. His 'doctrine of greater Asia', which suggested uniting India with China, Russia and Japan in order to defeat Western imperialism, influenced a great Indian artist, Abanindranath Tagore (1871–1951) and a traditional school of painting in Bengal.[12] The Bengal School of painting was opposed not only to British rule but to international Modernism that became the dominant cultural force in Indian painting and sculpture at the tail-end of the Raj. Today, the School is one of India's most fruitful sources of traditional inspiration. India's ancient crafts may well yet be seen as a more truthful and valuable reflection of China's cultural needs in the twenty first century than international contemporary art.[13]

China's leaders today wish to develop relations with the emerging world. The wielding of *ruan quanli* (soft power) Leonard (2008) and Fenby (2008) note, has been the most notable feature of recent Chinese diplomacy. The government, for instance, has set up an international network of Confucius Institutes, a global TV news station and opened its universities to the teaching of Chinese to foreigners. Crucially, it is exporting its belief that for emerging states, economic development need not be accompanied by liberal democracy. Traditionally, Terrill suggests (p.36), Chinese rule at home and its diplomacy beyond the Chinese world has adopted the approach of the iron fist in the velvet glove, although in recent years it has encountered in Taiwan and Hong Kong a reluctance (from within) to accept control from the centre (Beijing). The separateness of Taiwan and Hong Kong, more than anything else, threatens China's view of itself as an anthropologically unified whole. It certainly gives rise to three distinct forms of contemporary Chinese culture: Hong Kongese, Taiwanese and mainland. But there are many variants of Chinese culture, which will give birth to disparate, provincial sub-cultures which will in time develop into a multitude of regional art economies – numerous independent walled worlds that come together for pan-cultural and pan-economic reasons.

Perhaps a generic term such as Chinese contemporary art is too simple to describe the creative impulse which extends

over a landmass many times the size of Europe, encompassing innumerable traditions and histories. Over such a vast territory one might expect dramatically different regional styles. This is not the case. Mainstream art made within China broadly conforms to the intellectual ambitions of international Modernism, flavoured (for sale) with Chinese characteristics. The 'Defensive Modernism' espoused by the late nineteenth-century foreign interlocutor, Li Hongzhang, which sought to maintain China's traditional dynastic foundation but to introduce modern Western methods and technology in a political philosophy known as 'Self-Strengthening', belongs to today's China, to Yuan Shikai's, to Deng's and Jiang Zemin's technocratic China, but it has seen its best days.[14]

China's diplomatic, cultural charm offensive marks the beginning of a new approach. Today's policy seeks to re-evaluate the fundamental Chinese traditions of the past through national Confucian, Daoist and Buddhist government-sponsored fora[15] and to promote these schools of thought beyond China's borders. It certainly helps to explain the popularity of the New Literati brush painting movement and the revival of interest in calligraphy and antiquarianism.

The political picture

China is, as Fairbank and Goldman (2006) explain, the world's oldest, successful autocracy[16] and it is only in the last hundred years or so that Sun Yat-sen re-imagined it as a democratic nation state, a vision that was snuffed out with the Communist victory over the Nationalists in 1949.[17] Crucially, Ross Terrill (2003) explains, Sun played the 'Manchu card' to add fuel to the *Xinhai* Revolution (1911–1912), laying 'the foundation for modern Han imperial chauvinism that was unlikely to ever bring democracy (p.97).[18] Sun talks of the role cosmopolitanism played in the collapse of Old China and of the need for a racial nationalism in the interests of the survival of the Chinese people. Democracy for him meant national not individual freedom. China, Terrill argues provocatively, is today a 'civilization pretending to be a nation' (p.2), the last of the great Imperial empires without the ability (or will) to project itself onto the international stage. It is not a federation, but a 'Great Systematic Whole' (p.4), wishing to sinocise its competitors and especially fearful of *neiluan* (disorder from within) and *waihuan* (external threats) (p.25). Sun would probably recognise this description of China. He advocated

just that. To rule a single race was, he felt, quite natural and for that race to deal with its vassal states benevolently, the ideal form of government. The empire is transformed into a nation, and one with very high walls.

China today is numerically dominated by its ethnic Han majority, although within this great mass of Han humanity there are regional cultural differences. The written Chinese language is, along with Spanish and English, one of the true *linguae francae* of the modern world – and that is a tribute to the foresight of the Republican government – which simplified the characters in order to increase literacy, although the origins of linguistic unity can be traced back to the First Emperor. The Chinese pictogram or character still has meaning across Asia, despite the adaptation or development of new writing systems in countries like Japan and Korea.

The Chinese have, until the international art market arrived in the 1980s, made much less of a distinction between high art and craft than has the West. China also clearly differentiates the cultural artefacts that it exports from the ones that it consumes internally. The concerted buying of Chinese government representatives, dealers and private collectors of Chinese antiques and classical works of art on the international market in recent years is for material made originally for the Chinese Emperor and absolutely not for articles derisively known in China as 'export ware'.

Maoist, and particularly Cultural Revolutionary-era memorabilia, has failed consistently to attract the interest of the Chinese collector, although a private museum in Sichuan holds some of the finest examples. The memory of those years is too recent for the scars to have healed and the Chinese Political Pop artists of the 1990s made the mistake of opening suppurating wounds.[19] This brash, brightly coloured work has had a short-lived appeal for an international audience. But despite the antipathy of the Chinese to the Cultural Revolution in particular, nationalist sentiment can be roused.

A record price was achieved for a piece of political propaganda by Chen Yifei (1949–2005). *Eulogy of the Yellow River* (1972) depicts a soldier of the People's Liberation Army, with a fatuous grin, standing guard over the liquid artery of Chinese civilisation.[20] The record price achieved for *Put down your whip* (1939) by the academic oil painter Xu Beihong (1895–1953), is another example of the latent power of nationalist sentiment in today's China. The painting describes, in Xu's stiff academic manner, a popular drama

in which a dutiful daughter, Lady Shang, forced to flee China after the Japanese invasion in 1931, performs street theatre but fails one day to appear for work. She pleads with her father to turn his angry whip on the Japanese rather than on her. Xu shows his characteristically meticulous attention to detail. He has depicted a range of Chinese victims of the Sino-Japanese war from small children to the elderly, to a KMT soldier.[21] Heroic narrative painting still has a place in China, and Chen's sensationalist romantic realism is part of a continuing tradition dating back to the early years of the twentieth century.

During the years following the collapse of the Qing dynasty (1644–1911) and the outbreak of civil war, China was a beleaguered polity. The modernist writer Lu Xun (1881–1936) once likened the State to syphilis 'congenitally rotten and with dark and confusing elements in its blood which required total cleaning' (Fenby 2005, p.112). It was not a place in which artists would choose to settle. Most modern Chinese oil painters like Xu Beihong and Chang Yu (1901–1966) emigrated in the first half of the twentieth century and were educated in a European academic style that they acquired in the art academies and ateliers of Paris or Tokyo.

16 Wang Chao, print from book *Foreign Images*, 1998

The great prices paid for these history paintings reflect a vehement nationalism, which fears the interference of foreign powers, splitists on Taiwan and in Tibet and insurgency in its Western provinces. This fear is largely manufactured, but it matters little to the bidders at auction. The fact that Zhang Xiaogang's market was rescued in 2010 by the overtly patriotic work *Chapter of a New Century: Birth of the People's Republic of China II* (1992), suggests that Chinese jingoism has a growing influence on the prices of works of art at auction.

It should be remembered that the Nationalist government on Taiwan was 'at war' with China until the Generalissimo's death in 1976. Chiang planned an invasion of the mainland in 1960 at the height of Mao's disastrous 'Great Leap Forward', and so the fear in modern China of insurrection or invasion runs deep. The Great Leap Forward was the most ill-conceived of Mao's ventures and is lampooned by the contemporary woodcut artist, Wang Chao (b.1974) in a print from his book *Foreign Images* (1998) (**fig.16**). In this series of woodcuts dealing with the subject of modern innovation in China, Wang presents the twelfth as the bicycle. Printed in colour it is accompanied by the embossed image of a peasant who has fallen off the bike and is hurtling towards the clouds accompanied by the caption 'Great Leap Forward' (Farrer, p.132 8.3).

The greatest and most monumental self-inflicted wound in China's recent history was visited on it in the mid-nineteenth century at a time when Marx likened the Chinese empire to a mummy sealed in a hermetically sealed coffin, bound to disintegrate when it met the day. Hong Xiuquan (1814–1864) led a messianic revolution known as the Taiping Rising, which affected 16 provinces and resulted in the deaths of 20 million people. Two effects of this uprising, which was put down in 1864 were, according to Fenby (2005), the ceding of much power by the Manchu to the majority Han population and the professionalisation of army commanders advised by foreigners.

It should be remembered that the Manchu had culturally subjugated the Han, forcing them to shave their foreheads and wear pigtails (Fenby 2008). The fact that the Taiping rebellion coincided with the sacking of the Yuanmingyuan (Old Summer Palace) by French and British soldiers has cemented, not unreasonably, the thought in Chinese minds that an internally divided China is very vulnerable to invasion. It helps to explain the apparently peculiar behaviour of the Chinese bidder, Cai Mingchao[22] at Christie's Yves

St Laurent sale in 2008, who refused to honour his bid for the two bronze incense burners appropriated by those foreign armies in 1860 in protest at their 'theft' 150 years ago at the conclusion of the second opium war.[23] 'Yuanmingyuan' writes Mark Leonard (2008, p.10) 'is a physical embodiment of the "century of humiliation" which ran from China's defeat in the opium wars of 1840, through to the loss of Taiwan, the various Japanese invasions and the civil war right until the Communist Revolution of 1949.' They are, he neatly explains, open wounds that can be salted whenever citizens need to be mobilised or the Communist Party feels it necessary to reassert its legitimacy.

The consequences of the Taiping Rising were even more far reaching. They can be seen in the warlordism that afflicted the country after the premature death of Yuan Shikai[24] (the Qing's most able general and self-proclaimed emperor from 1914–1916) encouraged by his American advisor, F.J. Goodnow[25] (Fenby, 2005), Chiang Kai-shek's enlightened despotism,[26] Mao's brutal autocracy and Deng's decision to deploy the army in Tian'anmen Square in order to put down the student protests in 1989. Chiang, Fenby confirms (2005, p.226), like Deng and all Chinese emperors before them, stressed order and stability and absolutely ruled out democracy. Mainland China, it should be remembered, held multi-party elections only once in 1912, which resulted in the assassination of the head of the winning party.[27] This may partly be why free and democratic elections held in the neighbouring Republic of China on Taiwan irritate Chinese bloggers as much as the State's Communist politicians.[28] Chiang's Nationalist *Lixingshe* movement,[29] on the contrary, 'presented an authoritarian view of Chinese tradition as a historic justification for dictatorship with a conservative cultural policy to buttress the supremacy of the State and its chief. It was "Confucian Fascism"' (Fenby 2005, p.266).

Today's China bears a closer relation to Chiang's and that envisioned by Sun than to Mao's. Mao was an autocrat, but had internationalist ambitions that were coloured by a Western political philosophy. His rule combined neo-Legalism with neo-Confucianism, a hybrid political philosophy that has been described as Tsarist-Qin-Leninism.[30] Tomorrow's China is more likely to adopt another hybrid philosophy, Confucian-Qin-Republicanism.

International contemporary Chinese art is an export commodity and was never intended for internal consumption

The Chinese contemporary art that we in the West have grown accustomed to, and which has achieved auction house records, has relied for its success on the support of European and American collectors and investors and the mediation of international auction houses and dealers. This is, in theory, no bad thing, because those influential collectors have persuaded internationally renowned museums of modern art and *kunsthallen* to hold exhibitions of Chinese contemporary art and through judicious 'gifts' encouraged them to add 'important' pieces to their permanent collections. The small extent to which this has happened suggests that the international public sector museum world, by which I mean largely Western European and American institutions, has been slow to agree with the market.[31]

The West's view of the cultural importance of the work produced for the international market within China was, in the early days, muted. Subsequently, for a combination of economic and political reasons, Chinese contemporary artists have been involved in seminal overseas exhibitions.[32] Those shows have tended to showcase the work of émigrés like Gu Wenda (*b*.1955) and Cai Guoqiang (*b*.1957) and those artists who enjoy close ties to the Western art establishment such as Xu Bing (*b*.1955) and Ai Weiwei (*b*.1957). But energetic Western and Chinese curators have been keen, in recent years, to make their mark by presenting their own 'selections' before a global audience. Whether these new 'selections' end up like the sculptures of Yue Minjun (*b*.1962), on permanent display in the forecourt of the Today Museum in Beijing, in the courtyard of the Abu Dhabi Arts and Culture Department building or on permanent display in the Tate, Centre Pompidou or MoMA in New York, is fundamental not only to their long-term cultural value but to the future structure of the international art market.

If the greater proportion of Chinese international contemporary art is validated, through accession and display, by Chinese cultural institutions then the Western model has, in part, been successfully exported to China. If, on the other hand, the new cultural institutions in emerging markets like China choose to negotiate the art economy in a different way and treat the international contemporary art museums as only a part of a richer picture, then the future value of this art is much less certain. The Chinese painter,

Wu Guanzhong, said when asked about the international standing of his work that it was only possible to judge its value over time. If it was still appreciated hundreds of years later then it had value. A high price at auction was not necessarily, he asserted, confirmation that the picture was great. Wu was astute enough to donate a number of his paintings to cultural institutions in Hong Kong and Singapore, showing that he had confidence in the Western model, whereby the museum nurtures and enhances the reputation of the artists in its fold. Wu may be amongst the last of the significant Chinese artists to express his confidence in this system.

A handful of international collectors hold large quantities of international Chinese contemporary art. Zhou Chunya (b.1955), who held a retrospective of his work in the Shanghai Art Museum in June 2010, is a good example of one such artist. Zhou's green dogs, predatory Alsatians and lurid landscapes are far removed from the essential elements of Chinese art. His show ran amidst a score of commercial gallery and public museum exhibitions in Shanghai that summer, which dealt with a very different art; one that revolved around a re-examination of China's ancient culture. Zhou's exhibition was an anachronism. The repetitive imagery of the work of Political Pop artists like Wang Guangyi (b.1956), whose combination of revolutionary figures and American brands are outdated, the depiction of Mao by Yu Youhan (b.1943) and most strikingly the young Mao by Li Shan (b.1942) (*Rouge* Series) in the 1990s are unlikely to find favour with the new generation of Chinese collectors and artists. A much more interesting comment on American consumerism is now made by other artists working in very different ways; He Xiangyu (b.1986), for example, whose small circular landscapes on silk have been drawn with the residue left after boiling gallons of Coca Cola.

Chinese academic oil painting is a facet of the national Chinese art market that has prospered and shown little sign of abeyance since *Father* by Luo Zhongli (b.1950) created a sensation at the second National Youth Exhibition in December 1980 launching, as Sullivan (p.227) explains, 'the new Sichuanese school of Superrealism with great eclat'. The artist famously amended this portrait of the sun-blackened, creased face of a Chinese peasant holding up a bowl of soup by adding a biro behind his ear, to show that there had been 'progress' since the Communists came to power. More recently, but at the start of the commercial art market in China, Guardian auction house sold Chen Yifei's *Four Graces* for the equivalent of $250,000 in 1997 in Beijing. Since then the market for

17 Liu Xiaodong, *Three Gorges: Displaced Population*, 2003

Modern and contemporary oil paintings has continued to do well culminating, as we have seen, in the sale of Xu Beihong's *Put down your whip*.

The oil painting tradition has retained favour in China, with artists like the former Cynical Realist Liu Xiaodong (*b.*1963) adding cutting-edge twists to his depictions of 'real people' enduring at times unsavoury and hard lives. His portraits of Chinese girls, *Xiao Yi* and *Qiqi* (2007) for example, fall between the harsh cigarette-smoking and sometimes eyeless models portrayed by He Sen (*b.*1968) or the decapitated and mutilated figurines of Liu Jianhua (*b.*1962) and the syrupy rosiness of Chen Yifei's *Graces*. Liu's giant scrolls of the Qinghai-Tibet Plateau (2007) look at the plight of Tibetans caught up in the wave of Chinese expansion. His work has certainly more feeling than the work of the Cynical Realists[33] with whom he was once grouped – and whose images of a traumatised society played on Western perceptions of a modernising China – but less sentimental than the oil painters like Chen Yifei and Wang Yidong (*b.*1955) whose work is drenched in nostalgia. In one of the two scrolls, *Sky Burial* (2007), for example, Liu depicts in a remote place in Tibet called Yushu, a corpse being ritually fed to swooping vultures according to an age-old Buddhist ceremony. The faint blue mountains in the background could almost be the work of a brush painter.

It would not be lost on the Chinese that the remoteness of Yushu also once made it an attractive base for China's military and nuclear facilities. So Liu brings together multiple cultural elements in this monumental horizontal scroll. In the other work in this series, *Qinghai Tibet Railway* (2007), the artist represents two men of Tibetan features wearing Western clothes, drawing horses across a vast savannah. In the background factories spew out smoke and fumes. Liu is questioning the benefits of modernisation, but he retains his neutrality. The work articulates the artist's social conscience in the same way that his earlier work on the displaced people of the *Three Gorges Dam – Displaced Population* (2003)

described the great movements of humanity in the wake of this giant undertaking.

A mammoth (8 x 2m) work – *Three Gorges: Displaced Population* (2003) **(fig.17)** – comprises six life-size workers carrying steel construction poles, two wearing surgical masks and one stripped to waist. The painting displays Liu's virtuoso brushwork and powerful unity of style. In the background, the electric blue tents of the labourers blend with the clothes and shirts of two of the foreground figures, perhaps in a reference to the blue Mao jacket. One worker wears a surplus, green People's Liberation Army tunic. It is a desolate scene, in which the once potent force of the Yellow River is reduced to a benign stream. The unmistakable message of the painting is the barbarism of grand projects and the unforeseen social and natural consequences that will unfold in the years to come. The workers in Liu's painting are more than likely migrants, whose lowly status and lack of rights, especially within China's cities, have created a dissatisfied underclass.[34] Liu's work does not seek to romanticise the life of China's Han population or its Minorities in the way of an artist like Chen Danqing (*b.*1953) who, according to Liu, depicted Tibetans in order to exhibit his skills as a naturalistic oil painter (Smith 2007), but places them and the realities of the modern world into context.[35]

China's art market infrastructure has grown dramatically since its beginnings in the 1990s and now boasts warehouse-sized galleries and purpose-built artist studios, particularly in Beijing but also in Shanghai. A museum style show, which means a large enough space to 'curate' an exhibition on an epic scale capable of entertaining a public audience, has become a feature of the international art world and is now a staple of China's as well. These mega commercial shows, often in foreign owned galleries, have effectively supported a critical debate in China in recent years in the absence of support from the State. It is remarkable how many overseas dealers have successfully transplanted their businesses from the West to China.

In the beginning small operations run by Westerners living in China, like Hans van Dijk (1946–2002), (New Amsterdam Agency), Brian Wallace (Red Gate) and Lorenz Helbling (ShanghART), jockeyed for space in hotel lobbies with perfumeries and newsagents. They now occupy cloistered real-estate in unlikely and expensive parts of Shanghai and Beijing where they run the risk of being unceremoniously displaced by local government in the pay of commercial interests. In Beijing and to a lesser extent perhaps, in Shanghai, their role is to sell Chinese contemporary art to

international collectors. But the gallery districts in both cities have also become magnets for cultural tourists. These foreign ventures have now introduced Western international stock to the Beijing market to see if it might act as an international centre for the world's contemporary art, as well as Chinese.

To make Beijing an international centre for the sale of international contemporary art would, from the Chinese perspective, make little sense. There is a vast and varied quantity of images being produced in China already and if Chinese collectors are reluctant to embrace international contemporary art, then they are equally unlikely to welcome a Chinese version of it. Recent nationalist sentiment, and a millennia-old belief in the superiority of Chinese culture over others, has conspired with the fear of Western cultural pollution and economic and political interference to direct Chinese attention away from international contemporary art to the roots of its own cultural identity.

National auction houses in China have sprouted equally rapidly. There is a law in China that prevents, or at least makes it extremely difficult for, foreign houses to hold auctions in the country. With the exception of the French company Artcurial and a small-scale joint venture between Christie's and China's newly incorporated Beijing auction house Forever, the market is the preserve of domestic businesses. The law is undoubtedly aimed at preserving the market's isolation and also at concealing its unsavoury aspects. It is hard to imagine a time when China would welcome international competition in this sector. It has only to look at the French market to see how quickly after deregulation Sotheby's and Christie's took a majority stake at the expense of the national houses. The law does not, it should be said, prevent Taiwanese auction houses from operating under joint-venture within China but it does preclude the possibility of a Japanese or Korean one from doing so. China's two leading houses, Guardian and Poly, are making great strides and developing into serious competitors for any potential Asian rival, but neither house shows a desire to expand beyond China's borders.

A strong national auction market, similar to the one that operates in many European countries, is crucial to the nation's long-term cultural vitality. Auctions at the mid and low levels are still spit and sawdust affairs but at the top end of the market sales are *bona fide* international events with prices to match. If China continues to protect this segment of the trade and to conduct its business in its national currency (the Renminbi) rather than the art market's international currencies of Euros, dollars and sterling the

international market might find itself shorn of a sizeable chunk of its trade.

There is a broader point to be made here, and that is that the art market could divide along three meridians; with the New York market focused on Canadian and South American art, with Sao Paolo as its secondary centre; Hong Kong concentrating on the Asian trade, with China's great metropolitan cities acting as secondary national centres; and London responsible for European, South Asian and Middle Eastern art, with Singapore or the UAE as secondary centres.

China's protected tertiary market could provide international Chinese contemporary art with a funnel through which the steam generated by a boom on the international market could be discharged. This won't happen because most of the art that has been collected by Western investors will not find a future home in Chinese collections.

The enduring fascination of art as a commodity is that it is impossible to say that this type of art, and no other, will find favour with this audience. So, while I believe that a revival will take place in the traditional arts in China and that the trade in these works will grow into the largest part of its domestic market, other forms of art will also thrive. Much of this work will be in the form of realistic oil painting and high prices will be achieved for works that have a nationalist sentiment. Chen Yifei and Wei Jingshan's (b.1943) history painting, *Overturning the Dynasty of Chiang Kai-shek* (1977), depicts soldiers of the victorious People's Liberation Army hoisting the red flag over Nanjing in the wake of their victory over the Nationalists. If this picture of patriotism ever came to market it would make several million dollars. But more subtle cultural forces are also at work in China and this is why I believe that the work of artists like Liu Xiaodong, who honestly, quietly and intelligently comment on the realities of a nation in transition, will find a future Chinese audience.

It is also why some of the best Chinese photography, which documents a transforming society, will resonate with Chinese collectors. Wang Jinsong (b.1963) first came to the market's attention with *Standard Family Series* (1996) which depicted a mother, father and child in a pointed reference to the one child policy. The series *My Parents*, in which the bedridden parents of Song Yongping (b.1961) are photographed in their dilapidated apartment over two years from 1998–2000, presents an equally accurate description of life now in China. Famous for his depiction of himself as a

18 Cui Xiuwen,
Lady's Room, 2000

disorientated scholar in an urban setting in *Seven Intellectuals in the Bamboo Forest* (2007), Yang Fudong (*b.*1971) has also made a series of alluring images of the fictional and glamorous Miss Huang in various city hotspots (*Miss Huang at M Last Night*, 2006) which would appeal to any aspiring, upwardly mobile Chinese collector.

There is a world of difference between Miss Huang and the hookers depicted by Cui Xiuwen (*b.*1970), covertly filmed changing and making up in *Lady's Room* (2000) (**fig.18**), but the fine line between second wives (*qie*) and prostitutes is brought into sharp focus by the two series as life at both spectra of Chinese society is rolled out for our inspection. The recalcitrant youth at home sitting detached beside an uncomprehending parent (*Cosplayers*, 2004) by Cao Fei (*b.*1978), which derives its inspiration from popular culture but avoids the crassness of Asian anima, may also connect with a younger generation of Chinese. The artist's recreation of the virtual reality of Second Life in *The Birth of RMB City* (2009) is an incisive commentary on the hyper-real experiences in contemporary Chinese cities. *Bunny's World* (2006) and *A Hutong War* (2006) similarly import outlandish elements that may at any moment de-energise into a rough urban Chinese landscape.

Han Tao, who we have seen from his Tian'anmen Square series courts political controversy, also works in multi-media. His seemingly innocent painting of pine trees conceal small photographs of the artist standing next to the pro-democracy activist, Liu Xiaobo (*b*.1955). The photographs were taken the day the dissident was sentenced to 11 years' hard labour. The artist's photo-documentary of his recovery from illness in hospital featuring his girlfriend, Xiao Ling, is another compelling example of a real-life drama. Intimate and direct, what all these works have in common is truthfulness and precision. They are not sensationalist, gratuitously violent or particularly shocking; they are intelligent observations of life.

There is a bleak postscript to Chinese documentary photography and one that anyone would find hard to address because while it has integrity and honesty, it is desperately difficult to embrace. The artist Sun Jingtao (*b*.1973) depicts the crippled, disfigured and destitute. Ning Zhouhao (*b*.1975) shows us the deformed and mentally ill. Chang Lei (*b*.1978) goes a step further and invites us to confront the eyeless. The subject matter of these artists is the *shou hai zhe* (the victim) of the Chinese economic miracle. A work like Sun's portrait of a burns victim and child or Ning's old woman clasping a giant rag doll in a deracinated hospital ward are important and necessary social commentaries, but too heart rending and raw, I would submit, to appeal to an influential collector.

Mainland China holds significant art fairs in Beijing and Shanghai to which the international community of art dealers are invited. Only a small percentage of overseas dealers accept and the fairs end up as domestic events. International art fairs reverse this equation in favour of European and American galleries. The notion of a commercial art jamboree held annually in cities around the world has proved so popular that brands such as Art Basel have extended their franchise to Miami.

The international art fair both attracts overseas representation and allows for domestic expansion. In the case of China, ShContemporary and CIGE in Beijing have conformed to this model and no doubt envisage a growth in overseas interest, although they will be outgunned by equivalents in Hong Kong and Seoul. Art fairs like biennales have become ubiquitous and unwieldy machines whose usefulness in all but major international art market centres is outmoded. Demand on a mass scale for international contemporary art ebbs and flows and is unusually, for art, dramatically affected by the broader economic indicators. China's two big internal markets

in Beijing and Shanghai receive sufficient consumer interest, both domestic and overseas, without the need for these annual art jamborees. In their place regional fairs, which encourage local cultural differences and exploit the great skill and craft base that still survives in China, would be infinitely more enticing than the vanilla flavoured international events that have become such a feature of today's industry.

It is certainly beholden on China's major cities to invest in their art academies. After all, it is these institutions that will help set China's new cultural agenda. Western Modernism was transmitted to Chinese artists through the art academy,[36] many of whose leading teachers had been trained in Europe and Japan. Modernism came to China because of the West's military and economic expansion into Asia. Such novelties in Chinese art as realistic oil painting first found expression in the country under the Jesuits at the court of the Qianlong emperor, but Modernism truly arrived in conjunction with the West's expression of its global power and with the Treaty Port artists working on spec in Shanghai and Guangzhou (Canton).

The commercial sector will struggle to validate contemporary Chinese art without some efforts from the central government. But the transformation of Beijing into an international art market capital on a par with London and New York has a number of sticking points. In the first place, Hong Kong is much better situated geographically, fiscally and legally. It will remain so until 2047, barring a dramatic change in policy direction by Beijing which cannot be ruled out, whereupon China will exert direct sovereignty over the territory.

There are certainly signs that China is willing to loosen its hold on its currency and allow it to operate within a broader band with other international currencies. The moment that China's currency is floated and restrictions on its export are abolished is when we will have to reassess the global competitiveness of Hong Kong against cities like Shanghai, Beijing, Nanjing and Chongqing. But it is not yet China's policy to level the competitive playing field of Beijing with Hong Kong. The City State remains China's international outlet while its great 'internal' meta cities will function as domestic cogs in a national market for Chinese art and antiques that will be protected from outside interference.

The *Xingxing* (Stars) Group of artists,[37] formed shortly after the death of Mao, and the Political Pop generation of artists grounded in the era of Deng and Jiang's technocratic age appear to have ingested Modernism and claim to have applied it to the Chinese situation.

The First Intellectual

19 Yang Fudong,
*The First Intellectual
I and II*, 2000

Yue Minjun's grimacing faces look very much like the countless images of a broadly smiling Jiang Zemin in front of a gleaming department store. The Chinese writer Lu Xun once showed his readers, through the amoral protagonist AQ, that nothing in China had changed but the actors on the stage. Zhao Yannian (*b*.1924), the Hangzhou-based woodcut artist who illustrated the famous life of AQ[38] at the tail-end of the Cultural Revolution, expressed his own sense of hopelessness at China's condition at the end of the twentieth century. But today's China is greatly revived and less in need of caustic commentary.

There are powerful individuals in China, notably the collectors, Guan Yi and Gao Shiming (the curator of the Shanghai Biennale), both of whom support international Chinese contemporary art. There are institutions like the Minsheng Bank that seek to promote this work within China. I believe that they are swimming against China's cultural current. The cultural misdirection of these individuals and institutions lies partly in the economic path that the technocrats in Beijing had chosen for the country. Foreign investment and joint ventures in cities like Shanghai basically revised the Treaty Port economic model. The unfettered capitalism that infects China's factory towns has temporarily shifted the

nation's cultural axis off centre which is, as we have seen, acutely observed by Yang Fudong's bloodied, bespectacled modern day scholar literati depicted in the photographic diptych, *The First Intellectual* (2000) **(fig.19)**. The protagonist is lost and bewildered in one of China's faceless new urban conurbations, unable to come to terms with the massive societal change, unsure at whom he should throw his brick.

Chinese society and its culture will regain its equilibrium as its economy matures. The next phase of the country's cultural development will be very different from the last. Its export driven arts industry will be replaced by a nationally driven revival of tradition fuelled by a vast, wealthy middle class.

The majority of contemporary art from China will return to tradition

Back in 1998 the dealer and curator, Chang Tsong-zung, spoke to me of his vision for China's cultural future: 'I want to find art that will define certain aspects of traditional culture, which I think of as high art' he said. 'We are not talking about international standards but about the Chinese contemporary art scene.' He went on to declare his disappointment at the eradication of China's enlightened feudalism by the Communists and the rapid disappearance of good taste and pleasing proportion. A year later, he confessed to being forced by the international market to promote the work of the young contemporaries, but said that he was actively seeking out a more traditional culture.

The path that Chang and the neo-traditionalists want China to take in the future is one that leads to the revival of antiquarianism rather than greater international engagement. It is a path from which China has strayed since the Cultural Revolution. In his essay accompanying the exhibition of contemporary calligraphy *Power of the Word* (2002) Chang reminded his audience that calligraphic inscription once appeared routinely as architectural ornament throughout China: 'Carved into wood or set into the architecture in brick or stone, calligraphy would appear centrally over the city gates, on beams and pillars of civic and religious buildings, and as poetic decoration in residential and garden architecture' (p.6).

The neo-classicists wish to preserve the grand tradition of Chinese calligraphy in which four scripts, in use since the fourth

century, are employed to articulate classical poetry and in which the good character of the writer is an essential ingredient in the finest works. A master classical calligrapher such as Sha Menghai (1900–1992) trained as a seal carver and calligrapher. He also demonstrated a talent for big characters and so received public commissions for such landmarks as the plaque for the *Da Xiong Bao Dian* pavilion at Hangzhou's Lingyin Temple (1955). Five years later he was asked to create another name plaque for Tianwangdian, one of the main pavilions in the Longhua Temple in Shanghai. Three elements to Sha's work – big character, architectural calligraphy and seal carving – suggest other untapped alternative markets. Prestigious commissions such as those that fell to a master like Sha are as likely, in the future, to be privately as publicly commissioned.

Calligraphy appeared in public on commemorative monuments in the form of an aphorism and short essay, making the art form uniquely and universally accessible. This shared culture ran deep and throughout Chinese civilisation, from the scholar examinations in which aspiring officials digested and memorised the Confucian Classics to the carpenter who might adorn the roof beams of a newly constructed house with images of the Daoist immortals. This 'alert attentiveness to the mundane routine of daily life' (p.10) that Chang acutely identifies in the Chinese is the *Dao* (the way) or enlightenment achieved through an intense focus on one's chosen task or professional calling, 'You must be serious in daily life, attentive in your work, sincere in your dealings with others. Even though you may walk among barbarians, you should not let concern slide' (Confucius, Analects XIII 19).

The break with the tradition of reverence for the past, which at the pinnacle of society took the form of the acquisition by successive dynasties of antiquities, calligraphy and paintings, was, Chang asserts, the final dominion of the icon (starting with Mao Zedong) over calligraphy. Over time this stigmatisation of the past has given way to a renewed interest in history, although the tendency to think in linear terms backed by shallow ideological constructions endures. Communist commands have been replaced by Capitalist entreaties. The *Land of Slogans* (2002) by Wu Shanzhuan (*b*.1960), employs giant machine-made characters (with the occasional counterfeit) to deliver instructions and orders in an impersonal manner. His message is clear; calligraphy has suffered from the mechanised creeds that have followed the fall of China's last dynasty and suffered a catastrophic loss of artistry.

Another challenge to calligraphy and tradition arrived at the end of the twentieth century in the shape of technology. How were characters to survive the computer revolution? The monumental technical achievement of Wang Yongmin (b.1943) in developing *Wubi*, the 'Five Stroke Character Code' system which has allowed keyboards to contain brush stroke characters and enabled the user to work from top left to bottom right without compromising the integrity of the character, has not only protected the Chinese character from extinction but enabled a skilled user to type Chinese faster than his counterpart typing in English.

There are no inscriptions on the clean white walls of the Suzhou Museum. The émigré Chinese architect Pei Ieoh Ming (b.1917), better known in the West as I.M. Pei, who can trace his ancestry back to this ancient cultural and trading entrepot,[39] elected to construct a bland, colourless arrangement of planes interrupted by hexagonal apertures. Pei has used glass and slate rather than tiles for the roof, which is inappropriate for a museum that shows light-sensitive brush painting. To the Chinese, the roof is a symbolic structure that alludes to heaven's shelter. By cutting windows into his roof Pei flies in the face of Chinese culture. In his internal garden the architect has sliced the rocks, which masquerade as mountains, in order to create a dramatic silhouette against the white wall backdrop, while a foreground bridge creates a horizontal axis. To one side a grove of bamboo dominates the 'mountain' range. Instead of multiple viewing points, Pei's garden is a single view panorama, in which each element is incorrect in its scale and proportion. Water plays a key role in the design, prompting the recollection of an upmarket, mid-West American shopping centre rather than the glories of the adjoining Humble Administrator's Garden. In short, Pei has done little for the historical patrimony of Suzhou.

The mistaken post-modernist approach to the revitalisation of Chinese culture is encapsulated in buildings like Pei's Suzhou museum. The cement-walled, courtyard structures of Beijing's gallery districts are further examples of this tendency to mimic the past without investing in craftsmanship or a proper understanding of their context. The censor-shaped Shanghai Museum, with its interior of polished marble and gilded balustrades, is the most glaring example of a misapplication of the forms of the past onto a twenty-first century Chinese city.

It is with that sense of displacement and incongruity that I listened to the critic Li Xianting (b.1949) express his vague hope in a new Chinese language and system to replace that imposed

by Western art. As we sat drinking tea looking out over snow-covered swathes of the peri-urban corridor of Songzhuang, in the company of the critic's female acolytes, Li pointed to a work by Mao Tongqiang (*b*.1960) which depicted a forest of wooden hammers. The hammers, he explained, were metaphors for the Communist Party. It is this new vocabulary, he continued, that will change the language of contemporary art. Li was less clear about a structure within China to contain its resurgent contemporary art, except to say that it should be based on authentic Chinese culture, but with global ambition.

A part of China's global cultural ambition was expressed in the destruction of large parts of its capital city in order to make way for Beijing's Olympic stadia, to which The *Xingxing* (Stars) Group artist, Huang Rui (*b*.1952), responded with the silkscreen

20 Liu Qinghe, *Self-ignite*, 2003

and oil work, *Chai/na/China* (2005). In the painting, Huang prints the word 'China' horizontally across an image of a partially demolished *hutong*. He also prints the two Chinese characters for 'demolish' *(Chai)* and 'that' *(na)* above and below 'China', making a subtle association between nationalist bombast and irretrievable cultural injury.

Li is not alone in envisioning essentially a Chinese culture of Han nationalism with internationalist ambitions. The principle on which this culture rests meanwhile, which is the process by which art is created, is ignored. The *agent provocateur*, Chang Tsong-zung, has been instrumental in reinvigorating China's crafts by either commissioning or advising wealthy individuals to patronise artists who work within tradition, for quite some time. His solution to the long-term future of China's beleaguered culture is much more substantial and sensible. Chang has much to say on this subject, and it is a tribute to him that he has spoken openly about the failings of the Chinese avant-garde while he was actively dealing in their work, 'market forces being', on his own admission, 'rather stronger than one's intentions' (Robertson 1999). But some of his beliefs resonate more than others. The notion of reviving sign-writing by encouraging the adoption of these artefacts by small businesses, the restoration of the traditional inns as a way to save domestic architecture and the re-introduction of natural rocks (Chinese sculpture) into the urban environment, are just three of his most practical suggestions.

It is the realist in Chang who admits that the scholar/apprentice model of brush painting tuition in China is unlikely to be re-vitalised to any great extent, and it is why he has focused so much energy on the China National Academy of Fine Arts in Hangzhou. The Academy of Fine Arts is renowned for its teaching of brush painting and it is through institutions such as these that Chinese art will move forward. The New Literati Movement (*xin wenren hua*), which came to the fore in China in the 1980s began, with artists like Li Xiaoxuan (*b.*1959), to address change wrought by modernisation, ostensibly urban life. Li's large brush painting of passengers squeezed into a city bus, *Big Vehicle* (1995), drawn in his characteristically dense brushwork, is a good example of this approach to new subject matter. Everyday life – the kitchen sink school of new brush painting – is rendered equally expertly by Liu Qinghe (*b.*1961). His monumental study of a destitute couple, *Self-ignite* (2003) (**fig.20**), and triptych of three prostitutes drawn with broad brushstrokes in the *xieyi* (free) style, that were propped up

against his Beijing studio wall one freezing cold January evening, are as expressive and emotionally charged as brush works can be.

The realist theme runs through the intricate horizontal constructions of Dou Liangyu (*b.*1976) and his colourful and extremely explicit accounts of behaviour in Chinese saunas. Above the glittering entrance to *Bathhouse I* (2007), framed by two *qipao* clad girls, naked men are pummelled by masseurs while others luxuriate in a steam bath. Above, in a dozen square openings, every manner of sexual offering is graphically depicted. Air conditioning units are attached to the exterior walls as they appear today in every Chinese city.

Realism in contemporary brush painting is comically captured by the epicurean, Li Jin (*b.*1958), whose appetite for corporeal pleasures is far removed from the aesthetic concerns of the traditional scholar/painter. Li's work, which has precedence in Ming and Qing erotic novels, is never painted more lovingly than when his long, colourful scrolls deal with food and sex. *The Spring Scene in the Garden* (2007) is a glorious example of these two traits in his work. We see the artist portrayed playing a traditional Chinese instrument, known as a *Guzheng*, eating his fill at a picnic table and depicting his naked girlfriend, *en plein air,* in a hot tub. *Holiday* (2006) is one of his most audacious works and compositionally one of his least traditional. In the painting, Li has inscribed the whole menu as a background on top of which he has placed wine, victuals and a nubile young girl in a floral costume. In the 14m long scroll painting, *Flowered* (2009), Li ventures into a fantasy world in which he appears bound and cowed before a gun-wielding Model Opera performer and female soldier, while behind him two partially clad women represent the indiscretion for which he seeks punishment and absolution. He is separated from his girlfriend by a void further on and, despite returning to his Bacchanalian life at the end of the work, appears reflective and almost sad.

Practice until perfect is a cornerstone of the very best art created in today's China.[40] It is something that a master like Xie Zhiliu (1910–1997) knew all too well. Xie repeatedly traced the works of Song dynasty (987–1279) figural, bird and flower painters in order to become one with tradition. He joined Zhang Daqian in the early 1940s in order to record the Buddhist cave paintings in Dunhuang. He used line in his work rather than shading, which is fundamental to Chinese painting. I sense in Xie's scrupulous approach to his craft the same dedication in the woodblock prints of Qiu Anxiong (*b.*1972). Qiu's adaptation of the *New Classic of Mountains and Seas*

(2008), a compilation of fantastical beasts and creatures formed between 500 and 200BC into the 12 signs of the zodiac, is as exquisite as it is amusing. One of the plates refers to Nie Jing, and shows a rat with an ear on its back. The accompanying calligraphy states, 'In the middle lands there is a rat. On its back there is a human ear. It is called Nie Jing'.

The re-interpretation of these historical and fantastical tales combined with Qiu's great craftsmanship is an excellent indication of how tradition can be made relevant in today's China. But perhaps the clearest act of devotion to rehearsal is the *Copying One Thousand Times of Preface to the Orchid Pavilion* (1995/1996) by Qiu Zhijie's (b.1969). *The Orchid Pavilion*, written by Wang Xizhi in 353BC, is one of the most famous pieces of Chinese calligraphy and Qiu Zhijie's repeated copying resulted in his homage appearing as a completely black image. By imitating the hand of the master so many times, and pursuing a practical path towards enlightenment, Qiu Zhijie, like Xie, believes that he can capture the spirit that inspired his illustrious predecessor. It is his ability to lose himself in his work that enables him to emulate the spirit of the author of *Preface to the Poems Composed at the Orchid Pavilion*.

The course of relearning the processes of multi-colour woodblock printing was restarted shortly after the formation of the People's Republic of China. Anne Farrer (Aldrich, 2009) recounts how the China National Academy of Fine Arts opened a section of the printmaking department, the Purple Bamboo Studio (*Zizhuzhai*), 'for research into the history and practice of processes of colour-printing and for the reproduction of model socialist-realist artworks, paintings, decorative letter-papers, folk prints, compendia of seals and illustrated books' (Aldrich, 2009, p.127).

A new generation of artists grew up in the 1980s with a renewed interest in China's native traditions and artistic mediums. An artist like Wang Chao, Farrer writes, has developed an individual antiquarianism in printmaking 'through which he uses formats, imagery and techniques drawn from pre-modern China to offer a personal statement about the present' (p.130). Wang has, in common with other artists working within tradition since the 1980s, adopted subdued colours and graded ink tones. In one particular work, *The Desk in the Jiuli Studio* (2003), he depicts scholarly objects on his desk, items that were esteemed by collectors in the late Ming period. By this act, he draws the comparison with his own devotion to the past. It is a zeal that extends to the artist's printmaking technique. Wang is alone, Farrer explains, in using the assembled block

(*douban*) technique printed with water-soluble ink in an unmodified form. The artist uses multiple small blocks in varying grains to lend a subtle surface texture to his works of art. It is a time-consuming labour. Wang carved 23 blocks for *The Desk in Jiuli Studio* (2003). The artist's subtle graduation of colour and prodigious graphic skills appear in another work, *A Show of Power on the Desk in Jiuli Studio II* (2004). Modern toy soldiers are shown attacking a walled, rocky enclosure while black fighter planes fly menacingly overhead, transforming into birds over a square of coloured landscape. China is still in danger of losing its past to modernisation, but there are signs in works such as these that some of the lost territory is being reclaimed.

There are a number of quasi-traditionalists today in China who display remarkable degrees of dedication to their work. Ying Yefu (*b.*1983), who has set himself the task of painting 500 *gongbi* paintings before he retires, creates precisely coloured ink studies of young, long-haired girls on *xuan* paper, which when examined alongside other works of a four-eyed god, can be read as nostalgic elegies to a simple past. The monochrome rice paper paintings of Ren Zhitian (*b.*1968) conceal, in a background filled with the artist's calligraphy, images selected from the internet such as war planes or the island territory of Taiwan, which the artist prints onto the paper using an inkjet process. Shen Chen (*b.*1955) displays a fanatical dedication to his water and acrylic canvases. The layered vertical strokes of his white paintings have *shi* (momentum) and in the most intensely worked pieces, an absolute whiteness that the Chinese refer to as *yubai* (beyond white). Zhang Yu (*b.*1959) practices his art in the most concentrated way. His coloured *xuan* paper, monochrome scrolls are made up of thousands of imprints from his fingers. The repetitive processes involved in all these works draw our attention to the 'oneness' and continuity that is experienced during meditation.

The work of both Shen and Zhang has a very clear meditative quality. The art of Qiu Shihua (*b.*1940) takes a further step towards 'oneness'. In his almost blank oil-on-canvas and fibre paper paintings, the artist rejects any remaining attachment to objectivity and, like the Korean Lee Dong-youb (*b.*1946), conveys a sense of 'nothingness' to the viewer. Shimmering through Qiu's canvas is the suggestion of land and sky. The sky has merged with the land, Chang Tsong-zung explains, and as the image becomes less clear the viewer is asked to focus on the spiritual rhythm of the work, putting aside any desire for representation. Qiu is preparing us not

for ascension into heaven, but for a transcendent life here on earth, experienced and understood through a deep reverence for nature.

The cultural messages sent to the world by satellite during the Beijing Olympics were of a bombastic China that was still intent on eradicating its material past. I'm not sure it is a China that the world will recognise in 20 years time. By then a rediscovered self-confidence will have created the climate for real change and usher in the age of Chinese cultural 'authenticity'.[41] The intriguing part to this evolution is the political path China will take in the course of this gradual transformation. In all East Asian examples, democratic government has led to great improvements in culture. One has only to think of Japan, South Korea and Taiwan to see how the conservation and preservation of the past has developed since those countries became democracies. Of course this is to ignore the fact that Japan and Korea also became very wealthy. Taiwan and Korea were wealthy even before they held their first open elections, but democracy in their cases seemed to be an inevitable consequence of greater material wealth. China is different. China will become extremely wealthy in spite of its political system. How that system treats the past and how the leaders regard the past are the keys to the future of contemporary Chinese culture.

China's art market is moving towards a layered, internal system of circulation

Chinese buyers now form an important segment of the international Chinese antiques market. But dealers and auction houses have been much less successful in convincing those buyers of the value of international contemporary Chinese art.

At the contemporary market's peak in the 2008 spring sales, nine of the 15 most financially successful artists were Chinese cutting-edge oil painters, with the Chinese performance artist, Cai Guoqiang, making the tenth. The combined turnover that year for Zhang Xiaogang (5th), Zeng Fanzhi (6th) and Yue Minjun (7th) was over 105 million Euros (Artprice 2009). These artists had come a long way from the early 1990s when a couple of Hong Kong dealers visited their houses and studios, spent between one and ten thousand dollars, rolled up a few canvases and tried to sell them in the Crown colony. A handful of intrepid Western entrepreneurs took up this baton and within a decade the international art world set up shop in China's backyard.

Traditional Chinese brush painting, and particularly calligraphy, has always had a particular appeal to Asian collectors. It appeals as much to the *Xiaozi* (petty Bourgeoisie) as to the super wealthy. In scroll form it makes the ideal gift. When rolled it is easier to transport and display than Western oil paintings. It also lends itself to an alternative form of enjoyment. Although it is often hung on a wall it can be appreciated when laid out horizontally. As with an illuminated manuscript or a Mughal miniature the viewer is obliged to scrutinise narrative details in order to get the sense. By the same token it is also the vehicle for language, poetry, monumental landscape, realism and abstraction. The unfurling of a brush painting is inextricably linked to the tradition of presenting 'gifts' to friends, which forms a significant part of the art economy in Asia. It absolves both the giver and recipient from the need to use money and it has no need of an intermediary. It is a tradition that will come to represent perhaps the largest part of the Greater Chinese art market.

There is a future for tradition in China because there is a ground-roots revival in traditional practice. This revival needs to combine with a resurgence in China's internal art markets, whatever their colour or shade, whatever their channels of distribution. They should, in point of fact, be many and varied. Only then will China have the culture that it deserves.

Notes

1. Gao Zhen (*b.*1956) and Gao Qiang (*b.*1962).

2. A number of families of victims of the earthquake in China's Southern province are seeking redress for the shoddy way in which schools and other municipal buildings had been constructed. This has led to thousands of unnecessary deaths when buildings have collapsed like packs of cards.

3. *Financial Times* interview, Pilling, D., 24–25 April 2010, *I Don't Think Anybody Can Protect Me*.

4. The size of the ink-painting market in China is estimated by Zhang Xiaoming – of the Guardian auction house – to be in excess of $100 million (in conversation, Beijing January 2010).

5. Chinese calligraphy appears in a number of forms: oracle bone (*jiaguwen*) from the thirteenth to eleventh century BC; bronze script (*jinwen*) appears on bronze vessels and metal weapons from the eleventh to third century BC. In 1952 a modern simplified script (*jiantizi*) was adopted in mainland China, although not in Hong Kong and on Taiwan.

6. Zhang Daqian was granted the services of Madame Chiang's (Soong Mei-ling) (1897–2003) personal photographer to take pictures of his magnificent lotus pond just before his death. Chiang signed each image.

7. Zhang Daqian was born in China, moved to Taiwan, then to South America, then back to Taiwan.

8. The previous record price for a brush painting sold at auction in China is the hanging scroll of Mountain and Water by the Qing dynasty artist, Bada Shanren, which made RMB 15.4 million (£1.54 million) at Beijing Huachen in 2006 (Hao 2007).

9. In the spring of 2009, China Guardian recorded a higher total than Beijing Poly. The Chinese auction houses that turn over the greatest number of works of art are: Poly, China Guardian Auctions Co., Beijing Hanhai Auctions Co. Ltd, Beijing Redsun Auction Co. Ltd, Beijing Jiabao International Auction Co. Ltd, Beijing Tranthy International Auction Co. Ltd., Beijing ChengXuan Auctions Co. Ltd.

10. The major Auction houses in China, when they are not owned by the State, are bestowed on the children of senior Communist cadres.

11. The Confucian notion of a harmonious mass behavioural pattern, which must result in a consequently good individual emotional pattern, is at the centre of the thinking of China's neo-conservatives.

12. Abanindranath Tagore's painting *Bharat Mata* (Mother India) (1905), which depicts an Indian woman with four arms, refers to a Hindu deity.

13. In conversation with Mr Chang in January 2010 in Hong Kong, Mr Chang declared: 'In order to develop creativity in China we need to re-examine the past and this will allow us to look at ourselves, rather than through a Western or Soviet prism. India holds the key to this process.' This view is a development of the passionate beliefs held by Chang that he first expressed to me in 1998, 1999 and 2000 (*Art Newspaper*).

14. The *tiyong* system established in the late nineteenth century by Zhang Zhidong sought to embrace the study of Western ways but insist that Chinese learning was essential (Fenby 2008, p.77).

15. In 2005 Confucius' birthday was celebrated and Hu Jintao promoted his Confucian doctrine of a harmonious society. In 2006 the government backed a world Buddhist forum in Zhejiang province and in 2007 it sponsored a six-day forum to examine and promote Daoism.

16. Not an autocracy in the European sense of the word. China has not had a hereditary aristocracy or a caste system like that which operated in India and Japan. Egalitarianism and mobility were both present in Old Chinese society (Linebarger 1937, p.90).

17. Sun's vision of democracy in China was justified through four key elements (Linebarger 1937, pp 88–121).

18. It was Sun who Terrill tells us (p.107) 'made a fiction of the Han race for political purposes, declaring that the realm of China was composed of five races: Han, Tibetan, Manchu, Mongol and Hui (Muslim)'. An examination of Han funerary figures suggests that the early yellow river civilisation comprised of ethnically diverse peoples rather than a single racial group.

19. The French nineteenth-century artist Paul Delaroche (1797–1856) waited some 50 years after the Jacobin terror had ended before representing some of the horrors of its government. See *Marie-Antoinette before the Tribunal* (1851) and *The Girondins' Last Farewell, 31st October 1793* (1856).

20. *Eulogy of the Yellow river* was sold for $4,694,400 through Beijing Guardian Auction House in 2007.

21. In this picture Xu uses the famous actress Wang Yin to represent Lady Shang. Wang Yin and her theatre troupe were staying in Singapore while Xu Beihong was enjoying his sixth visit to the British colony.

22. Cai made a winning bid of 31.5 million Euros ($40 million) but refused to pay and effectively sabotaged the auction. The bronze incense burners of a rat and a rabbit were sculptures that once adorned a fountain at the Old Summer Palace and were the work of a Frenchman.

23. It was the 8th Lord Elgin who ordered French, British and Punjabi soldiers to destroy the Old Summer Palace and loot its contents.

24. A core and efficient Chinese army grew up after the first conflict with Japan, which resulted in the ceding of Taiwan to Japan by the Treaty of Shimonoseki (1895).

25. Yuan Shikai commissioned a 40,000-piece porcelain service from the imperial pottery to mark the occasion of his inauguration.

26. Chiang followed the example the Zeng Guofan who had transformed the Qing's leadership and ruthlessly put down the Taiping and Muslim revolts of the late nineteenth century, which led to the short-lived Tongzhi Restoration (Fenby 2008, Chapter 2).

27. Song Jiaoren's Kuomintang party won sufficient seats in the lower and upper houses to form a government, with Song as prime-minister. Yuan Shikai had him assassinated.

28. By the same token, the Chinese government fears the independence of bloggers, and their ability to communicate rapidly en masse. In response it has created fire walls around such social interaction sites as Twitter.

29. Lixingshe was set up in 1932 by Chiang's supporters from his Whampoa Academy days, giving rise to political shock troops known as the Blue Shirts.

30. Edward Friedman in conversation with Ross Terrill (Terrill 2003, p.136).

31. Australian Museums provide an interesting departure from the norm. They have been assiduous supporters of the new art emerging from China.

32. *Silent Energy* at MoMA Oxford (1993), *Alors La Chine?* at Centre Pompidou (2003), *The Real Thing* at Tate, Liverpool (2007), *State of Things* at Bozar Festival, Centre for Fine Arts, Brussels (2010).

33. Zhang Xiaogang, Fang Lijun, Zheng Fanzhi, Yue Minjun.

34. The household registration or *hukou* system in China is a legacy of the past. But it is still a fact of life in seemingly modern cities like Shanghai.

35. *Qinghai Tibet Railway* and *Sky Burial* sold for $2million each at Mary Boone Gallery New York in 2007.

36. Shanghai founded in 1912, Beijing founded in 1918 and Hangzhou in 1928.

37. *The Diary of a Madman,* 1918; *The True Story of Ah Q,* 1923.

38. Suzhou is regarded as the cradle of Wu culture. It was founded by King Helu who died in 496BC. During the Song Dynasty it was renowned for its handicrafts (particularly silk production) and was home to artists, poets and opera singers.

39. The Stars Group (*Xingxing*) was amongst the first collective of artists to represent the avant-garde following the economic reforms of Deng Xiaoping. It was primarily active between the years 1979 and 1983.

40. Xie He's (479–502BC) 'Six Canons' that constitute good painting; in his sixth canon recommends 'transmission' [of the experience of the past] in making copies.

41. For the purposes of this book authenticity should be taken to mean cultural continuity.

4

The Persianate world: Iran, Iraq, Pakistan and Afghanistan

Iran's influence on the culture and politics of the Middle East, Pakistan and Afghanistan

A great slab of bronze almost two metres high, with an integral plinth covered in the pictograms of Ancient cultures, probably says more about the Persianate world than any other work by a living artist. This is the sculptor Parviz Tanavoli's most irrepressible creation. *The Wall (Oh Persepolis)* (1975) (**fig.21**) captures the essential elements of Persian identity: grandeur, internationalism, harmony and luxury.[1] The piece has a sense of physical and cultural permanence. It is a barrier between the viewer and the space on the other side. It demands to be seen and touched. It asks to have its hieroglyphics decoded. What Tanavoli is saying through this work is, before you can understand modern Iran and its culture you must know its past and its origins. You must examine its ancient material remains, look at the range and depth of its artistic achievements, breath in its cultural life-blood. A good place to start is at the apogee of Persianate might or, as seen through Western eyes, at the heroic last stand made by 300 Spartan (and under duress, Thespian) warriors against the Persian Emperor, Xerxes', vast Imperial army at Thermopylae in 480BC.

A year after this colossal historic event, the largest Spartan-led Peloponnesian army ever assembled delivered the *coup de grâs* to the invader at Plataea, which ended Xerxes' plans of a European

21 Parviz Tanavoli,
The Wall (Oh Persepolis),
1975

empire. The democratic state of Athens had also enjoyed seminal triumphs over the superpower on the sea at Salamis and on land at Marathon. Each Greek military feat was achieved against overwhelming odds. The lasting impression, certainly in the Western mind, is of the triumph of the world's first democracy and federation over a decadent, predatory and ultimately soft-bellied, autocratic regime which had little to teach the Modern world.[2] It is a misconception that Edward Said highlighted in his book, *Orientalism,* in which he maintained that the West has, since Aeschylus, positioned the Oriental mind outside and in diametric opposition to the Occidental mind and viewed it ever since as something to be not altogether trusted. In order to better conceive of it, the West divided the Orient up into spheres with appellations like '*L'empire du Levant*' or Middle East. Said bemoans the lack of a vocabulary in the West with which to articulate the richness of these realms. If indeed this is true, he is right to point out that it has to do with the reluctance of European Orientalists to engage with artefacts like sculpture and pottery but rather to reach their conclusions solely by way of books and manuscripts.

Nineteenth-century Classicists like Adolf Holm certainly regarded the Persian wars as the first and one of the greatest of all those waged by the 'kingdoms of the East against Europe'; one in which the East seeks 'to enfold European civilisation in its grasp from two sides, from Asia and from Africa' (Holm, p.1). And one which pits a single despotic power that considers men 'mere instruments of their will' against 'a race in the prime of its strength, full of enthusiasm for the beautiful and gifted with rare refinement of perception' (Holm, p.2). In the end, Holm concludes, mind triumphs over matter, discipline over mere numbers and life over routine. The Greeks, he maintains, were fighting for freedom and their religion against a horde of Asiatics collected by the caprice of a despot, and with no common intellectual tie to unite them (p.57).[3]

Yet at the time, and in the eyes of the Achaemenid Empire – the greatest of the day – that could count on the support of Phoenicians

and Carthaginians in the West, and whose empire stretched from Pakistan in the East to Egypt in the West and from the Indian Ocean in the south to the Aral sea in the north;[4] Athens and Sparta were terrorist states that threatened the security of Persia's empire in the Hellespont (Dardanelles). As if to emphasise the inconsequence of its failed Greek war of conquest, the great empire continued for the loss only of the Ionian seaboard peninsula (today's Turkish Western coast), until Alexander's successful, brutally efficient, but short-lived military offensive at the heart of Persia some 100 years later.

It is to antiquity that the Iranian artist, Massoud Arabshahi (b.1935) turns for inspiration. In a work like *Untitled* (1978), in which he has applied oil paint thickly onto aluminium and canvas, Arabshahi has created the affect of an ancient book on which he has marked with indentations the geometric signs and symbols of an ancient culture. The work is at once an aerial view of an archaeological site and an archaic language. Shapes such as the circle, which appear prominently in the piece, represented nature to the ancient Persians and the square, placed in this work in opposition to the circle, human consciousness. The strong vertical lines, which define the work's central raised spine, mean to the ancient mind celestial harmony while the weaker horizontals, earthly rationalism. The placement of circles inside a rectangular 'citadel' symbolises either the transformation of the sky into the earth or the earth into the sky.

Tom Holland (2005) argues that monotheism, the concept of a universal state, democracy and totalitarianism can all be traced back to the Persian Wars. He describes it as the axis of world history. John Curtis (2005) writes that the Achaemenid Empire 'was the bridge by which the achievements of the Assyrian and Babylonian empires were transferred to Greece and ultimately to Western Europe'.

It is worth recounting the wealth of riverine civilisation that, by the time of the Achaemenids, was available for transfer. Egypt was united under one king in 3100BC, over 2,500 years before the Achaemenid period. Pre-dynastic Egypt extended back further still with one of the world's oldest settlements at Nekhen functioning as the capital for Upper Egypt until the unification of the land and the establishment of its capital in Memphis. In the second millennium BC a number of significant civilisations flourished in the land that today forms the modern states of Syria and Iraq. Sumeria, a collection of city states in which Ur was the central component, developed cuneiform script and even left

written evidence of the use of heroin as a recreational drug, referring to the poppy as the 'plant of joy'. Mesopotamia and Assyria were the most resilient, and Babylon grew to be the capital of a single south Mesopotamian kingdom.

The great Achaemenid dynasty, although founded on shock and awe, evident in the unprecedented size of its armies, the monumental architecture of its cities and the absolute authority invested in its kings, was perhaps less brutal to its neighbours than Sparta, and no more exacting of its tribute than Athens after the formation of the Delian League. Persian statecraft was as successful as the threat of its military machine in securing allies from amongst the many smaller Greek states and, as Holm explains, the introduction of judicial arbitration and a sound administration protected Ionian interests better than the Ionians did themselves. Indeed, under Mardonius, the young son-in-law of the empire's presiding potentate, Darius (522–486BC) who, according to Holm, (p.25 footnote 1) made the most concession to Greek ideas, democracies replaced the tyrannies in the Ionian cities of the Hellespont. The model of this Persian Empire was one, according to Tom Holland, 'that would persist in the Middle East until 1922, and the deposition of the last ruling caliph, the Turkish Sultan' (2005, xxi).

Cyrus the Great (557–530BC) set the tone for his successors and his name has come to represent, by the standards of the day, moderation and civility. The Cyrus Cylinder (a barrel-shaped foundation deposit) can rightfully claim to be the first Bill of Rights. Laid to ground shortly after he captured Babylon in 539BC, the king ordered that statues be returned to shrines and deported peoples sent home. The peoples he refers to are probably the Jews who returned to Jerusalem to rebuild the Temple of Solomon, which had been raised by the Mesopotamians, an act for which the Babylonian king, Belshazzar, the Old Testament recounts, was killed and his kingdom annexed by the Medes and Persians.[5] Rembrandt's masterpiece, *Belshazzar's Feast* (1635), captures the imagined, actual moment when God lets it be known to the king that his days, and those of his kingdom, are numbered. On the contrary, religious tolerance became a hallmark of Persian culture.

In an act of *folie de grandeur*, the last Shah of Iran invited the heads of state from around the world to attend sumptuous banquets in Persepolis (in Persian, Paarsa) and Pasargadae in the Persian heartland of Fars, and in so doing drew the world's attention to pre-Islamic Persia. In another nostalgic nod to the past his father,

Reza Shah Pahlavi (1925–41), established a School of Traditional Arts in painting and calligraphy in order that the Marmar palace might be decorated. The self-aggrandisement of these gestures said more about the Shah's tenuous hold on reality than it did about any conscious shift in the Iranian mindset to a time before Islam, nevertheless it did distinguish Persia from the Arab world, and this has had consequences on the direction of the country's contemporary culture.

Pasargadae holds particular significance as the place where Persia's Achaemenid dynasty traces its origin. It was Cyrus' capital and the place where his tomb is to be found. Persepolis, the decorative schema of its buildings once thought to have been masterminded by a Greek sculptor but now accredited to Persian artists,[6] evoked an equally powerful feeling of Persian consciousness. It was, with Susa, the nerve centre of Darius' administration. Fabulous materials were imported from all over the empire and fashioned by Persian craftsmen into wonderful

22 Farhad Moshiri, *Drunken Lover*, 2003

artefacts and decorative master plans. Pasargadae was an equally sophisticated city which contained the earliest examples of the Persian park, known as *Paradaida* (paradise). The series of paintings of jars by the Iranian artist, Farhad Moshiri (*b*.1963), which he began in 2001, evokes this past through the simple medium of the vessel. The calligraphy on the pot, 'Drunken lover' (2003) **(fig.22)**, supports a poem by Omar Khayyam (1048–1131):

> 'The enchanted lover, always drunk and disgraced,
> Frenzied, love-mad and crazed.
> When sober, grieving he will be
> When drunk again, what will be, will be.'
> Translated by Farhad Moshiri, (Porter 2006, p.44)

Iranians, Moshiri observes, are always quoting verse from the past, without necessarily knowing its origins or the author. The inscription on another of his jars carries the words of the poet Hafez, which were inspired by the song of the nightingale.

Neither Persepolis nor Pasargadae, Holland explains, were cosmopolitan cities in the Babylonian sense; they were not home to the teaming mass of humanity, but rather exhibited Persian might in the manner of Hadrian's Rome.[7] Persian imperial authority could be seen in the pronounced use of precious materials from the lands of subject peoples that had gone into the construction of its major metropolises. The metaphor was extended even to minerals. After Darius had conquered the Punjab a gigantic jar filled with the waters of the Indus was presented to the king by his victorious armies to lie in his treasury with the waters from other great rivers from vanquished lands. This may have occurred to Moshiri when he set to work on his series of paintings depicting jars. On the other hand, the Persian conquerors appear to have assimilated other cultures very readily.

The internationalism of the Persian world, which was maintained under the Parthians[8] (247 BC-224 AD) and Sassanians (224–642), was expressed more subtly in the tri-lingual texts carved into relief rock sculptures of Darius and the subjugated kings at Bisitun.[9] Here, it is tempting to think, may lie the inspiration for Tanavoli's *The Wall (Oh Persepolis)*. Soft power was expressed in the quality of mercy. It was Cyrus who banished the defeated Median king, Astyages, rather than putting him to death and it was this mightiest of monarchs who, after victory over Lydia, allowed King Croesus and his fabulous treasury to remain in Sardis. In so doing he offered

a partnership to the conquered. The multi-lingual texts that were either buried in the foundations of buildings or marked on the column and cliff face were, according to Mathew Stolper, intended for posterity and representative of a diverse and complex society that, because of this inclusive approach to communication, failed 'to spread Iranian languages in Western Asia in the way that Hellenistic rule spread Ancient Greek or Roman rule spread Latin' (p.24).

Zoroastrianism, a religion that took root in Persia around the time of Cyrus II in 590 BC, although some scholars believe it could have been as early as 1,200BC (Nabarz 2005), divided the world into a battlefield between the forces of light and dark and in the form of Mithraism, permeated much of the Roman Empire. In the early stage of the development of this religion it is often referred to as Mazdaism, with other deities incorporated into its structure. Mithra, for example, became the sun god. Farhad Moshiri's diptych of ceramic bowls in silver and gold with alternate backgrounds (2006), gold representing Mithra, the sun and friend, and silver the darkness beyond, allude to the struggle between good and evil that is at the core of Zoroastrianism. The notion of a free human choice between good and evil was a genuine feature of the religion and as such Zoroaster can lay claim to being the creator of the moral world we live in (Axworthy, p.11, see Nietzsche, *Also Sprach Zarathustra*). Zarathustra was a shadowy figure who is said to have come from either the Steppes or Bactria (today's Central Asia). The symbols of the Zoroastrian and Mithraic religions appear in the work of Mansour Ghandriz (1935–1965). In the early 1960s, his trademark yellow circular discs in his paintings were used to symbolise the sun, the most potent element of both faiths.

The conversion of the Roman emperor Constantine to Christianity, and the subsequent official recognition of this act by Theodosius by the Edict of Milan in 313AD, was a key reason why Christianity rather than an Oriental belief system like Zoroastrianism became the official religion of the Roman Empire and, later, the whole of Europe. There is material evidence of Zoroastrianism in the form of stone fire holders in Cyrus' reign and Iranians to this day honour fire in a ceremony known as Chaharshanbe Suri. It was Darius, the successor and lance holder to Cyrus' son Cambyses, who legitimised his accession to power over Cambyses' brother Bardiya whom he assassinated by laying claim to a divine right to govern represented in Ahura Mazda, the supreme being that Zarathustra had encountered.[10] Darius, in short, came to represent Truth (Spenta Mainyu – Bounteous Spirit)

and anything or anyone that opposed him was a lie and a disciple of Ahriman, the embodiment of evil. Carved into the cliffs at Bisitun, Darius is depicted stepping on the prostrate Gaumata, one of the nine liar-kings (all are depicted) who dared to challenge his legitimacy and whom he in turn, one by one, destroyed.

A legendary figure who often appears in the work of the Iranian sculptor Parviz Tanavoli is Farhad the Mountain Carver, the mythical artist who fell in love with the Christian princess, Shirin, the beloved wife of the Sasanian king Khosrow II. The jealous king, in anger, tasked Farhad to carve a mountain or forsake his love. Just as he was about to complete this superhuman project the king falsely told the sculptor that Shirin had died. In despair Farhad threw himself off the mountain and fell to his death. The dramatic tale of the love between the king and his princess, recounted by the poet Nizami Ganjavi (1141–1209), is elegantly captured in a painting by the Iranian artist, Reza Derakshani (*b.*1952), *Khosrow and Shrin* (2009), which combines Mughal miniature type figures with a mottled, muted colour background. Tanavoli faced his own particular challenges on his return to Iran from his art training in the West in 1964. Under Islam three-dimensional representation had virtually disappeared in his home country, although the decorative arts flourished. It is from these artefacts and architectural ornament that Tanavoli would in future draw his inspiration.

The historical and political consequences of recent scholarly revisions of the Achaemenid period in which, in the words of Andrew Meadows: 'Democratic Athens developed an empire based on conformism and exclusion' whereas the Persian Empire was 'politically, religiously and linguistically inclusive' cast both societies and administrations in a new light. 'Such [inclusive] habits', Meadows asserts, 'did not necessarily originate with the Persians, but they were embodied in their empire and transmitted by later powers over these regions to the Modern world … and suggests that this underlying tolerance was among the reasons why the Persian Empire survived for two and half centuries and the Athenian barely a half' (p.181).

At the very least the notion of Persia as international cultural conduit and intelligent empire – the model empire and one of the longest lasting – questions the economic and politically liberal notion expressed by Fukuyama in 1989 that, 'The triumph of the West, of the Western idea, is evident first of all in the total exhaustion of visible systematic alternatives to Western liberalism' (1989, p.2).

His view that any threat to the primacy of the liberal democratic ideology must come from a large and powerful state, and that all states have either acquiesced or shown little sign of growing to a size capable of challenging the Western 'common market', is not the case. The threats and challenges to this model are widespread. They are prevalent as an amorphous theocratic force spread across the region once governed efficiently and productively by the Persians; they are prevalent as an economic force in the form of Middle Eastern (and Asian) government run Sovereign Wealth Funds, and they prevail in the form of state sponsored cultural nationalism or in the case of Iran, pan-continental cultural nationalism.

Perhaps rock music is, as Fukuyama writes, 'enjoyed alike in Prague, Rangoon and Teheran' (1989, p.2) and it may still be the staple cultural diet of many in the emerging world, but as these 'old' societies regain their economic power the airbrushed, antiseptic, Orwellian world that Fukuyama glimpsed will – in the world of art at least – lose its allure. International contemporary art, which has set the cultural standards by which we judge all contemporary art, and the global market for contemporary art, which has set the prices for this commodity, is another instrument of Western markets. The procession of artists from transitional economies travelling to the West in order to realise their creative and economic ambitions has been the norm for much of the last two centuries. This trend will lessen when grand cultures like Persia's rediscover their integrity. Which is why Shirin Aliabadi's (b.1973) lurid *Miss Hybrid* series (2006) of photographs of girls in patterned chadors with plasters over their noses and Youssef Nabil's (b.1972) tinted 'Orientalist' depictions of women are peripheral to the very serious and genuine work that is now being made throughout the region. Aliabadi's and Nabil's work, like Chinese Political Pop imagery, is made for the international market and is much less able to reveal the glories of Iranian culture than those whose work is guided by the past.

Somewhere between the outwardly commercial positions taken by these two artists and the expansive cultural statements of Parviz Tanavoli, lie the internationalist ambitions of photographers Shirin Neshat (b.1957) and Shadi Ghadirian (b. 1974). Both artists have worked consistently with a number of tropes associated with the Middle East with the veiled female form and Arabic and Persian script to the fore. Their images arrest the viewer's attention. One particular photograph by Neshat, a self-portrait, *I am its Secret* (1993), which depicts the artist veiled, the exposed part of her face partly concealed by the circular Persian verse of the liberal, pre-

revolutionary poet Forugh Farrokhzad (1935–1967) in alternative black and white rings, acts as a target and together with the heavily made up eyes, cleverly draws the viewer's gaze. Neshat's *Stories of Martyrdom, from the Woman of Allah* series (1994) shows a woman's palms covered in script with a gun resting on her wrists. Ghadirian's *Untitled: from the Qajar* series (1988–2001) arranges modern consumer objects in an early twentieth-century Iranian photographic style in an effort to articulate the traditional shackles placed on women in spite of the much heralded benefits of the global, consumer society. Ghadirian's piece, in particular, perfectly illustrates Fukuyama's thesis of the triumph of consumer banality over real sense and feeling, but in so doing it has itself become one of those consumer objects.[11]

The artist who defines the creative limitations of the chador as trope is the Pakistani, Rashid Rana (*b.*1967). His *Veil* series (2004–2007) presents frontal portraits of veiled women whose faces disappear beneath their heavy shrouds. The image is constructed out of millions of digital pixels built up into a large print of thousands of hard-core pornographic images. Rana intends to draw a connection between the two male attitudes to women both of which result in the dehumanisation of females. In one respect Rana's intention is underscored by the French born Kader Attia's (*b.*1970) installation, *Ghost* (2007), which depicts dozens of faceless silver foil creations representing Muslim women in prayer. However Rana's work is consciously international in a way in which Attia's is not, referring as it does so explicitly to one of the most widespread (and unsavoury) aspects of globalisation, the commercialisation of obscenity. The manufacture of Rana's prints, which are backed with aluminium and hermetically sealed in ultra violet protected Perspex – a process which is undertaken by a specialist company in Düsseldorf – further supports the view that the artist is intent on producing something that speaks to an international audience.

Each one of these artists has created images that contain sufficient regional cultural elements and an adequate level of dichotomy in order to deliver enough dissonance to please the international market. This in itself is a notable achievement and one for which Rana's work in particular has been commercially rewarded.[12]

The Persian language was transformed by the Arab conquests in the eleventh century, but it survived. The Shahnameh (Book of Kings) of Firdawsi is at the crossroads of this famed continuity. It recounts the stories and legends of pre-Islamic Iran in exquisite

23 Khadim Ali, *Untitled, Rustam* series, 2007

poetry. This text has provided inspiration to Persian miniaturists ever since. It is within the spirit and practice of this tradition that the Hazara-born artist, Khadim Ali (*b.*1978), works today. Educated in the art of miniature painting in Lahore's National College of Arts, Khadim Ali depicts in his *Untitled, Rustam* series (2007) (**fig.23**), the white (*Deo-e-Safid*) and black (*Deo-e-Siyah*) ogres of the Shahnameh with white beards, in an oblique reference to the Taliban. These modern ogres are accompanied by exquisite Persian *nasta'liq* script. In the Shahnameh, Rustam, the work's epic hero, struggles and finally overcomes the white demon after seven tests of his strength.

Khadim Ali is not alone in pursuit of cultural succession; the Iraq-born Iranian artist, Sadegh Tirafkan (*b.*1965), who studied photography in Tehran, employs photo-digital collage to breath new life into the stories of the Shahnameh. His *Whispers from the East* series (2006–7) uses for one image the inner lining (*doublure*) of a mid-sixteenth century Safavid leather and filigree book binding with contemporary figures inserted into the design's cartouches and invading soldiers deployed at the work's base and pictorial entrance. Both these artists have acquired rigorous skills and as a result have a sound base to push against and innovate from.

The Persians further protected their culture against Arab influence through the Shu'ubiyya movement[13] which, through an elite literati, asserted the superiority of Persian culture over others. It is the resilience and pliancy of the scholar elite that has secured the survival of Persian culture through the millennia. The wealth of verse patronised under the Safavids gave rise to major figures such as the poet Rudaki who, according to Axworthy (p.89), in the Shahnameh tradition looked back to a pre-Islamic, pro-Mazdaean Persia. Travelling Sufi poets known as dervishes were also key elements in the spread of Persian culture to India and beyond. Sufism became renowned through its poetry for speaking directly from the heart and through this 'religion of love', Axworthy asserts, emerged the Iranian soul. Something of that emotional directness is captured in Farhad Moshiri's iconic depiction traced in Swarovski crystals of the word 'Eshgh' (love) (2007), a central

Sufi tenet. Sufism was at the centre of sixteenth-century Iranian life, but so was jihad or the holy war against the infidel. The intellectual and political symbols of this Iran lay in the great shrines such as the one at Ardabil and later, in the mid-seventeenth century, the shrine of Fatimah Ma'sumeh at Qum.[14] The shrine at Qum has great significance for Iran today as the place of study of Ayatollah Ruhollah Khomeini. It is at the intellectual heart of the current regime.

The kernel of Iran's identity and contemporary culture, one instinctively feels, lies firmly in *its* past rather than in one based on very different criteria, with dissimilar origins, aspirations and outlook. From the historical perspective, Iran is perhaps the best suited of all the emerging markets to trumpet its particular brand of cultural internationalism. What it immediately lacks are viable economic conduits and a stable political environment.

Creating the basis for a regional cultural Renaissance

Described by Asher and Talbot (p.2) as either the medieval or Muslim period of India's history; the years 1200 to 1750 saw the introduction and assimilation of Perso-Islamic culture into the existing Indic civilisation, creating a composite culture that grew by the sixteenth century to form the splendours of Mughal[15] India.[16] The architectural legacy of this period can be seen to this day in grand monuments like tombs and forts, but also in domestic artefacts such as the enamelled and filigreed patterns on metal objects and textile designs such as paisley and the *salwar-kamiz* (tunics worn over loose pants). In the same way as Chinese potters created Sassanian-shaped vessels for the Persian market, so the curved and sinuous abstract patterns of Perso-Islamic design appeared in North Indian art. Like their ancestors, the Timurids, the Mughals also believed that a ruler's authority could be expressed through the magnificence of monumental architecture.

The area known today as Old Delhi was the result of just such a mammoth construction project undertaken by Shah Jahan (1592–1666) from 1639–1648 and named Shahjahanabad (the Abode of Shah Jahan), complete with a tree-lined esplanade through which ran a canal inspired, according to Asher and Talbot, by Isfahan. South India's infrastructure of roads and inns was dramatically improved, notably by Sher Shah in the first half of the sixteenth century. The

four-part garden (*chahar bagh*) which dates back to Cyrus the Great and can be seen at Pasargadae was a legacy of this Persian migration to the sub-continent from Central Asia. Mosques were one of the most important but also, latterly, contentious commissions. The Baburi mosque at Ayodhya was regarded by Hindu fundamentalists as a legitimate target for an act of terrorism in 1992 because of its supposed symbolism as the legitimisation of Islam in India by Babur and his descendants. There was a notable occidentalisation of Perso-Indic culture in the sixteenth century, which borrowed such Western religious pictorial devices as halos, which in their Mughal context were used to show the divinity of rulers rather than to mark a step towards their conversion.

It might be said that for much of this period a Persian cosmopolis existed in the greater part of South Asia in which there was a shared aesthetic, polity and religion – although Hinduism remained the dominant, majority religion. The Turkman, Mahmud of Ghazni was the first of the Muslims to successfully penetrate India, and we will learn more about how he has divided today's Muslims and Hindus on the sub-continent in the next chapter. It was to him that Firdawsi had dedicated the Shahnameh. The language at his court was Persian unlike the other Muslim dynasties of the day in Spain, Egypt and Baghdad that spoke Arabic. But 1206, and the unification of a series of dynasties in the Delhi Sultanate, is the date that truly announces the arrival of Perso-Islamic culture in the sub-continent. This empire under the great centraliser, Ala al-Din Khalji (1296–1316), became expansionist and also independent of the rest of the Muslim world although contacts between Persia and the Delhi Sultanate were maintained through the Sultanate's warrior families in Central Asia and Afghanistan. Its capital was now Delhi which took shape as a distinctively Islamic city.

Despite the shifting of the capital from Delhi to Agra by the Afghan Lodi dynasty in 1506 and Akbar's new capital in Fatehpur Sikri, Delhi became the symbolic centre of Perso/Indic culture until the expulsion of the last Mughal Emperor by the British in 1858.[17] It was transformed by the mid-fourteenth century into not only the largest city in India but in the East. This world is perhaps best illustrated during the reigns of Akbar (1542–1605) in India and the Safavid ruler, Shah Abbas (1587–1629) in Persia, both of whom operated gently expansionist policies throughout their reigns.

In its polity Mughal India, despite its greater size and wealth, recognised the Safavid emperors as the legitimate inheritors of Persianate culture and as a result large numbers of Iranian

intellectuals and administrators found influential positions in Delhi,
thereby strengthening the connection between the twin domains.
This tendency was reversed when in 1739 the Iranian king, Nadir
Shah, sacked Delhi bringing back to Iran such treasures as Shah
Jahan's Peacock Throne and giving rise to a taste for opulence which
characterised future Persian Shahs. The cultural and religious
influences from Persia extended south into the independent
Deccan Sultanates where the Afaqis – Persian-speaking Iranians –
successfully disseminated Shi'ism. The Rajput courts to the west of
Delhi in Rajasthan were, however, politically independent from the
empire for most of the Mughal period. The kingdom of Marwar in
the Thar Desert, for example, was able to negotiate the independence
of the Rajput princes from the Mughals, Safavids and Qajars over
a 300-year period. But the relationship was, as Jason Freitag (2009
p.6) explains, often quite subtle with the Rathore clan of Rajputs,
for instance, currying favour and gaining external legitimisation as
courtiers at the Imperial court in Delhi.

Mughal power declined in the eighteenth century and something
Asher and Talbot call regional centralisation came into being –
a process by which independent Mughal successor states, ruled by
Shi'a Muslims of Iranian descent, replaced the omnipotent emperor.

Sunni Turkey stood in opposition to Shi'a Persia. The Ottomans
recaptured Syria and Egypt from the Mamelukes in 1516–17 which
allowed Suleiman the Magnificent (1520–1566) to resume his advance
into Europe, besieging Vienna in 1529. Suleiman's campaigns against
the Safavids through the sixteenth and early seventeenth century led
to the gradual decline of Muslim power.

So a Persianate cultural zone is, perhaps, a more accurate
frame of reference when discussing the contemporary arts of Iraq,
Iran, Afghanistan and Pakistan than a division based on national
boundaries. The Iraqian artist, Hanaa Malallah (b.1958), whose
burned and rolled cloths on canvas – *Bullet Traces* (2008) – are
inspired by the style and imagery of Mesopotamian art, do not
owe a cultural allegiance to the newly created states that were once
the home of ancient cultures. They engage, rather, with a grand
civilisation. The strips of cloth may refer to the paper prayers that
are stuck to the walls of contemporary homes in Iraq, but the origins
of this practice run deep across the region. The cultural interaction
across West Asia and the Iranian Plateau is millennia old and the
artificial division of its contemporary art production into national
departments serves no obvious cultural purpose but clearly has an
economic one.

The key purposes of international auctions of Arab and Iranian Modern and contemporary art, a feature of the international art market, are to attract collectors from the Middle East, to advance the prices of the cutting-edge artists by positioning their work alongside established Western 'names', and to impose the international view of the region's art onto its neophyte collectors. Calligraphic artists like the Iranian, Mohammad Ehsai (*b.*1939), are included because they are seen to represent a style or trend in Iranian art, not because they are part of a greater movement or tradition. This is fair enough; it is not the role of international auction houses or dealers to nurture the development of 'regional cultural authenticity'. But we should know that it is ultimately a short-lived adventure because prices for art from emerging markets selected by the international art world form price bubbles. Expensive work is often, but not always, rubber stamped by *kunsthallen* curators, and so art that has little local relevance beyond a thin cultural tokenism finds its way, illicitly, into important national collections and museums.

Art from the Persianate zone will flourish in coalition with oil-rich Sheikdoms

It was during the internecine struggle between the Seleucids (330–247BC) and the Parthians that the Silk Road trade with China began to benefit Iranian towns. Its economic importance to Iran was to last a millennium. Under the Sassanians, trade was extended by sea to India and China and bazaars filled with exotic goods began to appear in a number of towns. The Mongol invaders introduced underglaze, blue and white porcelain vessels to Persia through maritime trade in the fourteenth century, not long after the discovery of this wondrous material during the Tang dynasty (618–907). The cross-fertilisation of cultural practice between China, Persia and the Middle East today is illustrated by an artist like Haji Noor Deen Mi Guangjiang (*b.*1963) who, as we have seen, revived *sini* script as an art form and means of cross-cultural communication.

Today, the world's cultural trade arteries are found, not in overland or maritime routes across treacherous terrain or seas, but in the sky. Art is imported and exported by plane. Its trading hubs do not need to be located off or at the end of an established terrestrial or maritime passage, but wherever it is most expedient. This feature of the modern art trade presents cultures located in

territories that are politically repressed and economically insecure, although not failed states, with the opportunity to promote and sell their wares either through their overseas representatives or foreign businesses with the utmost ease. In today's world, 'Silk Road' has a more immediate significance as the name of an important Iranian gallery that could play a vital role in introducing new Iranian art to the wider region by forming partnerships with other 'players' and representing its artists at regional art fairs.

There are few dealers in the region of the calibre of the Silk Road Gallery, so Iranian artists as well as those from Iraq, Afghanistan and Pakistan are forced to seek alternative outlets for their work. Political censorship within Iran forces them to look outside the country for commercial representation.[18] This has pushed artists to address an international audience and encouraged most of them to jettison the Persian ideals of the earlier generation. Rather like China in the 1990s, Iran's cultural infrastructure is relatively weak, although the Tehran Museum of Contemporary Art, founded by Empress Farah Pahlavi and Kamran Diba, who became its first Director, has an important collection of international art and until recently held critically acclaimed exhibitions of Iranian international contemporary art.

Cairo and Damascus are home to some of the more high profile dealers, such as the Townhouse gallery, but these cities are more likely to be useful to Persianate art when this commodity has an international price. Why should primary dealers in Arab centres promote the work of outsiders? It is much better to wait until this work appears in auctions and then to trade it on the secondary market. In terms of state cultural provision, Egypt is particularly generous and the Grand Egyptian Museum is due to open in Cairo in 2011 opposite the pyramids at Giza. Egypt also boasts the Cairo Biennale (founded in 1984), modelled on Venice. ArtTactic observes that it has been criticised over its selection process which reflects the taste of a narrow group of individuals running the country's major cultural institutions. This is no different from everywhere else in the world. There are a number of important cultural foundations in the Levant that play an essential role in supporting the regional art scene: The Fares Foundation, Audi and Heinrich Boll Foundations as well as George Soros' Open Society all contribute to the intellectual health of the region.

The primary market for a type of art from Iran, Iraq, Pakistan and Afghanistan best suited to appeal to an international elite lies primarily in the United Arab Emirates (UAE). Any type of work

that does not offend Islamic sensibilities can be sold by local and international dealers via the gallery and at the art fair, where in due course it receives an international, transparent price at auction. Later it will be validated by curators at world-class, branded international museums on Saadiyat Island and deliberated over at a regional Biennale in Sharjah. Further commercial avenues can be investigated in time in Doha and Oman, but this is a little further down the line.

There is every sign, on the surface, that the Gulf states' markets will perform the international art market quadrille: artists/dealers, curators/dealers, collectors/dealers and curators/collectors spinning artists' reputations until their work is secure in the Modern pantheon. But there are indications even here that older cultural values have returned to counter Westernisation. The current ruler of Dubai, HH Sheikh Mohammed bin Rashid Al Maktoum (b.1949) is one of the finest exponents of Nabati verse and a great connoisseur of Arabic calligraphy. His patronage, and that of his circle, may be increasingly less drawn to the brand of internationalism on display at the Emirates' international art fairs than towards more traditional forms of expression.

The Turkish art market is another that is growing fast according to ArtTactic (2009) and it provides a further potential conduit for Persianate art. New dealers and art spaces have sprouted in Istanbul, already home to established art businesses. The city also boasts some half dozen local auction houses as well as the four international ones. Turkey has a much more solid cultural infrastructure than either India or any potential centre in the Middle East. Istanbul is particularly well placed geographically with a foothold in continental Europe. The city's Biennale, established in 1973, is, with Sao Paolo and Venice, one of the three most prestigious in the world and its nomination in 2010 as the European capital of culture, combined with its strong corporate support for the arts, makes it another potential market for art from the Middle East, Iran, Iraq, Afghanistan and Pakistan. This is likely to happen after Turkish art has found a niche for itself on the international market – a process which is now underway.

From digital art space, NOMAD, to the Istanbul Museum of Modern Art, Turkey's largest city is extremely well served by cultural institutions. Alongside this drive to assert its position on the world art market stage, the Turkish government has shown its willingness to protect fast disappearing skills and art forms such as carpet making, seeking to revive the use of natural dyes

and traditional weaving methods as part of a scheme known as DOBAG.[19] The British Museum commissioned a magnificent example, which is testimony to the success of this scheme, from the Sezgin family in the village of Suleymankoy near Manisa in western Turkey in 1989. Turkey may have modernised its cultural apparatus but, particularly if it fails in its bid to become part of the European Union, is as likely to turn to the East as to the West for its economic and cultural sustenance.

It is traditional for Modern oil painters from emerging markets who have trained in Europe (usually Paris) within an academic style in the first half of the twentieth century to find a ready market for their work at home when the local economy begins to grow. In the case of Pakistan, Afghanistan, Iran and Iraq in particular, but also for much of the Arab world, this economic process has hardly started. Elsewhere the operation is well underway. The Gulf states, Saudi Arabia and Qatar have substantial gross domestic products and some of the highest per capita incomes in the world. This has enabled the UAE and Qatar to embark on huge cultural development projects. The large numbers of very wealthy Persian and Arab émigrés and regional millionaires would also suggest that the scene is ripe for a surge in the value of Modern Arab, Persian and Pakistani art. But the region's collectors have been slow to act in this market and this suggests that Western Modernism, because most of these painters were trained in Europe, is out of favour. Collectors will search for greater eclecticism in contemporary art and a less intentionally international style.

The prices for Modern art from this part of the world are far lower than the values for equivalent Chinese and Taiwanese twentieth-century oil paintings in the early 1990s. Their estimates are lower even than the tertiary market starting prices of the pre-Herwitz sale (1992) Indian Moderns – and that is very low indeed. The naïve, Mughal-inspired miniatures of London trained Pakistani artist Tassaduq Sohail (b.1930), for example, have estimates in the hundreds of dollars. An important work by the extremely talented Iranian Houshang Pezeshknia (1917–1972) and the famous Lebanese artist Paul Guiragossian (1927–1993) are measured in the thousands of dollars, although Guiragossian's pictures of women in chadors make a bit more. Landscapes by another Lebanese, Saliba Douaihy (1912–1994), and a well-painted Cairo Street Scene by Youssef Kamel (1890–1971) – a founder of Egyptian Modernism – are in the low thousands of dollars.

Works by the Syrian, Nasser Chaura (1920–1992), who studied in Italy and was a leading light of Syrian Impressionism and his countryman, Louay Kayyali (1934–1978), who by committing suicide added to his value, are a little more expensive. The work of Hafiz al-Drubi (1914–1991) who was educated at Goldsmiths College in London and a leading figure in Iraqi Modernism can again be acquired for a few thousand dollars. This type of Western style Modernism, which did so well in its East Asian manifestation, has been less well-received in its Middle Eastern and Iranian guise.

Mazan Qupty is a Palestinian who lives in Jerusalem. He has established a National Museum for Contemporary Palestinian Art with the support of the Oslo Art Academy and Norwegian Government and is at the forefront of a new generation of collectors who have in effect rejected the Modernist tendency. Mr Qupty, who has also launched a contemporary art academy in Ramallah, collects artists such as Nabil Anani (b.1943) who works in leather and wood and exhibits the qualities of craft and harmonious design inspired by Lebanese Folk traditions. Tayseer Barakat (b.1959) is another artist favoured by Qupty. He works in wood and mixed media and bases his art on mythology and the past. Barakat has set about building a new Palestinian and Arab art based on the symbols and designs that refer back to ancient regional art forms.

The Saudi based Mansouria Foundation's clear objective is to collect work that embraces local traditions and history. Taha Sabban's (b.1948) patterned images of town life reject the values of modern metropolitanism. Abdullah Al Shaikh's (b.1936) semi-abstract paintings question the value of so-called Western progress on the Arab world. Faisal Samra (b.1956) traces a deconstructed Arabic script in oil, pigments and gold leaf onto dry clay and wire mesh. The incomprehensible words recall the scrawl on charms that are intended to ward off evil spirits. The two elements – script and form – merge together, blurring the borders between sculpture, painting and calligraphy. All these artists seek their inspiration from their own culture and express their art in a way that is aimed to appeal not to an international market but to local concerns and tastes.

The alternative tendency towards an international style is also represented in the region, and no more clearly than by the Iranian collector Ebrahim Melamed, who has opened the private Honart museum in Tehran. There are also British collectors, like Charles Saatchi and Frank Cohen who dip periodically into emerging art markets and whose taste reflects that of the international art

market. The market is finely balanced between the two tendencies, internationalism and tradition, but the momentum is with the latter. The paintings and sculptures of the *Saqqa-khaneh* and *Naqqashi-khatt* group of artists – of which more later – are proving to be the most potent regional cultural forces. These works take their inspiration from the past and are disinclined to align themselves with international taste.

The two approaches that have formed out of the Modern and traditional approach to twentieth-century Arab and Persianate art have split the market. Both are commercially successful, boosted as much by the gaseous international contemporary art bubble as by the search from within that market for something new and exotic. Internationally directed art by émigré Shirin Neshat (*b.*1957) and her near contemporary, the Moroccan Laila Essaydi (*b.*1956), has so far performed relatively well, so has the Iranian Shadi Ghadirian (*b.*1974) who is represented by the Silk Road Gallery and in Dubai by the Progressive Gallery. Then there are artists like the Palestinian, Jeffar Khaldi (*b.*1965), the Syrian, Sabhan Adam (*b.*1972) and the Lebanese/Algerian partnership of émigrés Walid Raad (*b.*1967) and Adel Abdessemed (*b.*1971) who all take a provocatively political stance and in so doing play to an international audience. Raad in particular, through the work of his Atlas Group, is a political activist rather than an artist and as such finds Europe's *Kunsthallen* curators to be his willing sponsors.[20]

The other group tries, despite Iran's unhelpful political and cultural climate, to follow in the footsteps of tradition. The most famous work of art, which appeared to be the embodiment of a revival of this approach, was Farhad Moshiri's (*b.*1963) *Eshgh* (Love), which made over a million dollars at auction at Bonham's in Dubai in 2008. The picture was as much a commentary on rampant consumerism in the Middle East as it was a reflection on Sufi poetry. It struck a chord with the international market. Another commercially successful artist who uses calligraphy is the Egyptian Ahmed Moustafa (*b.*1943). His canvases focus attention on the structure, proportion, geometry and form of this discipline by exploring the building blocks of language; the dot and the cube. Parastou Forouhar (*b.*1962) produces interesting installations of illegible calligraphy in which she applies her script to the flat surfaces of building interiors. Her most recent digital drawings form patterned tiles, designed in disrupted arrangements that are made up of guns and missiles. The Iranian, Pouran Jinchi (*b.*1959), removes the consonants from Qur'anic texts leaving behind a meaningless,

mathematical lexicon rather in the way that the Chinese artist Xu Bing, whom we have already encountered, creates a nonsense language out of his square word calligraphy.

Most of this work is made for a geographically and culturally distant, homogenised marketplace and under inauspicious circumstances at home, or else made overseas by artists who are, to all intent and purpose, part of that distant, homogenised marketplace. What value does international Modern and contemporary art from recently invented, politically disengaged states have? It has a brief economic value, but swims frantically from sandbank to sandbank in search of the shore.

How viable is Iran as a cultural force of the future?

Today's Iran is a Shi'a state. Jafari Shi'a Islam was first adopted as the state religion in Iran in the first years of the sixteenth century. Shah Isma'il I, a Safavid, whose family headed a militant Sufi order, embraced the religion and gave rise to a flowering culture which reached its pinnacle in the reign of Shah' Abbas (1587–1629) and the new capital of Isfahan. For much of the twentieth century (1906–1979) Iran had a secular constitution (based on the Belgian constitution) drawn up by a cross section of the population represented by the Majles, which explicitly stated that the Shah's authority derived from the people, was based on trust and was not bestowed on him by God.

Like most of the empires and cultures under discussion, Iran became a pawn between competing European colonial powers. In Iran's case the powers in question were Britain, France and Russia. Britain's main concern was to protect India from Russian or French encroachment and Iran was once again at the centre of a strategic crossroads. By 1907, shortly after the declaration of its new constitution, the country was divided into three zones; a Russian sector in the North, a British one next to British India and a neutral portion in the middle.

Despite the interference of the Great Powers, the country did enjoy brief periods of representative government. British interest in Iran took a different course when the first oil in the Middle East was discovered in the south-west of the country in 1908, just as its Royal Navy changed its fuel from coal to oil. The Anglo-Persian Oil Company, in which the British government bought a majority

share, was formed in 1914.[21] Constitutional government in Iran was thwarted after the SIS (British Intelligence) and CIA assisted in the arrest of Mohammad Mosaddeq, who had threatened British (and American) oil interests.[22] The coup instigated against Mosaddeq and his National Front coalition in 1953, Axworthy explains (2008, pp 242–243), cemented the links between the United States and the Pahlavi regime while alienating the Shah from most young Iranians.

The upshot of Western interference in Iran is best expressed by the writer and unconventional Marxist, Jalal Al-e-Ahmad who, in 1962, coined the word *gharbzadegi* (Westoxication) in which he attacked the uncritical way in which Western ideas had been accepted throughout society, so that the country's contemporary culture failed to be either one thing or the other. Al-e-Ahmad's description of the nation's cultural ills met with an immediate response from the artist Charles Hossein Zenderoudi (*b.*1937) whose paintings were shown at the Third Tehran Biennial. They were described by the critic, Karim Emami, as *Saqqa-khaneh* in style. *Saqqa-khaneh* literally means water-fountain and refers specifically to the public drinking fonts made in honour of Shi'a martyrs who were refused refreshment at Karbala. A shadowy portrait of *Imam Husayn, the martyr par excellence* (2000) killed at the battle of Karbala in 680, by the Iranian artist Aneh Muhammad Tatari (*b.*1956), depicts the Imam's face covered in an indecipherable prayer scroll. Works of art created in the *Saqqa-khaneh* style employ traditional elements within a modern visual language and often borrow votive elements from Shi'a art.

The Folk Art element to this type of art, by which artists were encouraged to seek local sources of inspiration, lost a lot of its power through the international style in which it was represented. This is a common failing of the art from many emerging art markets, particularly China's, in the early stages of its development. It is extremely wearisome for non-Western cultures to create plausible, indigenous art in an internationally acceptable manner now that the old cultural markers are apparently redundant, and the environment that gave rise to the best of that past art has largely vanished. Caught between the devil and the deep blue sea, the broader context in which this cultural confusion arose in Iran really came to the fore in the 1970s when international companies outsourced the production of high-end goods to the country and, at the same time, speculated on property. The unhappy results were locally manufactured sub-standard international goods and poorly built tower blocks.

Early Persian Modernists studied, like most artists from colonial and pseudo-colonial societies in the early twentieth century, in Europe, ignoring the Impressionists in favour of the Old Masters and the art of the Salon. These artists, notably the Iranian, Kamal al-Mulk (1852–1940), returned home to teach a generation of local artists European Academicism. But this was only part of the story, because another group of Iranian artists resurrected miniature painting in the Timurid and Safavid traditions, which grew into the Tehran School. The (fifteenth-century) Timurid style, centred on the town of Herat, is characterised by small-scale and dense foliate forms with a preference for leaf décor and floral patterns held within geometric frames. The paintings are spatially logical, finely painted and restrained. In the sixteenth and early seventeenth century, the Safavid style centred in Isfahan emphasised the floral and included such nuances as the split-palmette-leaf arabesque, the lotus blossom, the curved serrated lancet leaf and a variety of framing devices. Under Shah' Abbas, the blue and red ground of Persian carpets also changed to warmer hues of yellow and gold, peach and off-white.

These relatively conservative trends persisted in twentieth-century Iranian art in opposition to the late introduction of European Modernism after the Second World War, which culminated in the 1958 Tehran Biennial. But even here there were, according to Hamid Keshmirshekan (2009), attempts to 'Iranicize' the works. Colours were said to embody those of Iran's topography, figures were inspired by Persian miniature painting, while subjects were drawn from rural and nomadic life, its women often depicted in the chador. The approximate balance between the adoption of international currents in contemporary art and remaining true to Nativist[23] principles marked the reign of Mohammad Reza Shah (1941–1979), a time when Tehran was culturally connected to the international art community.

It is worthwhile highlighting the work of three of the artists who formed the *Saqqa-khaneh* Group; Charles Hossein Zenderoudi (*b.*1937), Parviz Tanavoli (*b.*1937) and Faramarz Pilaram (1937–1982). The writer Hamid Keshmirshekan describes Zenderoudi's paintings as reworked Arabic calligraphy and, later, rhythmic compositions of words and numbers in the manner of written prayers which betray his fascination for Sufism. Zenderoudi's work is, commercially, the most successful of his generation and the most familiar to a Western audience – which suggests a predilection among international collectors for out-and-out calligraphic abstraction. The sculptor Tanavoli, he notes, worked in the manner of traditional Iranian

gold and silversmiths. He revived past traditions such as Folk Art, traditional literary tropes and calligraphy in a Modern idiom. Tanavoli is a quite exceptional exponent of a Modern Iranian aesthetic. He has travelled throughout his homeland examining incidental artefacts from ancient doors and locks to shrines and religious iconography.

This assimilation of the essence of Persian culture is brought together in extraordinarily simple, unassuming sculptures. Tanavoli, whose studio 'Atelier Kaboud' was the focus for the *Saqqa-khaneh* Group, offers the most articulate explanation of the objectives of the group:

> I've always been fascinated by the culture of my Persian inheritance: poetry, architecture, and other arts ... It wasn't as if there was nothing for me to see [in Iran]. We've had art in every century in every place throughout the history of Iran. The three-dimensionality of Islamic architecture, which is not just seen in the [buildings themselves], but also in details such as doors, doorknobs, grill-work ... to me these were all forms of sculpture as good as any in the West. In every aspect of Iranian life there is a touch of religion, traces of mystical elements in everything we experience. Religion never stopped my work ... on the contrary I've managed to adapt my work to my religion and drew my inspiration from it. Every shrine in Iran is like a little museum and I have visited thousands of them. The best of all artworks – tiles, woodwork, brass-work and textiles – are displayed in these shrines. These became my sources of inspiration' (2009, pp 274/5).

One particular concept in Tanavoli's art has the value of an over-arching cultural theme. His sculptural rendition of the Persian word 'Heech' (nothing), which comprises three letters in the Persian language, acts as a talisman for those artists who are disillusioned with international Modernism, but also dissatisfied by an uncritical and ill-adapted re-introduction of historicism. There is also a crucial, shared cultural significance between Tanavoli's re-introduction of 'Heech' into the cultural consciousness of Iran and the description of brush and ink as 'nothing' by the Modern Chinese brush painter, Wu Guanzhong (1919–2010) whom we encountered in chapter 3.

The work of two other artists interrogates the past in a fresh and plausible way. Massoud Arabshahi's (*b*.1935) thick impasto, mixed media works draw inspiration from Persia's deep past, incorporating

Achaemenian, Assyrian and Babylonian motives. His art engages with Ancient Persian history but needs considerable interpretation to make sense and lacks the genuine beauty of the work of the *Saqqa-khaneh* artists. The work of the Arab, Iraq-based artist, Dia Al-Azzawi (*b.*1939), uses folk motifs, arabesques, Assyrian and Babylonian figures, calligraphy and, since the late 1960s, poetry and prose – a rich assortment of cultural references – to create vital and energetic canvases.

Whereas the calligraphic works of the *Saqqa-khaneh* artists paid little heed to the strict rules of calligraphy, those of the *Naqqashi-khatt* group of artists 'adhered to the traditional standards of calligraphic form, its anatomical principles and also its legibility' (2009, p.23). The term *hurufiyya* after the Arabic word *harf* meaning 'letter', which alludes to the medieval Islamic scientific study of the occult properties of letters, Venetia Porter tells us (2006), is at the heart of the artist's relationship with the word. But perhaps the main reason for the re-emergence of calligraphy as an important means of contemporary expression lies in pleas from Iranian and Arab writers for artists to express themselves in a visual language that speaks directly to Arabs and Iranians.

One of the earliest and most interesting exponents of calligraphy was the Iraqi, Shakir Hassan Al-Said (1925–2004). In a work such as *The Envious Shall not Prevail* (1979) he spray paints this favourite Arab proverb, which is a warning against envy, onto painted wood in the manner of graffiti. But the artist's work has a more fundamental meaning, which can be found in the Sufi belief that one gets nearer to God in stages. So, Shakir Hassan Al-Said believed, artistic expression developed progressively and out of a mythological consciousness that reached back through Arabic script in its various forms and schools to Mesopotamia.

This force inherent in Arab calligraphy which the Egyptian artist, Ahmed Moustafa (b.1943), has likened (Moustafa, 1988 p.12 in Porter 2006, p.30) to: 'a finely tuned abstract vocabulary embodying universal mathematical laws, and therefore has the power to have an objective moral and spiritual effect upon the viewer' is most effective in a work of art when there is a pictorial balance, harmonious colouring and a spiritual meaning incorporated into the text. But as the Iraqi artist Dia al-Azzawi has said (Porter, 2006), a painting does not become Arabic because of the use of Arab script. The Arab quality comes from a group of elements.

Mohammad Ehsai (*b.*1939) is a leading exponent of this tendency. The artist's fluid style fuses Modern painting with traditional

calligraphy in a balanced and harmonious form. Ehsai's early childhood memories of sunlight filtering through the stained glass windows in his house and reflecting their light onto Persian carpets, have inspired him to create vibrantly coloured, dynamic calligraphy. This early influence on the artist's imagination is apparent in the gold colour that backs the painting, *Mohabbat* (the Iranian word for kindness) (2006), inspired by an extract from a poem by Jalal al-Din Rumi (1207–1273), gold being synonymous with the sun.

The tight calligraphic edifices, akin to the carpet designs, which Ali Ajali (Adjalli) (*b*.1939) constructs, are testimony to his expertise and position as one of the leading calligraphers in Iran. Ajali's paintings are, essentially, flat image interpretations of applied decoration, drawing inspiration explicitly from the craft tradition. Ali Ajali is a founder of the Gol Gasht School of Calligraphy. His *Untitled* (2003) painting (**fig.24**), of interwoven calligraphy, creates an abstract design which leaves serrated edges at the borders of the canvas. The intense colouring of the calligraphy hints at a world beyond language and our understanding. Ajali's process, if not intention, mirrors that of the Chinese artist, Qiu Zhijie (*b*.1969), who, as we have seen, repeats a single piece of script a thousand times until the paper is drenched in black ink and the edges frayed into unintelligible strokes and marks.

One of the most adventurous of the new calligraphers is the Iranian Golnaz Fathi (*b*.1972), who trained as a traditional calligrapher and later spent six years at the Calligraphy Association of Iran. Her reductive canvases, which are often untitled and in which the calligraphy is illegible, owe much to the American Minimalists, but she uses her skill and many of the techniques she acquired as a calligrapher to enhance the quality of her images. Despite the fact that Fathi does not define herself as calligrapher, citing dance as her main influence, her canvases such as the triptych, *Untitled* (2009), appear to convey poetically the essence of this art form (**fig.25**). She is able to do so in large part because she has a profound understanding of this traditional element of her culture.

Another artist should be mentioned in the context of contemporary calligraphy, and that is the Jordanian, Nassar Mansour (*b.*1967). His single word, precisely rendered inscriptions, *Kun I* (2002) and *Kun II* (2006) (to be) are painted in the angular Kufic script. The tension in the design, as taut as a drawn longbow, is dramatised by the clean black letter, the golden disk and off-white and white backgrounds.

The underpinning of the historic and archaeological approach to contemporary Iranian art can only be successful if Islamic and pre-Islamic Persian art is accorded more international attention. Which is why exhibitions of David Khalili's collection, *The Arts of Islam* at the Emirates Palace Hotel in Abu Dhabi and L'Institut du Monde Arabe in Paris in spring 2008 and winter 2009, respectively, have been so important. Farhad Moshiri's work *Allah* was inspired by a textile in Khalili's collection. It is also why the British Museum's 2005 survey of the art of the Achaemenian Persians and its Shah'Abbas exhibition in 2009 were of even greater significance.

It was encouraging to learn that some amends were being made for the destruction of Iraq's cultural patrimony, and subsequent looting of archaeological sites, at the end of the second Gulf War. At a meeting in Paris in May 2004, UNESCO experts adopted guidelines to help Iraqi officials conserve and protect their cultural assets. Many of the major items stolen from the National Museum in Baghdad have now been recovered and returned.

There are signs that alongside a renewed international enthusiasm for the scholarly appreciation of Islamic and pre-Islamic art, new approaches to stimulating the region's indigenous cultural creativity are being explored. The Jameel prize, the Victoria and Albert Museum's new biennial award for contemporary art

25 Golnaz Fathi, *Untitled*, 2009

and design inspired by Islamic traditions, has provided an alternative locus to the staple international contemporary art offerings sponsored by institutions representing the international cutting edge. The Jameel award joins the Abraaj Capital Prize for fine art from Islamic countries and the Aga Khan Award for Architecture, which seeks to discover a contemporary Islamic vernacular style.

On the basis of the selection of artists for the 2009 Jameel Prize there is every reason for hope. The Tehran-based artist Khosrow Hassanzadeh's (b.1963) *Ya Ali Madad* photographic and mixed media series of Pahlavan wrestlers surrounded by a Mullah, general and dervish takes as its inspiration leading figures in Iran's Islamic cultural and political history. The title itself is a prayer invoking the help of Ali, the first Imam in the Shi'ite tradition. The exquisitely crafted lapidary of the Istanbul jeweller/artist, Sevan Bicakci (b.1972), demonstrates the skills of intaglio carving, layered painting and gem setting. Within an amber-like cocoon, Bicakci has constructed the sea walls of the Topkapi Palace and the Mosque of Suleymaniye as well as other Ottoman architectural landmarks. The [perceived] cultural reference to the Ottoman love of luxury and fascination for jewels is transferred simply and effectively through the medium of the craft itself. The Lebanese, Camille Zakharia's (b.1962) photographs of street markings of white, yellow and blue on dark asphalt entitled *Division Lines* use discarded scraps to make an artist's book, the geometric designs of which show the influence of Islamic carpets and tile mosaics. All these artists draw intelligently from their culture and experience, and whether they are taken up by the international market or not is perhaps less important to their long-term future than their desire to continue so to do.

The question is not whether there was Westoxication in emerging art markets to different degrees, but whether the modern political system in place at the time was strong enough to resist its most perfidious influences. In Iran's case the answer is that it was not. The solution for strong emerging states is to adopt cultural protectionism and promote national cultural revivalism while developing an indigenous cultural economy. Iran's situation is far weaker, and its reception of international consumerism occurred in very difficult circumstances to the universally voluntary acceptance by East Asian societies. In Iran the influx of Western goods and services came in a rush following the oil boom of the early 1970s, creating patent and glaring divisions between a traditional and

often impoverished majority and an obscenely wealthy, Westernised economic elite. This gave way to inflation and rise to cultural insensitivity from the hundreds of thousands of expatriate oil industry employees.

Today's Iran, established on Islamic principles in 1979, reflects the views of the *Majles-e Khobregan* (Assembly of Experts) dominated by *ulema* loyal to Khomeini. Axworthy explains that 'The Iranian revolution in 1979 was the harbinger of Islamic revival more widely, showing that previous assumptions about the inevitability of development on a Western model in the Middle East and elsewhere have been misguided' (2008, p.287).

The constitution, which still operates, separates day-to-day government, which is secular, from the ultimate power in the hands of a religious leader committed to Islamic government. Ayatollah Khomeini essentially imported a centuries old notion called *velayat-e faqih* or governance of the Islamic jurist. The Supreme Leader basically serves in the place of the return of the 12th Imam. This odd, and in many ways irreconcilable, system is still the most representative form of government in the Middle East outside Israel and Turkey. There were strong signs in 2007, Axworthy suggested (2008, pp 287–289) that moderate and respected Shi'a voices within Iranian politics were asserting themselves. This he explained was leading to a withering of the moral authority of the current leadership. Rafsanjani's presidency promised, but has largely failed to deliver economic improvements. It made, however, inroads into reducing illiteracy and promised a more liberal arts agenda. It also showed that the Western model for the Middle East was unsuitable, but at the same time there was an age-old desire to engage with the West and reduce political tension in the region.

Since the radical conservative, Ahmadi-Nejad, was first elected president in 2005, Iran has been in conflict with the West. The reason for his victory and the defeat of the former president, Mohammad Khatami, was, suggests Najmeh Bozorgmehr (*Financial Times*, 19 December 2008), down to Khatami's failure to deliver on the economy and to the reformers' over-estimation of the country's desire for freedom and democracy. Not that Ahmadi-Nejad has fared much better in the years he has enjoyed in power. Domestically, his promised support for the poor has not materialised as the increased revenue from high oil prices has brought about inflation to an economy constrained by UN sanctions. Regionally, the great Western fear is that Iran will ignite the Shi'a movements throughout the Middle East (particularly Shi'a

Iraq) into a Jihad. Iran, as Axworthy points out, is a complex polity but not a dictatorship and there was dissent for all to see at the re-election of Ahmadi-Nejad in 2009.

The presidential inauguration ceremony, observed Katherine Butler of *The Independent*, was boycotted by two former presidents, Akbar Hashemi Rafsanjani and Mohammed Khatami as well as two defeated presidential candidates, Mir-Hossein Mousavi and Mehdi Karroubi. The symbolism of the muted greeting between Ahmadi-Nejad and Ayatollah Ali Khamenei spoke of lukewarm support for the president from Iran's Supreme Leader. It may yet pass that Khamenei and Ahmadi-Nejad fall under the control of the Republican Guard and Iran reverts to a military dictatorship. It may also transpire that a populist revolution brings about a regime change. Both cases would lead to a radical re-assessment of the Iranian art world. The volatile politics of Iran highlight the difficulties of arriving at future assessments of a new art from emerging markets.

The upshot of the current hardline leadership in power in Iran is a closed-door cultural policy between that country and the West. Alireza Sami-Azar, the progressive director of the Tehran Museum of Contemporary Art, who had held exhibitions of the Western Modern masterworks in the museum in September 2005, was immediately removed at the accession of Ahmadi-Nejad and there seems little chance of a thaw now that the president has secured his re-election. The loan of 80 objects by the National Museum in Iran and the Persepolis Museum to the British Museum in 2005 for its *Forgotten Empire: The World of Ancient Persia* exhibition was also nearly derailed, requiring the last minute approval of the Council of Ministers. But the Cyrus cylinder has been loaned to Iran by the British Museum, less the missing fragment that has been on long-term loan (since 1972) to that institution from Yale University. A sign, perhaps, that culture is able to over-ride politics.

There are three plausible future directions for Iran's polity. The current regime cements its position and the country remains a hardline theocracy (Cockburn, Axworthy, 15 June 2009).[24] A velvet or bloody revolution ousts the current regime and ushers in a reformist, secular government (Axworthy, 6 August 2009, Khalaf, 27–28 June 2009, Slackman, 9 July 2009). The Republican Guard assumes the reins of power and establishes a military dictatorship.

A particular Khamenei address at the end of 2009, which appeared verbatim in the *Financial Times*, displayed a naked fear that is shared by China's rulers, and one that the West would do well

to acknowledge – anarchy. 'Today', the Supreme leader began, 'is a sensitive, historic juncture for the country. Look at the situation in the world, Middle East, the global economic conditions, problems of neighbouring countries like Iraq, Afghanistan and Pakistan. We are all responsible for remaining cautious now and not making mistakes'. In short, we must be careful, bearing in mind our tumultuous history, not to usher in the anarchy that afflicts our close neighbours. Whether Iran's current and/or future political system is robust enough to avoid a descent into chaos is the most pertinent question, and one which only it, free of outside interference, can adequately answer.[25]

It is inconceivable to imagine an active international art market operating within an Iran that has an unsettled, chaotic polity and, despite its oil wealth, poor economic position. On the other hand, it is quite possible to imagine a vibrant national or regional Persianate art market operating in an Iran governed under the current regime or under a completely secular government. It is impossible to envisage a vibrant cultural and economic life under a military dictatorship; one has only to think of Burma and North Korea.

Since the revolution Iranian artists, many of whom have chosen to reside outside the country, have been the most successful in the region. The hope for a resurgent Iranian culture – one that can vie with others from emerging markets and offer an alternative to the international and to 'Westoxication' – is quite another matter. This hope lies in the beliefs and ideals of the *Saqqa-khaneh* group, which upholds the primacy of an interpretation of Iran's past and, more significantly, the intelligent re-interpretation of pre- and post-Islamic Persian culture into a new vernacular that borrows stylistic elements from Iranian art history. Once again, for culturally intelligent revivalism to be effective the State must set about awakening the cultural apparatus. Then, and only then, can Iran lead the way in much of the Middle East, Pakistan and Afghanistan by once again showing the world the marvels of Persianate civilisation.

It is fair to weight the argument for a resurgent Persianate realm heavily in favour of its ancient, pluralistic and accommodating civilisation, although the reception of those values in the former parts of its empire may be stretching the point. Persian culture has had an immense impact on the civilisations that are now the modern states of Iraq and Pakistan and also on Afghanistan. It has touched today's Turkey and Egypt and extended its influence into Northern India.

The current commercial arrangement between Iranian artists, the Gulf states and the international art market is an interim one brought about by cultural censorship and economic deprivation at home. It is also a consequence of the region's recent history. The domestic situation has made it difficult for a truly representative contemporary Iranian culture to prosper, but were the politics to change, the raw materials for a national cultural revival are waiting in the wings. Until that time, the international auctions of art from Iran, Iraq, Afghanistan and Pakistan in Dubai, Doha and London and the exhibitions of Persianate art in the West, will present a misleading picture of the region's culture.

Notes

1. *The Wall (Oh Persepolis)*, 1975, (181 x 102 x23 cm) was sold through Christie's in Dubai on 30 April 2008 for $2.5 million against an estimate of $400,000–$600,000.

2. The Persians were rich beyond the dreams of avarice; they were perfumed and effeminate; why, 'they even fought in trousers' (Holland, p.157, from Herodotus, 5.49). The Persians were, according to Holland, obsessed with their physical appearance (p.206) and the first to regard bed linen as an art form (Holland p.282).

3. Herodotus gives a graphic description of the multi-cultural complexion of Xerxes' army of invasion (Holm, p.42).

4. The Achaemenid Empire (550BC-330BC) encompassed: Iran, Iraq, Syria, Israel, Lebanon, Egypt, Turkey and Cyprus as well as parts of Afghanistan, Pakistan, Turkmenistan, Uzbekistan, Armenia and Greece.

5. The blasphemy that the king committed was to drink wine from the sacred cups plundered from the Temple in Jerusalem. The Hebrew inscription in the painting reads *Mene mene tekel u-parsin*, which Daniel interpreted as 'God has numbered the days of your reign and has brought it to an end – you have been weighed in the balance and have failed in the test – your kingdom has been divided and given to the Medes and the Persians'.

6. It is felt likely that there is a Persian influence on the Parthenon marbles (Curtis). The building programme at Pasargadae also shows Assyrian and Egyptian influences (Curtis, p.31).

7. The columns holding up the portico to the Pantheon were quarried in Egypt.

8. The Parthian Shah, Shapur, was tolerant towards Jews and Christians. He was mistakenly protective of the universally despised, Mani, an Iranian of royal ancestry, who gave rise to an eponymous, dystopic religion.

9. The words of the inscription appear in Old Persian, Elamite and Babylonian. Elamite remained the administrative language in the Persian centre, further West Aramaic dominated and in Egypt, Egyptian and the demotic and hieroglyphic scripts were adopted. In Greece and the Western Satraps (governed provinces of the empire) Greek was the *lingua franca* (Meadows in Curtis & Tallis, p.84).

10. The assassins kept the body of Bardiya from public view and announced that

he had been killed by his brother Cambyses several years earlier. The man that they had executed, they lied, was in fact a usurper to the throne.

11. Shirin Neshat's *Stories of Martrydom from the Women of Allah* series (1994), edition of ten made £39,768 and Shadi Ghadirian's *Untitled: from the Qajar* series (1998), edition of ten made £2,734 at a Bonham's auction in Dubai in March 2008.

12. Rashid Rana's *Red Carpet I* (2007), a series of five, was originally sold privately for 30,000 Euros. It was on sale at Chemould Prescott Road Gallery at Art Dubai in 2008 for 90,000 Euros. At Christie's, New York in May 2010 *Red Carpet III* (2007) made $150,000.

13. The title refers to the 49th Sura of the Qur'an, where Allah demands mutual respect between different peoples (shu'ub), (Axworthy, p.82). Shu'ubiyya refers to the response of non-Arab Muslims to the privileged status of Arabs within the Ummah.

14. It was for the Great Mosque at Ardabil that the magnificent carpet, now housed in the Victoria and Albert Museum in London, was commissioned. The carpet was woven elsewhere, probably in Kashan.

15. Mughal is a Perso-Indic corruption of Mongol. Early, but not the first, invaders of the subcontinent were a Turkic people who converted to Islam.

16. Asher and Talbot write that by 1600 virtually all the northern half of India had been brought under a unified Mughal Empire (p.115).

17. Babur, a central Asian Prince who defeated the last Lodi Sultan at the battle of Panipat in 1526, became the first Mughal – a Perso-Arabic term for Mongol.

18. The creative environment in Iran has oscillated between significant cultural liberalism at the turn of the millennium to a return to strict Islamic cultural norms under the Ahmadi-Nejad regime in 2005.

19. DOBAG (Dogal Boya Arastirma ve Gelistirme Projesi). Turkish rugs were the first to be imported into Europe and made famous on the (sub) continent by their appearance in paintings by Holbein the Younger (Reed, 1972). Some of the finest examples of Turkish carpet making can be seen in the Gulbenkian Collection in Lisbon.

20. From October 2010 to January 2011 Walid Raad enjoyed a solo show at the Whitechapel Gallery in London – *Miraculous Beginnings*. He demanded high levels of control when working on an exhibition of the Atlas group: 'The works are also created with the assumption that they will be presented as installations in museums, galleries and exhibition halls' (Borchardt-Hume, p.14).

21. Iran has the world's second largest oil reserves after Saudi Arabia.

22. Nasser followed Mossadeq's example in 1956 when he nationalised the Suez Canal.

23. Nativism is a term we have already encountered. It was coined in Taiwan in the 1970s to refer to art that is ethnically, culturally and politically nationalist in nature.

24. Axworthy argued that the current regime was intent on self-legitimisation.

25. Iran currently has three major ruling bodies: the Guardian Council, the Expediency Council and the Assembly of Experts.

5

Hindustan: India

Will India's increasing nationalism be the saviour of its contemporary culture?

My encounter with a giant one-rupee coin in the Saatchi gallery in the spring of 2010 brought into sharp focus the difference that the smallest denomination of wealth can have on some of the world's poorest people. The artist Jitish Kallat (*b.*1974) used the coin, in *Death of Distance* (2007), to highlight the case of a young girl who committed suicide because her mother was unable to afford the one rupee she needed for a school lunch. The themes of poverty, waste and sustainability are also central to the *objets trouvé* of the sculptor, Subodh Gupta (*b.*1960), who for the same exhibition built a flying saucer-shaped construction, *U.F.O.* (2007), out of his trademark brass water bowls. The best thing about these two works and another, a functioning but stripped down Xerox Machine, also by Gupta, is not the aesthetic achievement but the clear picture that it gives us of the terrible waste and uneven distribution of goods in our global, consumer society. *Master Plan* (2008) by Vivan Sundaram (*b.*1943) is a panoramic view of Delhi, made up of the rubbish that the city's 'unclean' collect. Sundaram builds an entire model city out of washing up liquid bottles, drink cans and discarded toys and draws attention to the 'Dalits' (also known as Harijan and formerly known as untouchables) that live off its detritus as well as

highlighting the mountain of waste produced by the showcase cities of the developing world.

At the risk of appearing simplistic, one gets a sense that a significant segment of Indian society is pessimistic about many of the changes wrought by modernisation; which cannot be said of China. This has much to do with India's political system which appears to enshrine diversity and embrace religion. The recent triumvirate that governed the country represented three of its minority religions. The Prime Minister, Manmohan Singh, was a Sikh, the president, A.P.J. Abdul Kalam, a Muslim, and the power behind the throne, Sonia Gandhi, a Catholic. India has always been a land in which a multitude of faiths and cultures have been accommodated. Today, Muslims, Catholic minorities in Nagaland[1] and Goa, Jains and Buddhists live alongside the Hindu majority. This tolerance has led until recently, says T. Richard Blurton (p.10), to an art that is inherently inspired not only by the Hindu religion, but by all Indian religions in which, for example, we can find the Buddha as one of the incarnations of Vishnu. It is Indian polytheism that has given rise to so much fantastic art and Indian syncretism that has allowed ancient beliefs to survive in its folk culture.

Historical background

The earliest settlement in the Indus valley, in a site called Mehrgarh, reveals that from 7,000 to 4,500BC, an agricultural community who made cotton, traded in Lapis and Turquoise and made beautiful, geometrically patterned pottery, thrived. This civilisation was an Indian phenomenon. New arrivals from the Iranian plateau entered this culture around 4,500BC and from 3,500 to 2,500BC it became part of a greater cultural zone. Around the third millennium BC, great cities and a written script (which has still not been deciphered) arose in today's Punjab, giving rise to the indigenous Harappan age. Late nineteenth and early twentieth-century archaeologists discovered over 2,000 major settlements extending the length of the Indus and as far as the Oxus in today's Afghanistan. Startlingly, it appears that the Harappan age was both leaderless and non-violent. Climate change, which dried many of the rivers of the Punjab, forced the migration of these peoples to the Ganges and the Jumna (now Yamuna) around 1,800BC, forming the sub-Indus phase in Indian civilisation which remains to this day.

What happened next according to Michael Wood (2007, p.42) 'is one of the biggest issues in Indian history today, massively controversial in recent years, with heavily politicized debates about Indian identity'. The Aryan peoples from central Asia arrived, says T. Richard Blurton, probably during the middle of the second millennium BC. They brought with them many new devises: gods, horse-drawn chariots, hallucinogenic drugs and a new language. The Sanskrit language, the language of the priesthood and Hindu *lingua franca*, although not the language of Southern India,[2] must have originated outside India, brought to the sub-continent, as well as to Iran and Mesopotamia, by the conquering descendants of a people who lived between the Caspian and Aral seas over 4,000 years ago. The Sanskrit cosmos, a far-flung realm of shared culture has, in the shape of the Brahmin priesthood, led Indian society ever since.[3] Hinduism itself has assimilated its prehistoric and Indo-Aryan strands and, without a central figure or prophet, has evolved by way of the insights of its many seers.

It is clear why the origins of the 'conquerors' holds such significance for today's Hindu nationalists. In addition to language, the Aryans introduced the first text of Indian history, the Rig Veda, and a belief in karma and rebirth which had the effect of fixing the poor in everlasting poverty and the rich in eternal wealth and power. The social mechanism developed to contain these beliefs is the caste system based on colour and birth. The system operates to this day and still, as it did at its inception, numbers the aboriginal peoples as the underclass. Cracks are beginning to appear in this theocratic mechanism – a system in which the Brahmin priest, the sole intermediary between the worshipper and his god, passes down his privilege, father to son. The surge in interest among ordinary Hindus in the dark-coloured, Vishnu *avatar,* Krishna, who together with his flute and peacock-feathered crown, speaks of a pastoral and non-Aryan past is a sure sign that deep cultural forces are at work. The growing popularity for 'the Black (female) One', Kali, one of the manifestations of Devi, is another signal that Hindus are turning to indigenous pre-Aryan gods. The fact that Kali haunts the cremation ground, a place inhabited by the Dalits again points to a groundswell against orthodox Hinduism. The description by William Dalrymple of Manisha Ma Bhairavi drinking from a skull – Devi's third eye – in a cremation ground in Kolkata (Calcutta), in the home of the great goddess Tara, captures an act of religious heterodoxy: 'the idea of reaching God through opposing convention, ignoring social mores and breaking taboos' (p.215).

The disciples of Tara work in defiance of a cleansed Hinduism, largely instigated by the British, and which became known as the Rama-fication of Hindu worship. So do the now debased *devadasis* or female servants of God, who are to this day, Dalrymple recounts, dedicated as young children to temples to the Goddess Yellamma in rural Deccan only to spend their young adulthood in prostitution. Legend has it that Yellamma was cast out by her husband after having let her mind enjoy illicit sexual pleasures. She was cursed and became sickly and ugly, later beheaded but reprieved and restored to life by the intercession of her son. Like the Goddess Tara, Yellamma is a survivor from prehistory and appeals, like Tara, to the outcastes of Hindu society.

The persistence of Tribal cults in Southern India, which venerate nature and create shrines to natural forces in an aniconic form, often no more than painted rocks, also harp back to a time before the Rig Veda. In parts of Bihar a sort of fresco, known as *Madhubani*, painted onto a smoothed plaster wall is still very much a feature of the local arts. The brightly coloured, stylised works, which often depict gods, are painted onto the sides of houses and are very striking. A particular feature of Gujarat are the block-printed textiles that hang on the walls inside houses. The subject will most commonly be the mother of India, the goddess Devi, depicted in her horse-drawn chariot at the head, or at least to the fore, of a vast procession. The Bengali artist, Jamini Roy (1887–1972), looked specifically to Indian pre-history, and the rural arts, for inspiration seeing it, as Blurton (p.19) points out, 'amongst the most culturally influential in the development of Indian, and specifically, Hindu, culture'. His style of painting was learnt from Bengal village *patuas*.[4] This ranged from the rhythmic *Dancers* to the simple and direct *Cat and Fish* painted with egg tempera on card.

The political and religious context

The first prime minister of independent India, Pandit Jawaharlal Nehru, insisted that Muslims be given equal rights in the new secular state and inflamed the passions of fundamentalist Hindus at the time. Since then there have been significant violent, religiously motivated eruptions, beginning in the 1980s, the effects of which lie simmering in the consciences of India's many religious communities. Since partition and Sir Cyril Radcliffe's rapid sketching of a border between the newly created, predominantly

Muslim Pakistan to the west and Muslim Bangladesh and largely Hindu India to the east, religious and political tensions have progressively increased. The artist Jitish Kallat (*b*.1974) wrote Nehru's entire inaugural speech onto a mirror calling the work *Public Notice* (2003), asking Indians to see themselves in Nehru's reforming zeal. He then went a step further in the name of tolerance, by building out of bones Gandhi's Salt March speech of March 1930, in which the guru protested against the British tax on salt, giving it the title; *Public Notice 2* (2007). Both pieces highlight the novelty of the modern ideals expressed by two of India's most important statesmen and give little assurance of its resilience.

Modern India faced opposition from the outset. A strain of radical Hinduism that grew up in opposition to the Raj in the 1920s and modelled itself on European Fascism maintained that traditionally passive Hinduism was subjugated by the Muslims, certainly since the establishment of the Delhi Sultanate in 1206, but even earlier when Muslim states were created in today's Pakistan. One particular figure designed to raise the ire of Indians is Mahmud of Ghazni whose name appears on jihadist banners (and some Pakistani rockets) throughout the Muslim world. He is felt by Indians to have been a Muslim iconoclast, although his violent reputation has been blown out of proportion by both Muslims and Hindus in order to justify their extremist reactions. The embodiment of this so-called 'historic shame' exists in the shape of Pakistan and in the large minority of Muslim Indians. Particularly in Northern India the supreme god, Rama, has acquired a talismanic quality and his birthplace, Ayodhya, was the scene of one of the worst atrocities in post-Independence India, when Hindu fundamentalists demolished a Mughal mosque that they claimed had been built on the precise site of Rama's birth. Rama, as Wood explains (2007, p.176), is an incarnation of Vishnu who visits the earth when injustice reigns. A 1980s television series developed his role as the ideal, pre-Aryan man and king and this reading of the god has been used as justification for extremist actions.[5]

The British, after the Indian Mutiny in 1858,[6] actively discouraged the Christian evangelicalism that had been a part of its earlier government and sought to rule through a series of political alliances with anglicised princes who might have a different religion to their subjects. This patchwork *realpolitik* of semi-autonomous states operated throughout the Raj until partition except for evangelical Nagaland in the north-east and Catholic-Portuguese Goa in the west. Incredible as it might seem, the inquisition was

still active in Goa until 1812 and memories of the earlier attempts by the Portuguese to forcibly convert Indians in the coastal towns and settlements as well as abolish Hindu customs and ceremonies have been appropriated by the Bharatiya Janata Party (BJP), the political embodiment of radical Hinduism. The objective of BJP according to Fernandes (2007) is to identify areas in which the local population has been coerced into either the Christian or Muslim faith and use it to radicalise Hindu youth.[7] Initiation ceremonies in which followers of the Rashtriya Swayamsevak Sangh (RSS) – The National Volunteer Organisation – swear allegiance to Kali with a copy of the Bhagavad Gita[8] in one hand and a loaded revolver in another are extremely sinister.

A further consequence of this aggressive nationalism is the eradication of local cultures, such as the Goan. Pandit Nehru (1889–1964) reclaimed Goa from the Portuguese by force in 1962 in an attempt to appease hardline Hindus. Indira Gandhi (1917–1984) similarly smashed any notions of Sikh separatism and an independent state of Khalistan when she authorised Operation Blue Star – the assault on the Golden Temple in Amritsar in 1984, an act she paid for with her life. Amritsar had been the site of another massacre, by the British of the Indians under Reginald Dyer in 1919, which, according to Tunzelmann, radicalised the Congress Party but also prompted the Sikhs to make Dyer an honorary member of their order by staging a ceremony in the Golden Temple.

The more recent massacre has been remembered in a modern masterpiece of the Mughal miniature tradition by Amrit and Rabindra Singh, otherwise known as the Singh Twins. The large picture entitled *Nineteen Eighty-Four* (1998) borrows imagery from the *Padshahnama*, the Chronicle of the Emperor, which depicts the life of Shah Jahan (1592–1666). It takes a bird's eye view of the golden temple and tilts the composition to give the sense of a vortex. It depicts blindfolded Western media cameramen taking pictures behind soldiers firing guns and Indira Gandhi facing the viewer from behind a military tank. It shows graphic accounts of bloodshed and perhaps most movingly three terrified women huddled together but isolated and vulnerable on top of the temple gateway. The soldiers are dehumanised by the omission of pupils from their eyes, while each victim's face might be a portrait.

A part of Muslim-dominated Kashmir was delivered to India at the last gasp as the Maharajah prevaricated, possibly considering whether to declare independence from both.[9] India felt that it would be unable to defend itself from an attack from China without the

state's mountainous terrain on its northern border. Kashmir was also Nehru's birthplace, and had a great hold on him.[10] Indian Kashmir is still claimed by Pakistan and in 1989 Muslim insurgency in the state attempted to drive out the landowning Hindu Brahmins known as Kashmiri Pandits. The end result is that both the Congress Party and BJP appeal to Indian nationalism, the former stresses centrist economics and the latter, Hinduism.

Moves by minorities within India towards autonomy have been settled effectively, but often quite brutally by the government. Perhaps because of these strong-arm tactics, radical notions of a land exclusively for Hindus – Hindustan (the Mughal geographer's name for northern India) – have been allowed to flower. It should be remembered that both Pakistan and India were conceived as, and are to this day governed by, civil not religious leaderships. It was a great shock, therefore, when in 2002 the Indian police in Gujarat stood by while the Saffron Militia – many from the lowest castes and high on drugs – attacked and killed over 2,000 Muslims. It was a shock because the world expected much more of the Indian government and Indian law than it did of the Chinese in 1989. The massacre was in reply to the incineration of Hindus, allegedly by Muslims, on a train a couple of years after the raising of Babri Masjid (Mosque of Babur).[11] The prelude to the atrocity, Doniger explains (2009, p.664), dates back to 1990 when L.K. Advani, the BJP president, donned the saffron robes of a renouncer (today a right-wing Hindu) and posed with a bow and arrow on top of a truck made up to look like Rama's chariot. Two years later hundreds of thousands of Hindus took sledgehammers to Babur's mosque. Over a thousand people died in the riots.

It is in response to sectarian violence in Mumbai (Bombay) in 2006, following the bombing of a train that the artist, Atul Dodiya (b.1959), created his *Shutter* paintings. The pictures are hidden behind the same type of house shutter that protected households from the violence perpetrated by Muslims and Hindus at the height of the troubles in Mumbai (Bombay). The skeletal rickshaw, *Autosaurus Tripous* (2007), is Jitish Kallat's rejoinder to the internecine conflict that has blighted Mumbai in recent years and has led to a gang culture akin to that described by Fernando Meirelles in his portrayal of feuding Rio de Janeiro mobs; only in Mumbai's case the differences are stirred as much by religious differences as by territorial infringement and personal vendetta. Mumbai's mafia, Gunda Raj, is today motivated by money, although religious differences often provide a reason for conflict.

India's new wealth has also brought with it greater political and military status. When the country successfully tested its first nuclear bomb the BJP swaggeringly asserted that whereas one nuclear attack on it by Pakistan would greatly inconvenience the country, an equivalent attack on Pakistan would destroy it. Provocative and bombastic statements such as these betray the fear that has entered the heart of Indian society that it is vulnerable to foreign aggression and acts of terrorism. The artist, Shilpa Gupta (*b*.1976), touched on this primordial fear in 2007 when she and her friends carried white suitcases displaying the words 'There is no explosive in this' onto Mumbai buses. The word 'no' was indistinct, whereas the other five words were clearly depicted. In 2009, the grim reality of a terrorist attack was felt by the residents of the upmarket Taj and Trident hotel in Mumbai.

Indian democracy has begun to empower the 200 million Dalits. Their social and economic position within the cities at least is greatly improved. The days when Dalits had to warn other castes of their approach by sounding a bell may still be a fact in isolated rural communities but it is no longer the norm. They are, therefore, a politically significant group, courted by the Hindu-inspired Congress and BJP parties alike, although the natural faith for the untouchables is Buddhism and many Dalits become Buddhists or convert to Islam in order to escape their caste. Since 1995, Uttar Pradesh has elected the Dalit, Mayawati, leader of the Bahujan Samaj (Majority People's) party, Chief Minister on three separate occasions. It is tempting to envisage a powerful political party comprising upwardly mobile Dalits, successful in the electronics, outsourcing and service industries all of which are thriving on the sub-continent. But Indian society absorbs and dampens such enthusiasms and the ruling Congress party comprised of upper caste Brahmins and the descendants of the once autocratic and wealthy princes, is allowed to take advantage of the deep divisions that exist between the various Dalit communities.

Rather like the British Raj, Congress divides and rules. Not only Congress according to Luce, but Shiv Sena, the army of Shivaji, a right-wing Hindu party, has filled the political space vacated by an easily fragmented working class, by winning power in Mumbai's civic elections in 2007. Today, every village and town in Maharashtra has a bronze, garlanded statue of Shivaji standing as a symbol of Hindu nationalism. But as Asher and Talbot (231–244) explain, Shivaji (1630–1680), the leader of the martial, Maratha peoples of the Deccan, was in conflict with Aurangzeb's

(1658–1707) Mughal Empire for reasons of power rather than on specifically religious grounds. Shivaji may have been Hindu, and his coronation a traditional Indic affair, and there seems little doubt that he was aware of his Hindu identity in a Muslim universe, but he was primarily a warrior seeking to carve out an autonomous state for himself.

These radical nationalist strains fly in the face of Indian history. The three most revered leaders of large parts of the sub-continent; Ashoka (304–232BC), Akbar (1542–1605) and Nehru have all, in the end, been conciliators and moderates. Their contribution to culturally heterogeneous India can be seen, Wood notes (p.103), in the national flag; Ashoka's lions are the emblem of modern India, his wheel of the dharma (law) set against a white band (signifying peace) between the orange and green fields of Hinduism and Islam. The first of this trinity of great leaders converted to Buddhism, the second was a Muslim and the third a Hindu, but none had any interest in promoting a state religion. A fourth figure, and pillar of Buddhism, Kanishka the Great created the huge Kushan Empire over which he reigned from 127 to 151. His empire stretched from the Aral Sea to the Bay of Bengal, a loosely affiliated, fantastically wealthy polity that marked a high point in Indian religious tolerance. A silver Buddhist reliquary casket with Buddha on a lotus petal on the lid, worshipped by Brahma, the creator god of Hindus and Indra the sky god of the Rig Veda, testifies to the ecumenical nature of Kanishka's rule. The many-headed Brahminical gods also seem to have made their first appearance under the Kushans, evolving out of the confluence of cultures; Greek, Indian and Central Asian that defined the empire. Yet Kanishka did not preserve a place for himself in the hearts of Indians, largely it seems, because he did not obey an ancient civil code for chivalry.

It is not to these towering figures of Indian statehood that the BJP and RSS look for validation, but to the Machiavellian first emperor of India, Chandragupta Maurya, who is accredited in c.300BC with creating one of the world's first great texts on statecraft – the Arthashastra, in which the caste system was encoded. Seven caste divisions are recorded in the Arthashastra, including the untouchables (*chandalas*) who, being unclean, lived outside the cities. Chandragupta also defined India's northern borders as bounded by the Hindu Kush, the Afghan mountains and the Baluchi desert. He was a strong, and in BJP terms, patriotic Hindu warrior.

Cultural influences

India has been anything but a static civilisation. It has experienced and, crucially, absorbed the effects of Dravidian, Aryan, Greek, Turk, Afghan, Mongol, Mughal and British cultures. Asher and Talbot (pp 5–9) argue persuasively for Europe to be considered a sub-Asian continent comparable in cultural and linguistic differences to India, and for neither to be seen as a monolithic, assimilated entity like China. If Europe is both a region and an idea[12] then India, as Asher and Talbot (pp 8–9) point out, is also a consequence of millennia of migrant cultures, which left ill-defined borders and consisted, arguably until the Raj, of a proliferation of polities.

The appropriation from history by radical Hinduism of certain southern Indian cultures has resulted in a corruption of the actual events. The Vijayanagara Empire, for example, carved out by the warlike Sangamas of Karnataka in the western Deccan, south of the Tungabhadra river, was not, according to Asher and Talbot (pp 54–70) set up as a Hindu kingdom in opposition to the Muslim states in the north, but as a religiously ambiguous, militaristic entity.

'For one thing', Asher and Talbot explain (p.64) 'the concept of a unified Hindu religion did not exist in the fourteenth century, nor did that of a nation composed of all the peoples within a state's borders. And the Vijayanagara state's greatest rival for power was not the Bahmani Sultanate but the Gajapati kingdom of Orissa, a state headed by rulers who were Hindu.'

The secular and sacred architecture at the Vijayanagara's capital city of Hampi was built in the Indic style, and so temples of every denomination were constructed with post and lintel. Where there is Islamic architecture in Hampi, it is interpreted in a highly creative manner. The culture in Hampi reflects, as Asher and Talbot suggest (p.72), Islamicate rather than Islamic culture; the cosmopolitan, not the intrinsically religious culture of a dominant polity. Perhaps the early Mediaeval, fourth and fifth-century Guptas, who undertook a revival of the ancient myths and Brahminical religion of India provide the nationalist model under which today's nationalists labour. They were certainly highly regarded by the nineteenth-century British.

The Guptas were, according to Wood (p.183) the precursors of modern Hinduism, a term used to define the polymath indigenous religions of the sub-continent only in the nineteenth century. It was the Guptas who, after all, suggested that god's

representatives on earth, such as Rama, were historical beings and it was they who moved their court to Ayodhya,[13] calling it the birthplace of Rama, where once it had been the Buddhist city of Saketa. Like Chandragupta who renewed the Vedic horse sacrifice, so the Guptas continuously renewed the Vedic institutions. There are, in any number of languages, hundreds of versions of the Rama tale in India. There is even a Muslim Rama story, according to Wood (p.222), told by the Mopylas boat people of Kerala and conversely a Tamil life of the prophet modelled on the Tamil Ramayana. The inclusiveness of Rama and the tolerance of India's past dynasties, foreign like the Aryans, Mughals and British and indigenous like the Guptas and Cholas, might still be the presiding legacy for today's country. The societal divisions that are being manufactured by radical Hinduism are at odds with this India and seek to undermine the soon-to-be economic superpower.

The forced departure from India of the artist Maqbool Fida Husain (b.1915), after he was believed to have blasphemed a Hindu deity, is a minor but troubling indication that the country is straying close to censorship on religious grounds. If the religious bigotry remains isolated then the country's cultural sector has little to worry about, but if the intolerance becomes commonplace, the cultural plurality of the country's life will change and so will the nature and form of its art. India may be moving towards Hindutva style[14] cultural nationalism; a step in this direction can be seen in the use made of the 'Indian-ness' of Harappan civilisation by the Rashtriya Swayamsevak Sangh (RSS) party, which now boasts between two and six million members. But positive radicalism can also be found, as we have seen, in a renewed interest in the often rural religious and artistic prehistoric traditions of India. Many of these customs and beliefs are frowned upon or ignored by orthodox Hinduism and by the secular government, but within them lies the essence of India. Their visualisation in the form of paintings and sculptures and re-enactment in the manner of ritual and procession are central to the cultural health of this nation.

Does India offer a practical solution to the economically and culturally disenfranchised?

Almost despite itself India has grown its economy at a close to double digit annual rate over the last decade. The country's infrastructure is far inferior to China's; income and social equality

are still hampered by the caste system and the country has been less successful than China at lifting its population out of absolute poverty. But are these perceived weaknesses actually the result of a great strength? India is the world's largest democracy and has been so, except for a short period in the mid-1970s during which time Indira Gandhi declared martial or President's rule, for longer than any other emerging economy. It has a free press, an established political framework and an independent judiciary that, in principle, observes human rights and acknowledges property and land ownership. The life expectancy of its people is steadily increasing and literacy in the country is rising. It is slightly more corrupt than China, but sits in the middle of the league table.[15] The comparison between India and the newly formed Muslim states from which it was separated, Pakistan and Bangladesh, is stark. The former has largely lost sight of the secular ideals of its founding father, Mohammad Ali Jinnah, and the latter is defeated by its geography and climate.

India has arrived at its current position as one of the world's fastest growing economies without significant amounts of government (or foreign direct) investment – as is the case in China – but through a number of private initiatives and the activities of entrepreneurs. It was 13 years behind China to introduce financial reforms.[16] The country is still a rural society with the majority of its population living in villages, giving rise to two notions; one, that giant metropolises or meta cities[17] may not be an inevitable consequence of modernisation, and two that indigenous culture, as we have seen, is best preserved in the village. The country is hugely advantaged by having English as its true and practical *lingua franca*, (although illiteracy afflicts 60% of the population), as well as an education system that in many ways mirrors those of the major industrial powers.

The world will soon discover whether a huge, imperfect, yet functioning democracy is the match of or better than a gargantuan, centralised single-party state, although today's India is more centralised than at any time in its long history. Tied to this question is another important one. Does the economic imperative outweigh greater levels of individual freedom and state accountability? In short at what stage in a society's economic development do notions of individual liberty excite the population to ask for democracy, if at all? The examples of East and South East Asia do suggest that as economies mature, so do their respective societies, but how much is the association of democracy and economic

maturity a legacy of, in India's case, the departing colonial power and in South East Asia's, American cold war ideology and the unhappy experience of Japanese imperialism?

India, like China, was for millennia governed by autocratic governments. It has only very recently decided upon democracy. Here, the psychological triumph of the British in planting this political structure, among other values, in the Indian mind was as significant as the three most important political figures of the newly independent state; Nehru, B.R. Ambedkar and Gandhi.[18] A constitution for India was not, in the words of Churchill, enforced by British arms. Credit should also be extended to the last Viceroy Louis Mountbatten, who orchestrated, according to Tunzelmann (2007), the most successful retreat from empire in history and achieved the largest and most closely integrated India that there has ever been.

India, not the West, is the country transitional economies turn to when they consider implementing the democratic process. The sub-continent does, after all, contain all the extreme social and economic conditions that characterise emerging markets. The findings are extremely impressive. In 2009, 543 constituencies, 4,617 candidates, representing some 300 parties, competed for the ballots of an electorate of 714 million eligible voters. In 828,804 polling stations, 1,368,430 tamper-proof electronic voting machines are employed. The lowest (Dalit) caste[19] is just as, if not more, keen to register its vote than the highest (Brahmin) caste. Dalits, a third of whom are now literate, regard their votes as the politicians' mandate. They believe that with it comes a right to demand of those politicians that they fulfil their promises, and key to these promises is greater emancipation for the lower levels of society. This belief in a virtuous upward political spiral combined with an inherent personal optimism and tolerance of physical hardship characterises India perhaps more clearly than other nations, and sets it apart from Western democracies.

Crucially, in a country as socially, economically and religiously diverse as India, democracy allows marked and fundamental differences – the rich fabric – to co-exist. But democracy in the case of Dalits is further assisted by Buddhism, a religion to which they have turned. It frees the shackled under-castes from their pre-ordained dharma or duty and recalls a casteless period in Indian history, the reign of the Buddhist Emperor, Ashoka. It was to Buddhism that one of the great Indian modern social agitators, B.R. Ambedkar – himself a Dalit – turned when he sought to break

the stranglehold of the caste system by founding a university for the disenfranchised.

If there are signs that the Dalits are finding their voice in India, the same cannot be said of the *adivasis* (the indigenous people of India), who live in the hilly forest belt that traverses several states across southern and eastern India. The armed militia, or Naxalites, who have been waging a bloody guerrilla war against the state are broadly supported by the *adivasis,* who are angry about the indiscriminate mining of their land for bauxite and iron ore. They, who have not experienced the benefits of modernisation, pose a great question to developing India: continue with the economic development and take on the characteristics of a police state, or sacrifice the speed of development for democracy.

Indian politics may suffer from corruption, but its elections are extremely fair. The Electoral Commission of India, set up shortly after independence, was adopted by the former colonial power, Britain, in 2000. It is probably the most respected public institution in the country and observes a model regulatory code. This has resulted in an enduring faith in the democratic process in India, qualified by an extreme and healthy scepticism for its politicians. *The Economist* (2009) points out that parliament has to make room for a lot of shady characters, with a quarter of its current members facing criminal charges for serious crimes. Yet India remains the country with one of the highest proportional political party membership. All this has resulted in Delhi, not London or Washington, becoming the beacon for democracy amongst emerging and transitional economies with a legitimacy that gives the sub-continent huge moral authority.

So it can be said that the Indian system of government and law offers emerging countries a functioning model. The manner in which the country deals with its future social and religious revolutions will be closely watched. The Indian model has much to lose and much to gain by its future actions.

The rising value of international contemporary art from India

Sevi Seti, the wife of the Gaekwar of Baroda, so treasured her bejewelled carpet, which was sold through Sotheby's in Doha for $5,458,500 on 19 March 2009, and 124 carat Star of the South diamond that she took them with her to Monaco shortly before

India declared its independence from Britain. Her decision to emigrate says as much about the princes' attitude to the British retreat from empire as it does about the extravagance of the maharajas.[20] The portrait of the Maharaja Yeshwant Rao Holkar II of Indore (1931–8) painted in Western white tie dress, cape slung over his shoulders, reflects the insouciant sense of aristocratic entitlement that each member of the elite felt and that in this instance was captured so well by the French society artist, Bernard Boutet de Monvel (1884–1949). The silver-encrusted bed commissioned from Christofle of Paris by Sadiq Muhammad Khan Abbasi IV in 1882 featured four naked females of varying skin tones who, by an ingenious mechanism linked to the mattress, could be set in motion and fan the recumbent Nawab while winking at him, all against a 30-minute cycle of music from Gounod's Faust.

Of course all this ostentation was nothing new. The sixteenth-century Mughal Emperor, Akbar the Great, lived in splendour in the perfectly preserved city of Fatehpur Sikri, collected emeralds and owned the enormous Koh-i-Noor diamond. Something of the Mughal prodigality can be gleaned from the perfectly preserved pictures of the eighteenth-century Rajasthani Maharajas of Jodpur. In one work in the Delhi style by the court artist Darchand, the turbaned Maharaja Abhai Singh sits on a gold, bejewelled throne before a lush Mughal carpet surrounded by dancing girls and musicians. This gilded world was very largely preserved under the British and a system known as the 'license raj', and for a while after independence, but it was clearly unsustainable in democratic India. The death of Gayatri Devi, the Queen of Jaipur, in 2009, has in a very real sense broken the last physical link with the world of tiger hunts and vast estates.

A new elite has replaced the old in the fine art sectors of the Indian Modern and contemporary market. Men like the Zoroastrian, Ratan Tata, and non-resident Indian (NRI), steel tycoon, Lakshmi Mittal now head India's wealthy elite. The Indian entrepreneur is the new patron of the arts and his taste has very largely shaped this money-spinning market over the last ten years. Tyeb Mehta's (1925–2009) *Falling figure with bird* of 1988, which made $1,248,000, was bought by a NRI, New York hedge fund manager, Rajiv Puri, in 2007. The dismantling of the contrived colonial economy has enabled the country to develop new industries and resulted in the transformation of the cityscapes of Mumbai (Bombay) and Delhi, highlighted as they now are by the shimmering forms of luxurious developments, rising like ice sculptures from the

squalid shanty towns. Midtown Mumbai, the home of textile mills until the 1980s, has been transformed into a hi-rise city generating wealth for a new generation of entrepreneurs either educated abroad or at India's new Institutes of technology.

It is this community that is attracted to the online painting auctions held by local houses such as Saffron Art and Ossian, and which have propelled the prices of Indian Modern and contemporary art to astronomical levels. The NRIs are a new and conservative addition to India's society. Guests to the community's multi-million dollar weddings now receive invitations designed by famous Modern artists like Maqbool Fida Husain as well as goody bags filled with branded European goods. Another significant portion of India's national wealth has been expended on its temples and religious effigies and recent projects suggest that this is likely to continue. In a number of instances these actions are politically motivated, such as the proposed construction of a Temple to Rama on the site of the demolished mosque at Ayodhya. Kumari Mayawati, the former Dalit, Chief Minister of Uttar Pradesh, embarked on a monumental composite style memorial to Dr. B.R. Ambedkar, India's campaigner for caste reform, made up of Mughal-style pavilions, Buddhist-style domes and neo-classical columns. It is a monument to extravagance and just one of a number of grandiose civic schemes undertaken by the governor in the city of Lucknow – a former home of the extravagant Nawabs of Oudh.

The Nawabs were more than capable themselves of creating pastiche architecture in an Indo-European, neo-Palladian style, placed as they were between the twilight of Mughal power in Delhi and the newly powerful East India Company in Kolkata (Calcutta). As Sally North explains, the Nawab style was 'a spectacular fantasy of Englishness, confidently amalgamated into the local style' (p.337). Mayawati's projects may, superficially, follow in the Lucknow tradition of a grandiose composite style of architecture, but the motivation behind her architectural fantasies carry a strong political message encapsulated in the new electoral power of her Bahujan Samaj Party. The politics that allowed Nawabs and Maharajas to exist lay in their 'value' to the Raj.

Today, the Indian state – but also autonomous states within the sub-continent and minority, radical political parties – is influencing the country's broad political and cultural landscape. It is not in the interest of India's contemporary artists or market to create pastiche Hindu-type art, but there are signs that this may be a direction that many will choose to take. The financial and ideological incentives

to create politically charged Hindu architecture and art may prove irresistible to a new generation of Indian art school graduates.

The Sanskritisation of Indian society (Luce 2006) has played into the hands of evangelical Hinduism. It is threatening to overturn the Brahmin ideal of material self-sacrifice. The social transition, brought about by wealth generation, favour the radical politics of the BJP Party, but Congress has been adept at placing key reformists in significant constituencies. In New Delhi, for example, where the average incomes of its 15 million inhabitants (to rise to 30 million by 2026) are twice the national average, the Chief Minister, Sheila Dikshit, has transformed the city into a magnet for foreign investment to rival Mumbai. Dikshit has also set about the task of improving the city's urban infrastructure, which suggests that India's political capital, rather than entrepreneurial and chaotic Mumbai, is set also to become its cultural capital. Near to New Delhi, the satellite city of Gurgaon has grown into one of the wealthiest and most vibrant metropolises in India, attracting foreign multi-nationals to the region. Historically this would make more sense; Delhi was after all the cultural manifestation of Mughal and British power.

The non-material values of Indian society encapsulated in the life of its spiritual leaders, not least Mahatma Gandhi, but also in its multitude of Holy men so despised by the moderniser, Nehru, are still a part of the country's social fabric. Luce (2006, p.307) identifies a new middle class that wishes to protect Indian culture and its religious heritage; one that bemoans the disappearance of traditional family values, while also abhorring the idolisation of money. The inconsequence of earthly possessions and relations reflect the teachings of most of the spiritual guides who adhere to the major faiths that co-exist in India. This view of life has always been an important part of sacred Indian art and architecture. Jon Guy tells a wonderful story of the rediscovery in 1987 of a cache of 23 Chola-period bronzes together with a 15-sheet copper-plate inscription fastened with the Chola royal seal near the village of Esalam in Tamil Nadu. 'The copper sculptures', he writes' (2006, p.22) 'were washed, clothed and garlanded and reintegrated into the ritual life of the village temple'.

The twenty-third in a long hereditary line stretching back to the Chola Empire, which ruled most of India until the thirteenth century near the great temple town of Swamimalai, is how Dalrymple (2010) introduces Srikanda, a contemporary maker of bronze effigies. Srikanda described his place of work during the

26 Kapalishvara Temple, Garlanded Chola Bronze

making of an icon as akin to a temple, a place where it was important to be kind, polite and speak the truth. He likened the creation of each image as an act of devotion. Each sculpture, he explained, contained the essence of the god and so was much more than just a work of art. To this day, portable icons are used in processions of the deity, empowered by rites on behalf of the immovable objects in the temple. At the richer temples like Kapalishvara in Mylapur the ancient quarter of Chennai, John Guy (2006) explains, a full set of bronze sculptures of the 63 *nayanmar* is paraded, decorated and adorned, through the streets at the time of the full moon from March to April. The god comes forth to see and be seen (**fig.26**).

It is important for Indian society to retain its tradition, much of which is tied to its great religious heritage. To steal a line from Gandhi's *Hind Swaraj* (Self Rule for India), we must 'attain mastery over our minds and passions' (2006, p.10). The cultural fabric of Southern India in particular is wedded to religious art and it would be a tragedy if either economic prosperity or radical politics ended some of the world's most enduring and meaningful traditions.

A revival of Indic culture in the new age of prosperity

The market for Modern and contemporary Indian art began in 1995 with the Herwitz sale in New York. The sale grossed over $2 million and set an international price for a generation of Indian Moderns. The Progressive Artists Group (PAG) was founded in 1947[21] and comprised artists who very largely trained overseas and practised in a quasi-Indian (figurative) Modernist style (Indian style figures backed by abstract backgrounds). The Movement's first price spike happened from 2005 to 2007, by which time its artists had achieved average prices of between $50,000 and $250,000 and occasionally substantially more.

The Modernist tide which swept India, encouraged by Nehru's Western outlook and acclaimed in Le Corbusier's Modernist city, Chandigarh, eschewed the traditional Indian affection for architectural ornament and paid no heed to local cultural or climatic conditions. The Modernist canon in architecture was

challenged in the 1970s by architects like Charles Correa (*b.*1930) and Balkrishna Doshi (*b.*1927) who sought also to address Indian myth and symbolism in their buildings. One of these Indian devices, the open internal courtyard, became by the 1980s, according to Himanshu Burte (2007), a central feature in the re-incarnation of pre-modern traditions across the country.

Architecture has since taken on regional qualities in the hands of important Indian architects. Chitra Vishwanath's mud buildings in Bangalore (**fig. 27**), Samaresh Mukerjee's low-cost energy-efficient housing in West Bengal and Dean D'Cruz's 'floating' Pavilions in Goa, the roofs of which are constructed out of wood and tiles perfectly suited to Goa's hot and humid weather, all pay attention to their surroundings. A textile artist's response to the increasing urbanisation of the sub-continent is brilliantly realised in Dinabandhu Mahapatra's *The Trees of Orissa* commissioned by the enlightened Martand Singh in the 1980s, who has made it his vocation to encourage other collectors to commission India's great textile artists. Mahapatra's towering achievement depicts in fine, hand-stitched detail the trees of the eastern state of Orissa as recorded by the State Library of Bhuvaneshvar. But the work is far more than a botanic representation of endangered species such as the Banyan and Palm; it is a rhythmic scheme of subtle monochrome that gently reminds its audience of the fragility of India's natural and cultural life in the wake of an expanding economy and population.

Visual artists like Maqbool Fida Husain (*b.*1915), the Goan, Francis Newton Souza (1924–2002) and Syed Haider Raza (*b.*1922) 'were', Mitter writes (2001, p.206), 'inducted into Modernism by three refugees from the Nazis: the Expressionist painter Walter

27 Chitra Vishwanath, Residence for Prithvi and Purushotam

Langhammer who joined the *Times of India* in 1938 as art director, Emanuel Schlesinger, who set up a pharmaceutical concern in Bombay, and who became their main collector; and Rudy von Leyden, who joined the *Times of India* as art critic'. These three championed the cause of the Indian Modernists. The three émigrés joined forces with the radical novelist Mulk Raj Anand (1905–2004) and Kekoo Gandhy, owner of the influential Chemould Gallery. The other members of the Modernist group were Sadanand (S.K.) Bakre (1920–2007), H.K. Gade, Krishen Khanna (*b.*1925) and Vasudeo (V.S.) Gaitonde (1924–2001). Progressive artists, Mitter continues, had kindred spirits, many of

whom trained under (the minor French Cubist) Andre Lhote (1885–1962), including Akbar Padamsee (*b*.1928) and Ram Kumar (*b*.1924).

These are the artists that the international (and Indian) art market has embraced since Independence. The prodigious and experimental Husain and the fashionably provocative Souza have enjoyed exhibitions of their work in prestigious, culturally mainstream Western institutions like London's Royal Academy and Tate Modern in 1982 and 2000 respectively and this has helped bolster their prices still more. International critical acceptance combined with the great wealth of NRIs and international collectors like the Japanese Masanori Fukuoka, who paid $317,000 for Tyeb Mehta's (*b*.1925) *Celebration* at Christie's, New York in 2002, very quickly pushed the highest prices over the psychological $1 million mark. The great event happened in September 2005 when Mehta's *Mahishasura* made $1.6 million at Sotheby's, New York. The prices of the leading Moderns declined in 2007 when Raza's (*b*.1922) index, which multiplied by over 200% between 2005 and 2007, slipped by 20% the next year. According to Artprice, the artist's index reached a peak in 2007 but has continued to fall year on year until 2009, at which point it fell to half its 2007 value. The pattern of decline has been the same for Souza[22] and Husain, although Husain's fall has been less severe. But as with all art markets, now that they have been inducted into the mainstream, the Moderns are likely to recover and to fall *ad infinitum*.

The next wave of Indian contemporaries has been quickly identified by the international art market, backed by an international (Charles Saatchi, Frank Cohen, Bernard Arnault and Francois Pinault) and the occasional Indian (Anupam Poddar) group of collectors. In 2007 and 2008 the art world put on international public and commercial shows of Indian contemporary art, notably at the Serpentine in London and at Frank Cohen's space in Manchester. The art market was fascinated by the new generation's take on the wealth divide and urban poverty. Subodh Gupta's (*b*.1964) *Identity of my shoulders* (2006) in which five brass traditional Indian pots are welded together and suspended, lantern-like, by rope became the seminal image for the new generation of Indian contemporaries.

Major Western dealers started to trade in the new work and prices soon exceeded those of the Progressives, reaching £500,000 ($981,750) for Subodh Gupta's *Untitled* assemblage at Christie's in London in June 2008. The year before, a colossal £2.4 million ($4,891,680) was paid for Raqib Shaw's (*b*.1974) enormous *Garden*

of *Earthly Delights III* at Sotheby's in London. The *enfant terrible* of Indian art, Jitish Kallat, also managed to sell a work at the height of the market for over a hundred thousand dollars, making $HK1.3 million ($166,660) for *Rikshawpolis 9* in Hong Kong in May 2008. Bharti Kher (*b.*1969), famous for her bindi-on-fibre-glass elephant, shot and lying down, entitled *The Skin Speaks a language Not its Own* (2006), which made $1.28 million at Sotheby's, London in 2010, also performed exceptionally well.[23] Kher is what is known as a conceptual artist. In *Another strange encounter* (2007) tea utensils and ceramic samosas on trays are placed on chairs, referencing the ritual Tiffin of the Raj.

The impact of the international market on Indian art has been great. Prices for Indian versions of international art have reached heights, but the allure of this market has taken contemporary Indian art further away still from roots which lie in its traditions. The rejection of the Bengal School by the Progressives in favour of internationalism after independence was, with the benefit of hindsight, a big mistake. It sidelined the likes of Abanindranath Tagore (1871–1951), who supported the initiative of the British administrator, Ernest Binfield Havell, to reinvigorate Mughal painting at the Calcutta School of Art in 1905.[24] The Progressives, one could argue, have succeeded not in freeing today's Indian art from the shackles of Westernisation, which they set out to do, but left it at the mercy of international Modernism and its market apparatus. The vast body of Tagore's work meanwhile forms a part of Rabindra Bharati's collection in Kolkata (Calcutta) and, as a national treasure, is highly regarded in India. But collectors for his paintings and those of his 'circle' such as Jamini Roy (1887–1972) and Amrita Sher-Gil (1913–1941) are few.

These artists had themselves rejected, as had the Progressives, the pastiche, Western-style art of Raja Ravi Varma (1848–1906) who painted sentimental, sari-clad Indian ladies and Hindu deities in a European Academic style. One of Varma's Millais-like 'beautiful ladies' the Parsee[25] *Vasantasena*, who stands nonchalantly, resting one arm on a riverside tree and holding a bunch of flowers in the other, personifies the formal aims of Anglo-Indian Academicism. The painting, the model of 'Bollywood' beauty, made a record $350,000 at Christie's, New York in March 2007. This stiff and lifeless nineteenth-century work embodied the Academic Western canon. In a series known as *The Native Types*, the feminist photographer Pushpamala N. (*b.*1956) draws on occasion directly from Varma. The *Lady in Moonlight* and *Lakshmi* (2000–2004) self-

portrait photographs of the artist as the goddess Lakshmi is Varma updated. The image of Lakshmi also mimics Botticelli's *Birth of Venus*, replacing a shell with a crudely painted lotus and introducing the typically Indian element of an elephant holding a garland in its hand, preparing perhaps to lustrate the goddess.

Varma's painting is in stark contrast to the light and delicate watercolour by Tagore, *Woman carrying a paper boat with two diyas* which sold for $48,000 at Christie's, New York in the same auction as Varma's standing lady. In Tagore's painting the branch of a tree forms a natural canopy over a woman intently studying her prize. Tagore's tree references Japanese wood-cut art and the pastel colour, the art of the Mughal miniature. It firmly rejects Western Academic illusionism and embraces not Modernism but pan-Asian modernity rooted in tradition. It also chimes with a current of European thought, Theosophy, which rejected Victorian materialism and supported Indian spirituality. The perceived divide between Asian spirituality and European materialism was exploited by the Japanese art theorist, Okakura Tenshin (1862–1913), also known as Kakuzo Okakura, who developed a new style of Japanese painting, *Nihon-ga,* that accepted elements of Western art but remained thoroughly Japanese in its materials, techniques and subject matter. It satisfied according to Michael Sullivan (1973, p.124), 'the Japanese love of fine craftsmanship, yet absorbed enough of Western realism to make it contemporary'.

Okakura set up the private Japan Art Academy which carried the message of new Japanese painting into the twentieth century. He met with Tagore and taught at the Bengal Art School, softening Tagore's formerly bright Mughal palette in the manner of *Nihon-ga.* The two most significant aspects of the Bengal School, according to Mitter (2001, p.180), are the merging of individual styles within a common language and nationalist sentiment which privileged the Hindu culture of India over a Muslim one.

The new pictorialism of the fine arts department of Maharaja Sayajirao University in Baroda sought to revive figurative art in India in the 1960s and to distance itself from internationalist stance of the Progressives, championing instead the Bengal School. Sudhir Patwardhan (*b.*1949), Bhupen Khakhar (*b.*1934) and Vivan Sundaram (*b.*1943) insisted that Western Modernism had side-tracked Indian Nationalism, but might yet be overcome by returning to India's folk traditions. Weaving, the Santiniketan mural tradition, and Rajasthani painting were introduced to the curriculum. The observation of rural life, depicted in a thick

28 Gulammohammed
Sheikh, *In Kavaad:
Travelling Shrine: Home*,
2008

impasto with the application of rudimentary materials served the
group's proletariat aims. The artist, Narayan Shridhar (N.S.) Bendre,
(1910–1992), for example, painted highly stylised, intimate studies
of women engaged in everyday tasks. The price of Bendre's works
has remained constant since 1998, ranging from a few thousand to
£68,664 ($120,000) for the geometrically constructed work, *Boats
at Porbandar* (Sotheby's New York, March 2006).

The multiple viewing points, characteristic of Mughal painting
and a feature of Cubism, also found favour with leading Baroda
school artists such as Gulammohammed Sheikh (*b.*1937) and
Bhupen Khakhar (1934–2003). Sheikh's construction of a Rajasthani
shrine, *In Kavaad: Travelling Shrine: Home* (2008) **(fig.28)** is a
topographical mandala of the shrine and its environs, in many
ways similar to traditional schematic temple painting. There are
nuances to Sheikh's work, such as the employment of deities from
the major world religions, and of course in the scale of the work.
The artist attached double doors to the side of his shrine which
could be unfolded to reveal other works of art. One of the images
is of a tree, comprising deities, sadhus and musicians, but also a car.
Sheikh's message is one of religious tolerance and humanism.

Yet another group of artists provided an antidote to the
internationalist concerns of the Progressives. They had been forced
to leave their native Lahore on the partition of India in 1947, and

on arrival in the Indian capital, formed the Delhi Silpi Chakra Group, the aim of which was to revitalise the crafts of their former homeland. The encouragement of a consciously indigenous, craft-based training can still be found in the Cholamandalam artists' village near Madras, founded in 1964 by K.C.S. Paniker (1911–1977). Paniker's vision was to train artists to create works of art within an Indic idiom and to fund their artistic aspirations by manufacturing craft objects. Paniker's work hardly ever comes to auction, but the naïve *Words and Symbols* (1970) made $35,000 at Christie's New York in September 2007, a tenth of the price of an equivalent work by one of the Progressives. The most individual of artists to emerge out of the village was the congenitally deformed, K.G. Ramanujam (1941–73) who painted oversized figures resembling, Mitter suggests (2001, p.211), 'the *papier-mâché* puppets carried in religious processions in Tamil Nadu'.

Someone who would have appealed to both Tagore and Okakura is the Bangalore artist, Prabhavathi Meppayil (*b.*1965) who has become a great exponent of the art of Tanjore painting. She was raised as the daughter of a traditional goldsmith and on occasion uses her father's tools to create her work. In the preparation of her painting surface, she mixes ceramic powder with glue and applies it to plywood to form the background, sandpapering it to a polished finish. She then creates silhouettes of animals, people and gods by the application of dots, fine lines, gold foil and paint. She employs the tempera technique used in Southern Indian miniature painting and her colouration is extremely subtle. Amidst the undulating patterns of gold, natural stones like malachite and lapis appear and add lustre to her images. The untitled paintings move in and out of focus as light plays on the metal. Human forms and buildings appear as a mirage, a commentary perhaps on the intransience of life and possessions, but more likely a meditation on the truth of materials. Her work has echoes in the Rangoli Folk Art tradition in which natural minerals are used to create simple geometric shapes, flowers or representations of gods at the time of religious festival.

India is best placed among the emerging art markets to enhance its rural culture

While mainstream Indian Modern and contemporary art is not, like Chinese contemporary art, a straightforward cultural export, it has from the outset worn the vestments of European Modernism. It has engendered an interest in picture speculation among Indian neophyte collectors that has rarely been equalled, but it has failed in the main to engage with the heart of Indian culture. A new museum devoted to contemporary Indian art in Kolkata (Calcutta) (KMOMA) is due to open by 2015 and it will probably choose to follow this internationalist agenda, largely because of the huge amount of financial and cultural capital that is invested in Modernism.

The Progressives and Indian contemporaries will undoubtedly continue to play a strong role on the Indian domestic and international art market although because of their high prices, the market will also be interested in the much more reasonably priced work of the Bengal, Baroda and Delhi Silpi Chakra Schools. In March 2008, ArtTactic concluded that Mumbai (Bombay) with its rapidly growing Colaba cultural district would become the centre of India's new art scene. Private money, it concluded, would fill the vacuum left by the State. Prominent overseas collectors and a swathe of art funds were seen as signs of future buoyancy. After all, the market for Indian art had grown from $2.3 million dollars in 2001 to $144 million in 2006. But India's cultural future lies elsewhere, outside the teaming conurbation. It resides in rural India where the ambition of art is very different.

In India it is vitally important that works of art that have a social function continue to be made and that the artist's skills are passed on to the next generation. It can be something as simple as evanescent terracotta equestrian figurines, which are thought by the people of eastern Gujarat to be a residence for a deity, with their horses providing night time travel through the forest. This particular art form has a very long lineage and can be found in the fragmentary effigies depicting the fertility goddesses of the Mohenjo-daro people, India's first inhabitants. It can be as sophisticated as keeping alive the skills necessary to make bronze sculpture in the manner of the Cholas.

There are encouraging signs in such ventures as the Cholamandalam artists' village near Madras, and in institutions such as the fine arts department of Maharaja Sayajirao University

29 Baua Devi,
Snake Goddess,
late 20th century

in Baroda, that suggest that there is an awareness of the country's future cultural needs. The intricate designs in rice powder (*kolams*) traced into the floors of houses in southern India and the painted murals of gods on frail paper created by the Mithila woman in Bihar and southern Nepal capture, in the words of David Shulman (Doniger 2009, p.681), 'the momentary, unpredictable reality of the unseen'. In 1966 the All India Handicrafts Board sent the artist Baskar Kulkarni to Mithila to encourage the women to make their work on more permanent material that could be sold and to provide them with an income. The work of the artist Baua Devi (*b.*1947) elegantly illustrates the transition from ephemeral designs in the sand to a tangible, commercial object **(fig.29)**. As Doniger points out, the work remains true to itself because to the artist it is still ephemeral. It leaves the lives of the villagers and enters the collections of wealthy Indians and foreigners just as traditionally it would leave on the soles of the shoes of departing guests.

India still has the basis for a mass, religious-based craft culture to prosper. There are sufficient examples of a revival in tradition and application of ancient art forms to contemporary life to offer hope for cultural continuity.

Notes

1. Nagaland is a semi-autonomous Baptist Christian state in Northern India inaugurated by the Indian government in 1963. If the government cedes the territory other states might follow and the country would disintegrate. There are 25 million Indian Christians.

2. The Southern languages of India are: Tamil, Malayalam, Kannada and Telugu. All belong to the linguistic family known as Dravidian.

3. Talbot and Asher (p.13) quoting Sheldon Pollock.

4. The *patuas* of Bengal are itinerant artist/story tellers who go from village to village and house to house offering to paint scrolls (*patas*), made of pieces of paper sewn together, while narrating the pictorial narrative in song.

5. Rama like Krishna means the black or dark-skinned one. The time of Rama's birth is in the Treta Yuga which is the second of the four eons (Yuga) of Hindu chronology, during which time Rama is said to have been born to King Dasaratha. The four Ages (Yugas) are a series named after the four throws of the dice (Doniger, 2009, p.5).

6. One of the reasons for the Indian Mutiny was the East India Company's adoption of the Enfield rifle on behalf of its Sepoys. The cartridges were supplied in greased paper which has to be bitten in order to be used. Rumours spread that the grease contained tallow derived from cow or pig fat offending both Hindus and Muslims.

7. The Cuncolim campaign in Goa is a good example of this approach. Cuncolim was the site of a massacre of village elders by the Portuguese in 1583.

8. In the holy field (dharmakshetra) the god Krishna, disguised as a charioteer, revealed himself to the hero Arjun before battle and uttered the words of the Bhagavad Gita.

9. Hyderabad, Bhopal and Travancore also wanted to become independent nations.

10. Britain had acquired Kashmir following the First Sikh war in 1846 and sold it under the Treaty of Amritsar to Gulab Singh, the Raja of Jammu.

11. Doniger (2009, p.679) writes that an advocate of Hindutva has argued that the Taj Mahal in Agra is not an Islamic mausoleum but an ancient Shiva temple that Shah Jahan appropriated from the Maharaja.

12. Barlett, R (1993, p.1). *The making of Europe: conquest, colonization and cultural change, 950–1350* (Princeton University Press) in Asher and Talbot (2006).

13. This may have been a myth because there are no Gupta archaeological remains. Their courts may well have remained in Patna and Ujain.

14. Hindutva – Hindu nationalism.

15. Transparency International awarded India a 3.4/10 CPI score placing it in 85th out of 180 nations and China a CPI score of 3.6/10 positioning it slightly higher, in 72nd position.

16. Deng Xiaoping initiated reform in China in 1978. India only began to abolish the 'License Raj', a series of quotas dating back to the British that necessitated avoidance and bribery, in 1991.

17. Cities with a population in excess of 20 million people.

18. The 1937 Government of India Act brought the vote to nearly 35 million people. A few years before, the Poona Pact between Gandhi and the representative of the untouchables – B.R Ambedkar had guaranteed a number of seats for the Dalits. Britain weighted the electoral system in favour of the Princes, caste and creed in 1942.

19. Indian castes are segregated according to dharmas or duties. For example, the priestly Brahmin caste has control over the spiritual and religious aspects of society, while the Kshatriya's dharma was to command the military and be kings.

20. The British administration in India propped up the 565 princely states while ensuring paramountcy of the Crown over its affairs. The Jam Sahib of Nawanagar, for instance, had 157 cars and a wife who owned 1,700 saris, while the Nawab of Junagadh spent £21,000 on the wedding of two of his dogs.

21. Progressive Art Group: 1947–1956: Francis Newton Souza (1924–2002), Maqbool Fida Husain (*b.*1915), Krishnaji Howlaji Ara (1914–1985), Syed Haider Raza (*b.*1922), Kattingeri Krishna Hebbar (1911–1996), Hari Ambadas Gade (1917–2001). Associates of PAG, Krishen Khanna (*b.*1925), V.S. Gaitonde (1924–2001), Akbar Padamsee (*b.*1928), Tyeb Mehta (1925–2009), Ram Kumar (*b.*1924), Bal Chhabda (*b.*1923).

22. Souza sold an *Untitled* nude at Sotheby's London in 2010 for over $450,000 and Husain sold *Sita Hanuman* (1979) for $700,000 in the same year through Christie's in New York. These were exceptional results for both artists and not representative of a dramatic fall in their indexes since 2007 (Artprice).

23. According to Latika Gupta, a version of the *The skin speaks a language not its own* sold at Art Basel in 2007 for $325,000 (p.126).

24. In 1854 the British East India Company set about 'improving' Indian taste with new art societies and art schools, the main ones being in Kolkata (Calcutta), Mumbai (Bombay) and Chennai (Madras), to train artisans. This extended to instruction in naturalist drawing.

25. Refers to the larger of the two Zoroastrian communities in South Asia, the other being the Irani community.

6

South East Asia: Indonesia, Thailand, Vietnam, Philippines and Malaysia

The colonial history of the greater part of South East Asia, and its bloody aftermath, is traumatic and recent. The people of this region share, with one exception, a common experience: Western colonialism, anti colonial revolution, the horrors of the world war in Asia, martial rule and dictatorship. The independent states that once compromised Indo-China have been formed out of genocide; others like Indonesia have yet to achieve political and economic stability. History has, in the main, left these new regional states with an impoverished cultural legacy and an anguished contemporary expression, which records the journey of a people from subjugation to assertiveness.

Mention the name of the Indonesian artists, I Nyoman Masriadi (b.1973) and Agus Suwage (b.1959) and the art world sits up and takes notice. The art of both men is highly political. It is similar in flavour, but more sinister, to the work of China's Cynical Realists who were active in the 1990s. Masriadi's pumped up cartoon-like characters in *Mobster Culture* (2002) paint a gruesome picture of the brutal gang culture that blights Indonesia's cities. A muscular arm pulls at the hair of a cowed, crouching figure, while a foreground gang-leader, eyes shielded by blue-tinged sun-glasses, barks his instructions. In the background men stand wielding semi-automatic weapons.

Suwage's interpretations of life are equally dispiriting. In *Only Demonstrating* (2004) he depicts an execution by asphyxiation.

Indonesia is the most important of the region's art markets[1] and its two principal auction houses, Larasati[2] and Borobudur, hold significant sales throughout Asia.[3] Its cultural position is critical within the context of the world's newly emerging art markets. Indonesian contemporary art, since young artists from Yogyakarta and Bandung organised a protest against the traditional and decorative art on show in the 1974 Jakarta Biennale,[4] has remained rebellious ever since. At its heart, Indonesia's artists' rebellion should be something more than just an attack on conservatism, it should be an attempt to reassert *kagunan* (the country's classical, native culture) over European nineteenth and twentieth century-cultural orthodoxy. But as yet there is little evidence to this effect. The reason for this has much to do with the extensive period of Western cultural saturation that the country was exposed to under its Dutch colonial administration.[5] Large parts of Indonesia – often former Portuguese colonies – were seized by the Dutch in the seventeenth century and, by the Treaty of London (1824), Sumatra was added to Java to form part of the Dutch East India Empire.

Western orthodoxy had run so deep in Indonesian cultural life by the second half of the twentieth century that a term like *seni rupa* (fine-art), a European notion which divided the arts into different disciplines, had been in use in Indonesia since the eighteenth century. A (Dutch) world was transplanted to Java, writes Takashi (1995), in the first decade of the twentieth century that was more modern at the time than Japan, the most advanced country in Asia. Although Indonesia is not a blue-print for South East Asia, it shares a long and protracted colonial experience with most of its neighbours. Its relationship to Modernism (and latterly to internationalism), and to its own culture is, as a result, harder to disentangle than in other emerging markets.

In Indonesia, the people's struggle for independence between 1942 and 1950 was two-pronged; they fought against the Japanese invader in the Second World War and, in earnest, against the Dutch colonisers in the aftermath of the Allied victory. Radical political and social reform had been a rallying cry of the earliest anti-colonial artists' movement, The Union of Indonesian Artists (PERSAGI), founded in 1938 by Sindutomo Sudjojono (1913–1986). This group of artists was the first to break free from the aesthetic shackles of the *Mooi Indies* (Beautiful Indies) School, a European institution in Indonesia which had a tendency to romanticise the land and its

people. Instead of idealised landscapes they portrayed guerrilla fighters, farmers, the *Kampong* people and market vendors with an expressionist fervour.

Indonesia's post-war governments headed by Sukarno and, in particular Suharto, following a bitter period of de-colonisation, were as blighted and bloody as any in the region. The subjugation and slaughter of the East Timorese Catholics by Suharto only ended in 1992 when the former Portuguese territory was handed over to the United Nations. It became the independent State of Timor Leste in 2002.

Indonesia is the South East Asian state that most clearly articulates the condition of a tenuous alliance of different races, languages and religious beliefs: 'There are over three hundred different ethnic groups in Indonesia, each with its own cultural identity, and more than two hundred and fifty distinct languages are spoken in the archipelago. Religious beliefs too are varied: nearly all the important world religions are represented in addition to a wide range of indigenous ones' (McVey p.24).

The great difficulty the country faced according to Max Lane, in common with many of the former South East Asian European colonies, is that it arrived at the beginning of the twentieth century with a 'diversity of defeated cultures' that became 'virtual museum cultures' (Lane p.13).

The extent to which its culture was defeated can be seen in the syrupy, academic nudes of Raden Basoeki Abdullah (1915–1993), which are very like the realistic Hindu deities that Raja Ravi Varma was painting in India a century earlier. The Western notion of ideal feminine beauty is something that Abdullah absorbed from European émigré artists such as Adrien Jean Le Mayeur de Merprès (1880–1958).[6] Le Mayeur de Merprès was part of the *Mooi Indies* tradition. Like France's Indochina Union, Britain's confederation of Burma and the Malay Peninsula, Dutch Indonesia, was a manufactured nation. It appeared on maps as a nation, but it was not. The 100,000 Dutch colonialists held sway over millions of natives largely by centralising power in Batavia (Jakarta) and confining knowledge of the Dutch language, which was spoken throughout Indonesia, to the Dutch minority and Malay elite.

The immediate consequence of this inheritance, following a bloody anti-colonial war, was a brief period when radical politics, enshrined in the word *'aksi'* (action) and inspired by other revolutions, attempted to reverse, in Sukarno's words, the creation of 'a nation of coolies and coolie among nations'. Sukarno's master

stroke was, according to Crump, to establish *Bahasa* Indonesia as the national language at the outset. The new Republic of Indonesia, declared in Yogyakarta in August 1949,[7] was enshrined in a new constitution the following year as a non-federal, non-communist and non-Islamic representative democracy. The distant and undeveloped island of New Guinea, with its hundreds of feuding tribes, was added to the Republic in 1955.[8]

Art became a political instrument for the new and dominant Indonesian political parties. *Lembaga Kebudayaan Rakyat* (Institute of People's Culture) or LEKRA[9] and the *Lembaga Kebudayaan Nasional* (National Cultural Association) were the first to be directly associated with radical-nationalism and a rejection of all Western cultural influences. Two 'official' art institutes also developed dramatically different ideological approaches to the new nation's post-colonial art. The ASRI – *Akademi Seni Rupa Indonesia* (founded in Yogyakarta in 1950) propagated the importance of an attachment to regional cultural tradition. The art academy in Bandung, on the other hand, adopted an internationalist outlook and orientation that favoured Abstract Art. The *Akademi Seni Rupa Indonesia* (Indonesian Art Academy) and another in Bandung were established shortly afterwards and received the support of the new State while artists like Srihadi Sudjojono (1913–1986) rejected the *Mooi Indies'* beautification of Indonesia in favour of an uncompromising Realism.

In a blow to radicalism and radical expression, Sukarno's guided democracy was derailed and Indonesia began 40 years of military rule. General Suharto took control of a disintegrating State in 1965 and held absolute power until his death 33 years later. He created, in Lane's opinion, a complete rupture with the past and a return to 'perceived' traditional cultural forms, in other words cultural revisionism, encapsulated in the Indonesia *Taman Mini Indonesia Indah* (Beautiful Indonesia Miniature Park) theme park, sponsored by *Yayasan Harapan Kita* (Our Hope Foundation) headed by Suharto's wife, Tien. Suharto used oil revenue and foreign investment to bolster Indonesia's economy and so secured his multiple re-election. The general established the *Orde Baru* (New Order) and eliminated Leftwing cultural organisations like LEKRA.

During his time in power he managed to contain religious and ethnic tensions, notably between Muslims and the *cukong* (top Chinese entrepreneurs) although these occasionally erupted into violence such as in 1985 when the ninth-century Buddhist

monument, Borobudur, was bombed. In the painting, *Borobudur; in a state of contemplation* (1999), the Bandung School artist, Srihadi Sudarsono (*b*.1931) has created a well balanced image of the temple, without any evidence of the bombing incident. The structure is depicted, instead, as an integral part of the landscape. The empty *stupa* at the very head of the monument is isolated from its body. This is because the stone chalice symbolises the highest spiritual realm, a state of nothingness – beyond life and suffering. Sudarsono painted a more dramatic version of the temple in 2001 in which moonlight cradles the structure in a perimeter of translucent light.[10]

The abuse of human rights that was a hallmark of Suharto's regime is recorded in an uncharacteristically embittered painting by Hendra Gunawan (1918–1983), created during the artist's time in prison. In *Si Kukut* (1975) (This is Kukut) he shows a prison guard with the head of a dog and a spanner for a penis (perhaps a reference to the colloquialism 'screwing'), drooling from its mouth. Inscribed onto the picture are phrases like 'who harasses other people's wives' and 'victimised by harassment', which recall the sexual favours guards demanded of prisoners' spouses in return for inmates' special treatment.

The Asian Economic Flu unravelled Indonesia's economy in the late 1990s and allowed the simmering Muslim and Christian disaffections in East Java and East Timor to surface. Violence also erupted at the extremes of the archipelago, in Aceh and Irian Jaya and in Jakarta itself where a mosque and a number of Christian churches were destroyed.

30 Suraji,
Competition of Life, 2002

The Economist summed up Indonesia in December 2004 as a long tale of woe. It attracted little foreign investment, was unproductive, had a poor infrastructure and was mired in corruption. It is, as Grump points out, a very poor country with vast economic potential locked within its plentiful natural resources.[11] Something of the country's disillusion is captured in the monumental painting *Competition of Life* (2002) by Suraji (b.1971) **(fig.30)**. In this nightmarish vision of twenty-first century meta-city life, a sea of humanity and fantastic creatures roll across the canvas. Office workers, protesters, ox carts, cars, vans, a train and plane sweep all before them. Flying in the opposite direction, camera wielding tourists record the mayhem. A monumental figure, drawn perhaps from the bare-torsoed, muscular stone-sculpted guardians of East Asia, exhorts the crowds through a loud speaker to greater effort.

In one of the most intelligent and far-sighted pieces of cultural policy today, the Thai government commissioned the artists Panya Vijinthanasarn and Chalermchai Kositpipat to paint the murals for the recently built Wat Buddhapadipa Temple in Wimbledon, South London **(fig.31)**. The project took four years from 1983 to 1987 and succeeded in conveying the timeless universality of Buddhism to a new public by introducing into the schema contemporary (British)

31 Panya Vijinthanasarn and Chalermchai Kositpipat, Wat Buddhapadipa Temple murals. The Mara army attacking the Buddha, 1983–7

symbols and icons. Thailand benefited from the physical expansion of this symbol of the nation's faith and 'New/Traditional' Thai art received a lift from this seal of government approval.

The temple murals, which are beautiful, are the culmination of Thailand's policy of 'soft' cultural engagement with the West.[12] Only Thailand amongst the countries of South East Asia retained its political independence[13] throughout the age of European empires (1487–1947).[14] This fact certainly ameliorated the impact of Modernism on the country's traditional culture.

The other reason was the Florentine sculptor, Corrado Feroci (1892–1962) who was invited to Siam[15] in 1923 to teach Siamese students Western techniques of sculpture and make statues and monuments

for the 'modern' state. Feroci never returned home, eventually taking Thai citizenship and a Thai name, Silpa Bhirasri. His statue stands outside Bangkok's main university for the arts, Silpakorn, opposite the Royal Palace. Feroci's creed, which was ahead of its time, was to urge his students to respect and nurture their own traditions. Universalism in art, he argued, led to monotony and insincerity. Thai art, he insisted, must be different from European art, and the difference will correspond to the 'individuality of the race' (Junichi, p241, footnote).[16] The arrival of Feroci followed the officially sanctioned visit to Italy of King Chulalongkorn's court painter, Luang Soralaklikhit. This event was a part of the king's policy to Westernise Thai art[17] in order to better represent the will of the monarchy.

On the 25 June 1932 a *coup de théâtre* by a secret cabal of 141 European trained army officers, calling itself the People's Party, brought to an end Siam's absolute monarchy, but did not weaken the resolve of the Feroci faction to retain the essence of Thai art.

The Italian's favoured pupil, Fua Haripitak (1910–1993), spent time in Rabindranath Tagore's University of Visva-Bharati Santiniketan in 1941, where he was influenced by Gaganendranath Tagore's paintings. Tagore's art drew inspiration from Indian mysticism. He returned to Thailand inspired by Tagore's instruction to Indian students to record their heritage before it disappeared. For the rest of his professional life Fua copied decaying Thai temple murals and restored the very finest, leaving behind one of the most comprehensive pictorial records of Thai mural art.[18] His art and deeds mirrored those of his contemporary, the Chinese artist Xie Zhiliu (1908–1997), whom we encountered in chapter 3. Another artist, Surasit Saokong (*b.*1949), who lives in Chiang Mai in the north of Thailand, shares Fua's reverence for the nation's Buddhist heritage. His still-life paintings of the interiors of temples taken in candlelight are acutely observed, tranquil studies. But the large landscape, *The Realm of Serenity* (1995), which depicts a temple and a pair of giant stone chimeras set between two raging rivers, is a much more ambitious work. The painting steers the viewer through a fantastic landscape and projects onto its audience a spiritual sphere that lies beyond us. Surasit's ability to manipulate light is the key to the painting's ethereal colour effects, and the religious conviction that he attained as a novice monk emboldens his palette and composition to create a rich, dense canvas.

Thailand may have escaped European colonialism and the worst excesses of military dictatorship, but the country has been

intermittently plunged into political turmoil. On 8 November 1947, Colonel Sarit Thanarat's *coup d'ètat* brought the army to power under Khuang Aphaiwong and in 1971, Thanom Kittikachorn, who succeeded Sarit Thanarat, staged an *autocoup* and re-established the military government. It was a general – Prem Tinsulanonda – in collaboration with the monarch, King Bhumibol, who created sustained economic growth for the country. During the third decade of the reign of King Rama IX (1966–1975), there was a significant level of political instability which permeated every level of Thai society. A military junta imposed its authority on the people by accentuating the importance to Thais of Buddhism, the monarchy and development in a blatant appeal to nationalism. Generals Sarit Thanarat and Thanom Kittikhachorn used the power of the military to suppress the rights and freedoms of the people and this led, on 13 October 1973, to mass protests at the Democracy Monument in the capital, which effectively brought down the government and bequeathed to the king a supra-constitutional position. Severe political conflict continued in Thailand for sometime after the 1973 protests. Socially engaged works by the artists of the Art for Life Movement formed a strong current of expression until electronic and multi-media artists groups[19] began to establish themselves in the next decade, responding to more stable government.

Those gains were lost through corruption during Thailand's period of civilian government, which culminated on 2 July 1997 in the floating of the Baht and the resulting collapse of the Thai stock market and its currency. In the same year, the Thai photographer and social agitator, Manit Sriwanichpoom (*b.*1961), produced a series of works lampooning the conspicuous consumption of Thais. One still from *This Bloodless War, greed, globalization and the end of independence* (1997) replaced the screaming child and other fleeing victims of a napalm bomb attack in Nick Ut's famous 1972 photograph, with today's Asians holding and wearing Western branded goods.

Following the economic disintegration of the Thai economy, the government inaugurated *Amazing Thailand Year* which promoted the benefits of Thai Tourism. Sriwanichpoom's response to this initiative was a series of photographs depicting a man dressed in a pink suit pushing an empty pink trolley, which was inserted into urban squalor or Western style food and retail outlets. In the work, *Pink man on tour no 4 – Amazing billboard Pepsi hill-tribe conservation village* (1998), the pink man stands with his trolley in front of a shack that sports the livery of the well-known drink.

The artist points out how ludicrous, but also how inappropriate, are the often tatty Pepsi and Coca-cola awnings that hang over drink stands throughout the developing world. In 2009 the dissatisfaction amongst ordinary people at a fall in their meagre living standards prompted the pro-Shinawatra activists to protest aggressively over a prolonged period against what they perceived to be stark inequalities in the system.

Those economic inequalities, which plague South East Asian societies, are uncompromisingly articulated by Vasan Sitthiket (b.1957). Sitthiket was one of a number of Thai artists who participated in the pro-democracy, student demonstrations in Bangkok in May 1992, which were put down by the military. He has remained true to his early idealism and continued to make provocative art. In a work like *All for me shit for you* (2009), a khaki-clad, zoomorphic figure, with the body of a man and head of a wolf suspends two plates of faeces above the imploring hands of three starving, naked human beings, painted in red for South America, yellow for Asia and black for Africa. The work attacks directly the use of military force by the United States in its overseas 'adventures' and the debilitating and short-lived impact of global capitalism on the emerging world's economies.

A radical statement against the development-at-all-costs formula that has bedevilled Modern Thailand can be seen in a project overseen by Kamin Lertchaiprasert (b.1964). The artist founded the gallery cum meditation space, Umong Sippadhamma Art Center, in the northern Thai province of Chiang Mai. He has also founded an influential project called *Land*, which provides for an alternative, self-sufficient lifestyle. Established at the time of the Asian Economic Flu in 1997, it encompasses art, Vipassana meditation and organic farming. The complex contains structures that fulfil specific low energy functions that it is hoped will provide the seed for alternative, economically viable and ecologically sound living outside the city.

The former Spanish colony of the Philippines, which Spain had ruled since the sixteenth century, reverted to America in 1898 and remained a virtual United States (US) protectorate after the Second World War. The Spanish cultural legacy was predominant until the 1950s. Fernando Amorsolo's (1892–1972) *tableaux vivants* showed a world of sunlit rice fields and contented peasantry. It was imagery that he drew from the works of Goya and Velazquez, which he had encountered during his term of study at the Real Academia de San Fernando in Madrid. It was a style that the new American

colonialists also appreciated, so much so that Amorsol – who as a 16 year-old had led a successful campaign to persuade the new government to incorporate the Academia de Bellas Artes into the newly established University of the Philippines – later secured the post of professor of painting in that institution, a position he held for 38 years. From that moment Amorsolo held sway over the course of Philippine art. The Americans were enchanted by the artist's *dalagas/dalagangs* (beauties) which were, as Guillermo explains, idealised types tailor-made for American style advertising imagery. Amorsolo described his perfect Filipina beauty in the following way:

> My conception of the ideal Filipina beauty is one with a rounded face, not of the oval type often presented to us in newspaper and magazine illustrations. The eyes should be exceptionally lively, not the dreamy, sleepy type that characterises the Mongolian. The nose should be blunt form but firm and strongly marked ... The ideal Filipina beauty should have a sensuous mouth … So, the ideal Filipina beauty should not necessarily be white-complexioned, not of the dark brown colour of the typical Malay, but of the clear skin and flesh-coloured type which we often witness when we see a blushing girl. (Alfredo R. Roces Amorsolo Filipinas Foundation, Manila 1975, p.90)

The artist's images of bucolic bliss became increasingly hackneyed as he grew older, although it was towards the end of his career that he also began to realise that the cultural mood had changed. In the *Burning of the Idols* (1955–60) he depicts, in a grand mural style, the Austronesian-speaking people[20] summoning up their gods to protect them from the invader. In the background a cross signals the imminent approach of the *conquistadors*.

The Amorsolo School of painting, although dominant, was not the only style that competed for attention in the post-war period. A group of Filipino abstract painters, the Neo Realists, challenged the *status quo*. Their explorations into abstract art triggered a debate amongst many young artists, which was reflected in future practice for decades to come. The Modernists, which included artists such as Vicente Manansala (1910–1981), Cesar Legaspi (1917–1994) and Hernando R. Ocampo (1911–1978), worked in a quasi-Cubist manner which, in the case of Ocampo in particular, emphasised colour relationships and patterns. Manansala looked beneath the surface of everyday life in the Philippines and depicted a darker world of rural

poverty and shanty towns, which laid the foundation for the Social Realists of the 1960s and 1970s.

The Philippines is the perfect example of the short-lived benefits to the general population of global capitalism. Subsequent American backed presidents: Marcos, Aquino, Ramos and Estrada were all guilty of corruption and mismanagement on a colossal scale. A better illustration of the corrosive effect of poor government on the economic health of a nation is hard to find. Compared to the rapid post-war development of Taiwan, which shared with the Philippines the same American influences, the stark contrast in 'character' between East and South East Asia is brought into focus. The pain of family separation, in Rodel Tapaya's (b.1980) *Farewell to Father* (2007), captures the plight of Filipinos forced to work overseas in order to support their families at home. In the picture, the migrant worker is visited in his dreams by the ghostly spectres of his family, house and the physical landscape of his homeland.

The Philippines is one of the world's most corrupt nations.[21] The island state endured three decades of extortion by its president, Ferdinand Marcos. The parallel between Chiang Kai-shek's Taiwan and Marcos' Philippines is marked, although it has to be said that Imelda Marcos invested a great deal of money and energy into revitalising the contemporary arts. Two of her lasting legacies are the Cultural Center of the Philippines and a resurgent internal art market. The United States viewed both the Philippines and Taiwan as essential anti-Communist bastions at a time when Asia showed all the signs of embracing Communism, and in return guaranteed the security of both islands, a policy which has left, if not an indelible, then certainly an enduring American imprint on both states.

Its Spanish heritage and the moral authority exercised by the Catholic Church to this day make the Philippines a uniquely Christian society in a part of the world dominated by other religions. Again, the corollary with Taiwan (and in this regard, South Korea) is remarkable.[22] In Cardinal Sin, the head of the Catholic church from 1974 to 2003, the Philippines had an outspoken critic of Marcos, who was hugely influential in the election of Cory Aquino and the first of a series of reforms.

In what can be interpreted as either an affirmation of the sanctity of Christ's suffering or a commentary on the futility of blind faith, Alfredo Esquillo (b.1972) represents in *Tanggulan* (Sanctuary) (1996) Christ crucified and tormented. The proliferation of crucifixes and the desperate prayers of the believers in the picture highlight either

the dependency on, or necessity of, the Catholic faith to ordinary Filipinos as they face daily injustices and economic privations. Unfortunately, corruption is endemic in Philippine politics because of the strong ties between wealthy families (*ilustrados*) and their political choices, a situation that is exacerbated by the low salaries paid to government officials, which opens them up to corruption.

So as the Marcos era faded from memory leaving behind colossal debts[23] and Aquino's and Ramos' governments fought a disaffected military and the Moro Islamic Liberation Front respectively they were replaced by the corrupt and inexperienced Joseph Estrada, who resigned after a *coup d'etat* in 2001.[24] Antipas Delotavo (*b*.1954) illustrates the gross inequalities between rich and poor in the Philippines in *Inaasam-asam* (Covet) (2005) by viewing the isolated and impoverished through the lens of a sumptuous interior. The tension in the work is expressed in the envious stare of the woman at the very centre of the composition, which gives the scene its air of menace.

Vietnam was gradually consumed by France from the mid nineteenth century until it became part of French Indochina at the end of nineteenth century.[25] The extension of the Vietnam War into Cambodia in 1970 and the resulting collapse of prime minister, Lon Nol's government, in the face of Vietnamese aggression (backed by Sihanouk) and the internal revolution about to be waged by Pol Pot and the Khmer Rouge created a situation in the words of Henry Kissinger in which 'the ultimate victims of America's domestic crisis [were] the people of Cambodia', so that 'with the inevitability of a Greek tragedy ... there descended on that gentle land a horror that it did not deserve and that none of us have a right to forget' (Crump 2007 p.168).

The sheer horror that Cambodia had to endure throughout the 1970s can be measured in the half a million tonnes of bombs dropped on the country by the Americans by August 1973 and the one million deaths and half a million refugees created by the Pol Pot regime. There is also a legacy of 10 million landmines that have left Cambodia, proportionally, the country with the most disabled subjects. In spite of its experiences, the country has retained its faith in Khmer culture and with the lifting of US sanctions in 1992 enjoyed a return to economic normality. Central to the country's stability after the abdication of Sihanouk in 2004 is the former prime minister Hun Sen, whose People's Democratic Party of Kampuchea provided the main opposition to the Khmer Rouge. The participation of former Khmer Rouge in Cambodian politics

until the late 1990 (Pol Pot did not die until 1998) has made the trauma for the many that suffered under its direct government all the more intense.

L'Ecole des Beaux-Arts de l'Indochine was founded in Hanoi in 1924 and became a laboratory for cultural fusion. A first generation of Vietnamese artists[26] trained in the Hanoi Academy learnt Western oil painting techniques but was encouraged to acquire or retain traditional Vietnamese craft skills, such as silk and lacquer painting. The most successful went onto further study and commercial success in France, where there was a deep appreciation for the region's decorative arts. Pham Hau (1903–1995) was one of a number of important first generation Vietnamese artists who worked in lacquer.[27] His six-screen view of either the Red or Day river *Alentours Du Fleuve Rouge, Tonkin* (1939) depicts, in a rich umber, a luxuriant tropical landscape in which the shimmering foliage and boats are picked out in gold and silver leaf and mother of pearl, and the rock faces of the distant mountains delineated in black. The process by which Pham Hau arrived at his masterpiece was long and arduous. The wooden surface needed to be perfectly smooth to receive the first layer of lacquer, which was then left to dry, a process that was repeated several times before a final application of several layers of black lacquer completed the work. The red lacquer was made from mixing natural lacquer with candlenut or tallow tree oil and vermilion, and the black lacquer manufactured by mixing turpentine and a small amount of iron or copper sulphate with the natural material.

Traditional attitudes, particularly to the position of women in society, informed the art of the Vietnamese artists painting before the war. It was rare for one of the first generation to paint a nude for example. In this respect the group of Vietnamese artists who studied in Paris differ wildly from their near contemporary and fellow émigré, the Chinese oil painter Sanyu (1901–1966), who drew and painted thousands of nudes at the *Académie de la Grande Chaumière*. Vu Cao Dam's (1908–2000) *Conversation D'Elegantés au Jardin* (1939), a gouache on silk in which five elegant, archetypal Asian beauties wearing traditional hair bands, which could be mistaken for nimbuses, sit composed in a semi-circle in the midst of a verdant landscape, acknowledges a conservative, Confucian morality that has proved a very resilient cultural force in the country. Le Pho (1907–2001), who was one of the most successful artists of his generation, absorbed Western art during his time studying in the Hanoi Academy and then in Paris; but

successfully incorporated this knowledge with the lessons he learnt from Chinese and ancient Vietnamese art, which he acquired from visits to Beijing and a stay in Hue, the ancient capital of Vietnam, in the 1930s. His *Jeune Fille Aux Fleurs* (1938–1939) shows a demure young lady with downcast eyes, a high forehead, porcelain skin and straight nose, inclining her head to form a graceful arc. She brings a transparent silk scarf to her lips, and the slight pink blush that colours her cheeks is reflected in the warm tonal qualities of the background.

Both Le Pho and Vu Cao Dam created their quintessentially first generation pictures after the mood of the nation had changed quite dramatically. Progressive elements in Vietnamese society called on France's Popular Front government, which came to power in 1936, to extend its social and political advances to Vietnam. The new spirit of political activism is recorded in Nguyen Phan Chanh's (1892–1984) painting *La Marche* (1937), which depicts, in the foreground, three children and a mother and child with their backs to the viewer gazing at a passing crowd. The individuals in the crowd clearly have a purpose, and appear very different from the passive and decorous individuals that were represented up until this time. The foreground figures are witnesses to the beginnings of social and political change in Vietnam.

On France's defeat at Dien Bien Phu in spring 1954, America set about constructing a bulwark against the threat of Communism in South East Asia. By 1961, the strategy seemed to have worked. South Vietnam had become an economic miracle. By 1965, and for three years, American bombing of North Vietnam – Operation Rolling Thunder – resulted in a greater tonnage of munitions being dropped on that country than on the whole of Europe throughout the Second World War. Post-Tet offensive[28] American policy was to 'Vietnamize' the war – a euphemism for American strategic withdrawal – while providing the South Vietnamese with the means to prolong the civil war.

At the height of the Vietnam War in the late 1960s, a group of young artists in Saigon formed the Vietnamese Young Artist Association (*Hoi Hoa Si Tre Viet Nam*), which provided a fresh direction for contemporary painting in South Vietnam. The group was made up of graduates from the Gia Dinh and Hue National Colleges of Fine Arts. They experimented with abstraction and have had an enduring influence on the 1990s generation of Vietnamese cutting-edge artists. The north of the country endured the ideological re-education inherent in Social Realism, which replaced

the internationalist precepts taught in L'Ecole des Beaux-Arts de l'Indochine, renamed the Hanoi University of Fine Art.

By 1974, Watergate paralysed the American administration and the North Vietnamese, in violation of the Treaty of Paris (1972), conquered the South the following year. In common with most new Communist states in the region, the Socialist Republic of Vietnam relied on Soviet aid. It also began the systematic destruction of traditional culture. The aftermath of the north's victory caused almost a million Vietnamese to seek refuge outside the country.[29] Vietnam's Communist government was more flexible on economic matters. After the failure of the planned economy, the Doi Moi policy in 1986 introduced liberal laws that permitted foreign investment, with a proper legal framework for property rights and commercial transactions. In 1991 foreign banks were permitted to operate in the country. Vietnam is now a member of all the international clubs it is entitled to join.[30] The country's economy is based on natural commodities like rice and coffee that are subject to dramatic price fluctuations and oil which, located in the South China sea, is subject to territorial disputes with surrounding states.[31]

The country's greatest political achievement has been its *rapprochement* with the West, and in particular with America. This has given Vietnam one of the region's fastest growing economies but also begun to unbutton its social fabric. Women, millions of whom were involved in or affected by the country's wars of liberation and civil war, are portrayed very differently from before. On the one hand, Nguyen Quang Huy's (*b.*1971) *Indochina Girl no 48* (2006) is a strong, forceful independent member of a post-revolutionary society. On the other, Do Hoang Tuong's (*b.*1960) *Sleepness Night* (2005), shows a tormented creature lying on a mattress (the bed of society), afraid and isolated. How different both these representations of females are from Nguyen Cat Tuong's (*b.*1912) tender *Mother and Child* (1940) portrait, in which an adoring mother wearing the latest, redesigned *ao-dai* (the traditional Vietnamese dress for women) watches over her child who sleeps beneath the ornate bed canopy.

Malaysia is the region's success story. British rule ended in 1957 after Sir Gerald Templer's administration had made sufficient provision for both the economically dominant Chinese minority and Malay majority and institutionalised Islam as the State's creed. The National Art Gallery was founded in 1958. The Malaysian Federation may not have included Brunei (which declined to join at its inception in 1963) or Singapore (which was expelled in 1965) but

Sarawak and Sabah (North Borneo) as well as the Malay Peninsula comprised the union. Prime minister, Tun Abdul Razak, steered the economy to new highs and with the Second Malaysia Plan attempted, through affirmative action, to redress the economic imbalance in favour of the Chinese community towards the Malay majority. In the end, annual growths rates of 7% a year from 1970 to 1990 turned this multi-racial country (there was also a significant Indian community) into an Asian Tiger in which everyone prospered. The multi-ethnicity of Malaysia is gently lampooned in Simryn Gill's (b. 1959) photographic series, *A Small Town at the Turn of the Century* (1999–2000), in which the artist sticks different types of fruit onto the heads of his subjects. One fruit in particular, the durian, is notorious in Asia for its appalling smell and the term durian or coconut-head has comic overtones.

The racial consciousness and nationalism that is now a part of Malaysian society was introduced during the colonial period. The 'racialisation' of politics in the newly independent nation was therefore extremely marked, and the region's immensely diverse cultural origins were very largely forsaken. Malaysia had been home to a great variety of ethnic, cultural and religious communities for centuries. Indian culture in particular had a strong influence on the Malay archipelago and on a number of important Malay-Hindu and Buddhist kingdoms such as Majapahit, Mataram and Srivijaya, although as Fiona Kerlogue explains (2004, p.12), the 'Indianization' of South East Asian cultures is now regarded as far too sweeping. Chinese modes of living were also blended with local tastes and habits and the presence of both Indian (Hindu and Buddhist) and Chinese (Daoist and Confucian) culture is evident in the art and architecture of the archipelago up until the nineteenth century. Much of this cultural richness, although it survives in the crafts and in rural traditions, has been lost in the country's efforts to modernise.

Mahathir's government broke the power of the establishment in Malaysia. The sultans lost their status and the country's hi-tech exports rose to exceed that of oil and tin. Malays were also integrated into the economy. A period of excess saw the construction of the Petronas Twin Towers, completed in 1997, and the beginnings of reactionary extremism in the form of the Pan Malaysian Islamic Party. Malaysia succumbed to Asian Economic Flu in 1997, but under the new prime minister, Abdullah Ahmad Badawi, corruption has been tackled and Islam Hadhari[32] embraced. But how deep an effect has the economic success had on Indonesia asks the artist,

Nadiah Bamadhaj (*b*.1968) (in collaboration with Tian Chua), in a series of photographs entitled *147 Tahun Merdeka* (147 years of Independence)? He imagines the country's institutions, such as the 2004 Palace of Justice buildings, in a 100 years' time, stripped of their glossy veneer – empty relics to ostentation and greed.

Britain saw its three protectorates (North Borneo, Brunei and Sarawak) and the Straits Settlements[33] as economic and military assets, and yet outside the main rubber and tin producing federated states and Straits Settlements, the *kampung* or Malay village culture was allowed to continue as was the local power of the (Muslim) Sultanate. As a result of this policy, the disparate elements that make up the Malayan Union have arrived in the twenty-first century with far fewer mental and physical scars than the rest of South East Asia.

Artists have retained their cultural integrity despite fractured societies

Revolutionary figures like the Indonesian artist, Sudjojono, said that European (style) painting during the years of colonisation was to him like looking at his land through the mental world of the tourist. In the course of his career, the artist tried to break free from the constraints, particularly of the *Mooi Indie* style of landscape. He wanted, quite literally, to reclaim the land for his people. This proved rather harder to execute. Sudjojono's landscapes from the 1960s are very similar to those of the artists he was rebelling against and illustrate one of the great problems that artists from transitional cultures face in the aftermath of political independence; cultural freedom takes rather longer to achieve. His later landscapes, especially those from the 1990s, mark a departure from the past certainly, but like his portraits of dancers, lack a particular cultural reference. It is almost as if, having freed himself from the bondage of Western Academicism, Sudjojono does not now know where to turn.

Self-reflection and critical commentary need not be as bereft of meaning as Sudjojono's paintings or as unsubtle and confrontational as the work of Masriadi and Suwage. Artists from an earlier generation like the self-taught Indonesian, Hendra Gunawan managed to overcome their misfortune[34] and reveal the richness of Javanese culture. Some of the artist's strongest works are landscapes, painted from memory while he was in captivity. In Java the *gunungan* (mountain) and *kekayon* (tree) are, like the mountain and water in Chinese art, metaphors for landscape. His most

striking landscapes show a blue (volcanic) mountain and meandering river framed by trees and small groups of people undertaking simple, traditional tasks. The artist also excelled in depicting the *rakyat kecil* (common people). *Papaya Seller* (1970s?) in which the brightly clothed, lascivious tradesman offers his fruit to a batik-clad, flirtatious woman whose ample bosom strains at her slight support, contains all the elements of humour, detailed observation and riotous colour in the best of Gunawan's everyday life genre paintings. Drawing on his experience as a traditional dancer, the artist paints a squatting man in *Fish Seller* (1970s?) whose seated posture resembles that of a Javanese dancer. The man's legs, like those of the papaya seller, in order to acknowledge the underlying poverty, are covered in sores. Gunawan, like Affandi (1907–1990),[35] worked as a puppeteer for many years. In *Melasti* (1958) he records the Barong Dance drama in Bali at the moment when the *Barong* (mythical lion) is about to confront the *Rangda* (the witch). The artist revels in the masks, parasols and costumes of the procession and in the drama of the occasion.

There are overtures of the traditional Balinese Batuan and Ubud styles in the preoccupation with masks and focus on village scenes and market life in both Gunawan's and Affandi's art. But their work is far removed from the stylised images of a genuine Ubud artist like Dewa Putu Bedil (*b.*1921) or Dewa Putu Mokoh (*b.*1934), who work in the traditional manner with egg tempera on canvas and show how characterisation and individual expression can enliven Balinese art while at the same time retain its essential pictorial elements. Anak Agung Gde Sobrat's (1912–1992) *Ngaben Procession* (1991), another Ubud style work, shows all the qualities of the consummation of a tradition. But Sobrat's serpentine, vertical procession of carefully articulated effigies and worshippers despite being painted over 30 years after Gunawan's *Melasti* (1958), does not try to situate the scene in the 'modern' world. Gunawan's great achievement was to take tradition and re-interpret it to suit today.

Djoko Pekik (*b.*1938) is an artist who is able to reveal the changes that modernisation and the underside of capitalism are bringing to the remnants of tradition in Indonesia. His recording of dancers, in particular, captures the drama of the event but also the brutal reality of an art form that survives as a tourist attraction. *After the Performance* (1988) depicts two exhausted skeletal forms with painted faces, collapsing into crumpled heaps after an evening's performance. *Street Girls* (1996), in which two prostitutes theatrically smoke cigarettes beneath two neon streetlights,

observed by a solitary client, is close in feeling to the artist's portraits of dancers and makes an unsavoury connection between the two professions. It is hard not to sense Pekik's disillusionment with the modern world throughout his work. As a trained textile weaver – he used to make a cotton cloth known as *lurik*, which is characterised by stripes and quiet colour hues – his fight is with the ills of standardisation and economies of scale that have marginalised his industry and many of the country's once buoyant crafts. As a direct result of unfettered capitalism and endemic corruption, Indonesia has become a country of have and have-nots, with gross inequalities of income. *Bekas Setasium Ngabeam* (1988) (former Ngabeam village station) painted in oil, employing the wet on wet Chinese bursh technique in muted tones, attests to the inequalities in his society, in which the super-rich travel in air-conditioned comfort in limousines and on planes and the poor endure the privations of an under-funded public service. Two solitary figures squat under the canopy of a disused railway waiting room, their senses dulled to disappointment. Three rail tracks partition the foreground from the rest of the work, indicating the absence of trains and the collapse of a system.

Thailand's relatively poor economic performance has perhaps helped safeguard its cities, towns and villages from the worst excesses of modernisation. The artist, Damrong Wong-Uparaj (1936–2002), in a work like *Traditional houses on stilts* (1962) gives form and colour to Thai identity in very much the same way as the Taiwanese painter Chen Cheng-po's *Sunset at Tamsui* roused self-awareness amongst the Taiwanese. In this work, Damrong has transcended tradition and produced a perfectly balanced, harmonious painting that recalls, without sentimentality, the simplicity and beauty of rural life in Thailand. Every object and structure that he depicts in his picture has been made by hand: the fine wicker baskets, red, blue and white dyed clothes and the bamboo, wood and grass houses. As with many of Damrong's paintings, any signs of the modern world have been airbrushed out.

The artist Montien Boonma (1953–2000) has re-interpreted Damrong's *Traditional houses on stilts* in the large steel and graphite sculpture, *Breathing House* (1996–7). The cluster of geometric boxes resting on thin poles of steel conveys the sense of village life and community in spite of the man-made materials used to represent them. The baskets in Damrong's work find sculptural expression in Jakapan Vilasineekul's (*b.*1964) *The Ancestor* (2005), in which a stack of six baskets with a single base is placed beside a solitary basket,

moulded in copper. The art of traditional basket making is raised to the level of high art and, just like a wooden sculpture, lovingly preserved in metal. The Chang Mai artist, Den Warnjing (*b*.1967), presents a snapshot of village comings and goings in *Thai Rural Life I* (1995). His patterned, diagrammatic picture is viewed from multiple points. It is divided into sections, each of which tells its own story. A white haired man with a stick is shown beside what might be his daughter in different situations; comforting, directing or simply passing the time of day with her. She, like he, appears in different clothes in every episode and is often depicted labouring in the fields. Perhaps she is preparing for marriage because to the right of the picture three girls appear to be combing her hair. The figures and natural and man-made landscapes merge into one with the trees and fields, indistinguishable from the stilt houses and distant temple.

Found materials fashioned into Philippine proletariat and cultural icons characterise the work of Rey Paz Contreras (*b*.1950) and cleverly utilise modern waste to reconstruct, in the *Homage to the Sacred Land* series, a pre-Columbian past. *Sinulog* is a particularly ingenious collage in which native masks, a tomahawk, an advertisement for Coca-cola and a wooden statue of a Christian figure wearing a crown are attached to a natural rattan ground. His life-size public sculpture *The Trees*, made out of textured steel, highlights the artist's concerns with the detritus of industrialisation and its impact on the environment and shows, perversely, how forgiving man-made materials can be, bent in the service of nature.

Santiago Bose (1949–2002) was another Philippine artist who worked with discarded materials. In the painted collage, *Garrotte* (2000) **(fig. 32),** the artist depicts a Spanish style execution by strangulation. Above the throttled, hooded figure floats the Virgin Mary, while elsewhere American cartoon characters and Ronald MacDonald perform inanities. In the foreground the artist has located the figure of someone very like Imelda Marcos, while in the far background Japanese soldiers feast. Bose has created a 'history painting' for the people, leaving his audience in no doubt that he sees all the foreign intrusions into the Philippines as pernicious and, worse still, with the compliance of its own government.

By working within a tradition, the Vietnamese artist Bui Huu Hung's (*b*.1957) paintings refer back to the early development of art in his country. Bui creates simple, beautiful works in lacquer on wood and canvas. *Poetess* portrays a seated woman in traditional clothes, adorned with a green jade necklace, gazing at a white handkerchief on which is written in gold the words of a poem in

GARROTTE Spanish capital punishment by strangling with SP tourniquet

32 Santiago Bose, *Garrotte*, 2000

Chu Nom – an ancient Vietnamese form of Chinese script. Bui's family used to make lacquer statues for temples and the artist prepares his materials in the traditional manner which gives his panels a deep lustre. His subjects are often devotional. *Praying* presents a slight female figure dressed in a traditional, loose white robe decorated with black circular discs, a string of black beads around her neck and her hands clasped in prayer. Behind her lies a Chinese scroll on which rests a blue and white stem cup, and beyond these items a giant bronze censer breathing smoke.

Bui's picture brings us full circle to a world before European intervention had left its mark on South East Asia, to a time when China's age-old world-order, which radiated out from the Middle Kingdom to influence lands as far afield as Java, was the dominant force. Imperial China's political and cultural hegemony utilised the suzerainty principle that operated throughout the region to employ its famed tributary system. The outside influences on South East Asian cultures, as Kerlogue (2004) explains, have been significant, beginning with Hinduism and later Buddhism from the Indian sub-continent, followed by Islam and culminating in European mercantile capitalism. China has played a seminal role throughout in the region's politics, economics and culture.

Chinese culture may yet reassert itself in Confucian and Daoist states like Vietnam, which was under direct Chinese control for a thousand years,[36] and perhaps also in former vassal states like Indonesia. China's economic importance to the Association of South East Asian Nations (ASEAN) is of growing significance to the organisation's members. The realisation amongst member states of its cultural importance is sure to follow.

Notes

1. Indonesian Modern and contemporary art dominates the South East art sales at auction, followed by Indo-European art and, a long way behind, art from the Philippines and Vietnam (Sotheby's and Christie's press releases 2007–9).

2. Larasati partnered with the Dutch auction house Glerum in 2000, after Glerum had discovered a market for Indonesian art in the Netherlands.

3. Other Indonesian auction houses are Masterpiece, Cempaka and Sidharta. Sotheby's and Christie's entered the market for Indonesian art in the mid-1990s.

4. The artists published their criticisms in the *Black December Statement.*

5. In 1602, the States General of the Dutch Republic placed the military and administrative control of Asia in the hands of the Dutch East India Company (VOC), making the board, known as the Heren xvii, the overseas administrators (Zandvliet 2002).

6. Adrien Jean Le Mayeur de Merprès is the highest-priced South East Asian artist at auction (Sotheby's and Christie's press releases).

7. On August 20 1945, the Soeara Asia newspaper ran the headline, *Proklamasi Indonesia Merdeka* (Declaration of Indonesian Independence). Immediately preceding the proclamation Sukarno and Mohammad Hatta had signed a document and declared that they were assuming office as president and vice president. Four years of colonial conflict was to follow.

8. East Timor, Portugal's last East Indies colony, was added in 1974. It gained its formal independence from Indonesia in 2002 after a long and bloody struggle.

9. LEKRA was associated with the Indonesian Communist Party (PKI).

10. Rudolf G.Usman (*b.*1953), who has been painting Borobudur for decades, made a very similar moonlit image of the temple *Borobudur in black night* in 2007.

11. The fact that Indonesia is not considered one of the BRIC (Brazil, Russia, India and China) pack, some analysts argue, is due solely to its low foreign currency reserves.

12. Despite the modernisation programmes of King Rama 1V (1851–1868), King Rama V (1868–1910) and King Rama V1 (1910–1925), Thailand was spared the rampant Westernisation of its neighbouring states.

13. As Takashi (1995, p.259) points out, Thailand was fettered to British economic and maritime power.

14. The European voyages of discovery began in the early fifteenth century when Portuguese navigators went in search of gold, slaves and spices on the African coast. In 1487, Dias and Covilha arrived in the Indian Ocean. Thereafter the voyages of discovery multiplied encouraged by the resurgence of Islam which made the old route east of Alexandria and the Red Sea precarious (*Atlas of World History*).

15. The country's name was changed from Siam to Thailand on 23 June 1939.

16. Taken from Silpa Bhirasri, 'Thai Culture', *New Series No.8: Contemporary Art in Thailand*, 1959, 6th edition 1989, Fine Art Department Bangkok.

17. The Poh Chang School of Art, which laid the foundation of Modern Western art, was established in 1913.

18. Very few examples of Thai mural painting before the eighteenth century survive (Fisher 2006, p.182).

19. Lanna Group (1978), Thai Art 80 (1980), E-Sam Group (1981) and the Four Artist Group (1981).

20. The Austronesian-speaking people are a population group present in Oceania and Southeast Asia who speak, or had ancestors who spoke, one of the Austronesian languages. The language comes from the same source as Malay, Formosan (Taiwan's aboriginals are divided into ten distinct clans, each speaking a different dialect from the other), Micronesian, Melanesian and Polynesian.

21. Transparency International 2008 measures the Corruption perception index (CPI) of 180 countries and territories. It gives The Philippines a score of 2.3/10 which relegates it to the world's 141st most corrupt country.

22. Both Taiwan and South Korea have large Christian communities.

23. Marcos was deposed after the Epifanio de los Santos Avenue Uprising in February 1986.

24. Gloria Macapagal-Arroyo was sworn into office in 2001 and was faced by a military rebellion in 2003.

25. In 1887 the Khmer Empire of Cambodia became, with Vietnam, part of French Indochina. It gained its full independence from France in 1953 and would be inextricably linked to the irrational behaviour of King Sihanouk until 'free and fair' elections in 1998 (see Crump 2007, p.168).

26. Before this time, artists in Vietnam were largely anonymous.

27. The technique of lacquering was introduced to Vietnam from China in the mid-fifteenth century, although lacquered utensils were made in Vietnam long before this time.

28. The Tet offensive demonstrated the ability of the Vietcong to attack the Americans and South Vietnamese government at its heart in Saigon.

29. The international community referred to them as the 'boat people' because they often arrived in foreign harbours in ships.

30. ASEAN – 1995, APEC – 1998, WTO – 2005.

31. The Spratly Islands are disputed by China, Taiwan, the Philippines and Malaysia.

32. Islam Hadhari is a doctrine which allows Islam and technological development to co-exist.

33. The Straits Settlements are defined by the three harbour cities of Penang, Melaka and Singapore.

34. The artist was one of the central figures in the People's Cultural Organisation, which was closed down by Suharto in 1965 after an anti-Communist purge. Gunawan was imprisoned without trial and held for 13 years at Kebon Waru in Bandung during which time he painted some of his most tranquil, optimistic and beautiful works.

35. Affandi, like Gunawan, was an idiosyncratic artist who, despite his debt to Modernism, pursued an individual style of multi-coloured hues and exaggerated expressions and often portrayed masks or performers in masks.

36. Vietnam was mostly under Chinese rule from 111BC–938.

7

The offshore art exchanges: Hong Kong, Singapore and the United Arab Emirates

The best way to sell international art is through city-states, which is why Hong Kong, Singapore and Dubai have become such influential art conduits. But these art exchanges should be seen by large states with rich cultures like China, India and Iran as convenience stores on the road to market devolution. They are not the means to safeguard indigenous cultures or develop national art economies.

A well-known Chinese antiques dealer in central Hong Kong, with one of the finest stocks in the territory, confided in me that if he detected a Beijing accent in his shop he would not complete a sale with that customer. The reason, he explained, was that once a mainland Chinese client bought something from him that piece was unlikely to reappear on the international market. The Hong Kong market thrives on the circulation and re-cycling of the highest quality works of art through its antique shops and sale rooms. China is intent, through its state-owned auction house *Baoli* (Poly) which translates, appropriately, as wealth protection, on buying the very best works of art that the international market has to offer. It then secretes its treasures away in public and quasi-private museums.

The price index for Chinese imperial ware[1] has soared to an unprecedented level because of China's renewed interest in its heritage. It has been propelled by such sales as the spring 2010

Sotheby's auction in Hong Kong, at which an imperial white jade seal from the reign of the Qianlong emperor (1736–1795) achieved a price of $12.4 million, doubling its value in three years. In a year in which major Warhols lost two thirds of their 2007 value,[2] Chinese antiques and works of art defied the downturn and Hong Kong joined New York and London as the third *bona fide* international art market centre.

It is significant that three of the world's most important trading centres for works of art are former British colonies or Protectorates. They each bear, like today's international art market, an Anglo-Saxon stamp, and they are prepared to function in the interests of that market. Hong Kong was ceded by the Qing (1644–1911) government to Britain in 1847 as part of a series of concessions to the foreign powers following the forced introduction of opium into China. The land surrounding Hong Kong Island was leased to Britain for 150 years although Hong Kong was given in perpetuity.[3] When Britain claimed its bounty it was regarded as an adjunct to empire. Its economic progress from fishing village to global financial centre has been rapid. Its role as a sanctuary for Chinese dissidents, ranging from Sun Yat-sen to Jimmy Lai (the owner of Giordano) has encouraged the international community to regard it as a beacon of not just the free market but an exemplar of the rule of law.

It is important to know, as Peerenboom explains (2010, pp 206–7), that in Asia and the Middle East many of the legal systems that are highly regarded in terms of the rule of law are not democracies or illiberal democracies. I think it is also significant that most of them were former British colonies or Protectorates. During its time under British colonial administration Hong Kong was given a legal framework that enabled an entrepreneurial society to flourish. Today, it is home to some of the richest families in the world. Its proximity to the mainland of China, its international culture and its ethnic and commercial links with the Pearl River Delta have all helped secure its immediate economic future.

A fraction of the money from Hong Kong's vast Sovereign Wealth Fund (Hong Kong Monetary Authority Investment Portfolio)[4] is now funding the large scale land reclamation and cultural development project underway in Kowloon. This project will guarantee that Hong Kong remains one of the three international art market centres. The Basic Law, which ensures that executive decisions are not confused with legal ones, which was bequeathed to the city-state by the outgoing colonial government in 1997, is central to Hong Kong's continued success. The suitability

of the current constitution will be reviewed in 2047, when it is anticipated that the former crown colony will succumb completely to Chinese rule and that the one-country two-system structure that exists today will be abolished.

Hong Kong had previously offered a lifeline to traditional Chinese culture. In the 1960s when China's Cultural Revolution raged, the colonial authorities established a design school to instruct a new generation of industrial designers, who were in demand from the city's rapidly developing economy. It was in the Hong Kong Polytechnic's School of Design that the artist Wucius Wong (Wang Songji) (*b.*1936) successfully brought together two seemingly alien traditions; traditional Chinese landscape painting and the geometry of early twentieth-century design. His work is particularly pleasing when the rocks and trees in his paintings are precisely articulated and still recognisable as a landscape. But it is the aerial topographies and *New Dream* series that best display his use of a new vocabulary. Here the landscape is defined within a strict geometric grid, which adheres to nature in only colour and texture. Wong identified two groups of Chinese artists at that time; the one educated in Western art trying to find a way back to tradition and the other steeped in the Classics but seeking innovation from the West. This *xinpaihua* (new style painting) concept evolved into the Tao (*Yuan Dao*) Art Association and One Art Society (*Yihua hui*) whose members sought to remake Chinese culture by introducing to it new styles of painting from elsewhere in Asia and the West. At the same time the artist Lu Shoukun (1919–1975) preached liberation from the formal constraints of traditional brush painting, establishing a Movement known as *xinshuimohua* (new ink and water art).

Britain acquired Penang in 1786 as it encroached into Malaya. It acquired Malacca from the Dutch in 1824. Singapore's eventual accession to the British Empire was down to the buccaneering activities of the maverick, Sir Thomas Stamford Bingley Raffles (1781–1826), who established it for the East India Company in 1819. Raffles' objective had been to introduce free trade into the region but Singapore became a Crown Colony in 1867, its rule officially transferred to the Colonial Office in London, along with Malacca and Penang, forming the Straits Settlements. Rather like Hong Kong, Singapore prospered under a British colonial administration, which protected the rights of its subjects and encouraged the development of a vibrant multi-national, economic community made up, principally, of the Fukienese and Hakka peoples of Southern China, indigenous Malay and imported

Indian *coolies*. Superimposed on top of this structure was the British administration.

Singapore achieved its independence in 1969, a full 28 years before Hong Kong and evolved, under the controversial strong-arm leadership of President Lee Kuan Yew, into one of the world's largest commercial ports and most dynamic service economies. Singapore also has one of the world's highest government capital reserves. In terms of the art and antiques trade it has aspired, as Christian points out (p.i), to be a stable regional and economic platform for the international trade of the region's high-end commodities. It is located in a different part of the world from its sister Hong Kong. Across the Indian Ocean from the eponymous sub-continent it sits at the heart of South East Asia. Amidst the turmoil of a series of bloody late twentieth-century wars sponsored by the Soviet Union, China and the United States as well as the retreating European colonial powers, Singapore remained untouched. Under the Lee administration – so admired by Deng Xiaoping and China's leaders today – it appeared to point the way for all aspiring Asian economic tigers. Like Hong Kong it has one of the world's finest legal systems, which has created for the city-state a stable, business friendly environment. There are similarities in the manner in which Korea, Taiwan and Singapore have all developed powerful economies under authoritarian governments and grown into rich, developed societies.

Dubai, one of the eight emirates that comprise the United Arab Emirates (UAE), unlike Singapore and Hong Kong, was not settled until the end of the twentieth century. Until then it was a desert inhabited by Bedouin nomads and a part of the Safavid and then Ottoman empires before its eventual accession by Britain at the end of the nineteenth century. It was not until 1971 that the UAE was created out of the former British-protected (Trucial) States. The discovery of oil in the Middle East has had a dramatic impact on the wealth of the region and the UAE is one of the beneficiaries of this bounty. Sheikh Khalifa, who became president in 2004, has benefited from his father's willingness to save the money accrued from the sale of oil. Most of the oil profits since 1976 have gone into the Abu Dhabi Investment Authority,[5] a government fund that is the world's largest single Sovereign Wealth Fund.

A proportion of Abu Dhabi's great wealth has gone into the construction of a giant, amphibious cultural city half the size of Bermuda named Saadiyat Island (Island of Happiness). Dubai, which does not have oil, has embarked on a different path of sustained prosperity to its oil-rich neighbour. Its model also differs

from both Singapore's and Hong Kong's in so much as its economy has no manufacturing base and is absolutely reliant on foreign expertise. Dubai may aspire to be an international centre for finance and trade, but it has a skill and cultural[6] deficit that will be very hard to offset. The fact that the city is built on a desert, dependent on a vast desalination programme for its fresh water, puts it in an even more precarious position. But there is a powerful reason why Dubai's aspiration to become a major art market centre is more likely to succeed than Singapore's bid, and that reason lies with its adjoining Emirate, Abu Dhabi.

Abu Dhabi holds the key to the future success of the Emirate's art market. It became the official capital in May 1996 and is the political and cultural centre of the UAE. The Emirate's political culture is remarkably sophisticated: 'When the rulers of each emirate convened over thirty five years ago' writes Dejardins (p.5) 'to discuss the preliminary structure of the newly formed Federal state, they deliberately chose to create a society that would offer a modern administration while simultaneously retaining the traditional forms of government and rule.'

The leader of each Emirate would have been the Sheikh of the most powerful tribe. The Sheikh's 'people' gained, and continue to gain, access to him through the 'Majlis' (councils), which provide, as they do in Iran, the building blocks of indirect democracy. At the foundation of the new State, the Sheikhs of each Emirate appointed themselves as representatives of their 'people' to the Supreme Council, which in turn elected the President to a five-year term. A Federal National Council, which sits just below the Supreme Council, polices the parliament. The UAE also has an independent judiciary and foreigners are now entitled to a 99-year lease on land ownership allowing, as Dejardins explains, for the possibility of a permanent overseas resident community and the establishment of long-term markets. Although less highly regarded than Hong Kong's and Singapore's legal systems, the Gulf states are in the top quartile on the World Bank rule of law index.

The Abu Dhabi Tourism Development and Investment Company (TDIC) intends to complement Dubai's programme of mass entertainment with a high level cultural infusion aimed at the discerning Arab, Iranian, Chinese and Indian tourist as much as the Western. Two offshoots of the TDIC, The National Media Council and the Ministry of Culture, Youth and Community have made it their priority to safeguard the Bedouin's oral tradition.[7] Nicolai Ouroussoff, writing in the *New York Times*, goes so far as to say

that the UAE is not an example of another Arab country embracing Western modernity, but rather a 'chance to plant the seeds for a fertile new cultural model in the Middle East' (Dejardins, p.22).

Although some way behind the UAE, Qatar's ruling Al Thani family is swiftly developing an economic, arts and residential infrastructure to challenge that of Abu Dhabi and Dubai, employing the wealth accrued from the kingdom's oil and gas industries. The Museum of Islamic Art in Doha is designed by I.M.Pei (Ieoh Ming Pei). His design is based on a small fountain for ablutions outside the Mosque of Ahmad Ibn Tulun in Cairo. It is part of a huge urban, cultural project that seeks to make Qatar the region's centre for education and the arts. The Kingdom's property laws for non-residents have also been relaxed since 2004 and foreigners can now hold property on a freehold basis in select locations.

It is too early to say whether the right balance between Western-style internationalism and local cultural enhancement has been struck with the Saadiyat Island Project. The entire project comprises 27 kilometres of island turned into a cultural oasis, at the centre of which lie four great museums, 19 art pavilions and a biennial (art) park. A 'string of pearls', it is said, will rise out of the desert by 2018.

A Guggenheim designed by Frank Gehry, evoking a Bedouin tent in which loosely arranged galleries suggest a souk, will hope to replicate the success of the Bilbao version. A third of the collection will be devoted to contemporary art from the Middle East and Iran. It is clear from the outset that the Guggenheim will have to respect the cultural, national and Islamic heritage of the Emirates and control its radical instinct. A Classical Museum, designed by Jean Nouvel will house much of the Louvre's Islamic hoard. A Maritime Museum designed by Tadao Ando will pay homage to the region's seafaring traditions, notably the building of dhows (traditional Arab sailing vessels) which continues to this day in the Emirate of Umm al-Quwain. A Performing Arts Centre, designed by Zaha Hadid will complete the set. I was critical of I.M. Pei's (Ieoh Ming Pei's) Suzhou Museum partly because of its blandness, but mainly because of its insensitivity to its environment. Suzhou is after all one of the world's most ancient and best-preserved cities. The big name architects who have designed museums for the Saadiyat Island project have no need to integrate their fantastic structures, beyond the ecological, into desert and sea. The outcome is likely to be both appropriate and impressive.

The question of whether to integrate regional culture into world culture or to retain inter-dependence from the international art

market does not only affect the UAE. Egypt is perhaps the most conspicuous example of an Arab country that has followed a policy of international cultural integration and has, as a result, posed for itself and its culture a great many questions that the Gulf states should heed. Do cutting-edge art events such as Egypt's Nitaq Festival cater for the needs of Arab culture or dance to the tune of internationalism? Initiatives such as the Alexandria Contemporary Arts Forum and the Contemporary Image Collective in Cairo may assert their grassroots credentials, but they in fact act as platforms for aspirant local artists and curators intent on securing international recognition for themselves and their work at the expense of their communities. Egypt is certainly a special case, weighed down, as Nat Muller (p.16) points out, by its epic Pharaonic past and dream of pan-Arab Modernity conjured up by Gamal Abdel Nasser (1918–1970). It has a highly institutionalised cultural bureaucracy and is the only Arab or African country with a permanent pavilion in the Venice Biennale, Giardini.

The Lebanon is forced to operate at the polar extreme of Egypt. Its weak state means that its cultural funding is driven by private donors who, for example, funded the Lebanese Pavilion at the Venice Biennale in 2007. In the absence of government intervention, national 'cultural' currents are taken up by artists who create their own structures, such as Walid Raad's Atlas Group, set up in Beirut in 1999 to document Lebanon's living history from 1989 to 2004. This is culture in its very broadest sense, and Raad's 2008 exhibition in Gallery Sfeir-Semler in Beirut, entitled *A History of Modern and Contemporary Arab Art Part 1: Beirut 1992–2005*, was the first in a series of events employing the archive, according to the artist, as the medium for the transference of 'the emerging infrastructure for the creation, distribution and consumption of Arab art and artists'. Subsequent shows feature the work of Lebanese artists past and present. The directness and acuteness of Raad's approach is admirable, but also sadly indicative of the absolute reliance of artists from weak states on the international art market's instruments.

At the 2009 Venice Biennale a better indication of the ambition of the Gulf states to integrate their contemporary art within the international art world would be hard to find. The French curator, Catherine David, masterminded the Abu Dhabi Authority for Culture and Heritage (ADACH) pavilion and the Swiss/Iranian, Tirdad Zolghadr, curated the UAE pavilion. There has also been a spate of Middle East themed exhibitions in Europe since 2003, which once again cover the region's contemporary culture in an

internationalist blanket. In cultural economic terms, this strategy is highly attractive, and it is one that we have seen South Korea operate extremely effectively, but it fails to provide the region with cultural security. The international recognition that such events give contemporary art from emerging markets rarely benefits the region's broader arts economy or adds any lasting value to its indigenous cultural expression.

The art markets and museums of the UAE and Qatar are crucial as international outlets for Iranian contemporary art. A gallery like Majlis, which operates out of an elegant courtyard building in Dubai's old town of Bastakiya, provides a commercial platform for artists from Iran who find it difficult to trade their work inside their own country. Abu Dhabi's neophyte museums may also enjoy a cultural association with Iranian ones like the Tehran Museum of Contemporary Art and the newly opened contemporary Imam Ali Arts Museum, which show contemporary art inspired by the Islamic tradition. The Abraaj Capital Art Prize, which is awarded to artists from Iran and the Middle East, gave its support to one particularly interesting project in 2009. A traditionally made Persian carpet called *Rhyme and Reason* was decorated with the symbols of modern Iran by the Iranian artist, Nazgol Ansarinia (*b*.1979).[8] The centre of the carpet is dominated by three rings, depicting women in chadors, a family of four balanced on a motorcycle, a fight, schoolchildren forming a crocodile line behind their teacher and, at the rug's edges, boys drinking and girls dancing. It is a portrait of contemporary Iran with all its bumps and bruises and in many ways a tangible complement to Marjane Satrapi's novel, *Persepolis*.

Storage and dissemination of international art

The importance of offshore art market centres need not lessen with the advent of cultural protectionism and the rise of nationalism in emerging markets. There are moments in the cycle of democratic governments when it is politically expedient for them to voice their dissatisfaction with and commitment to regulate, if not abolish, the tax haven. It is certain that the resolve of governments throughout these rotations is prompted by a decline in tax revenue at home and the perception that offshore jurisdictions are somehow in large part responsible for their nation's plight.[9]

The question arises, therefore: how safe are Hong Kong, Singapore and Dubai from these cyclical attacks on their governance? Hong Kong is quite safe. It effectively comes under the protection of Beijing, and China certainly wouldn't countenance an intimate enquiry by a foreign government or league of nations into the tax regime of its recently recovered territory. It is less hard to imagine that international pressure brought to bear on Singapore might bring about concessions from the city-state, because Singapore is without a powerful protector. But it is difficult to foresee the Singapore authorities bowing to pressure to close their recently established free port,[10] so vital to the storage of works of art in transit.[11] The UAE is again more vulnerable to international sentiment than Hong Kong, but the ill-feeling that such demands from the West would stoke up in the region makes direct action unlikely.

In the end, the consequences of such a crusade would, unwittingly, have a detrimental effect on London – the world's second largest art market. London behaves in many ways as a city-state and its competitiveness is driven by the forces that propel offshore centres. It is also dependent on the special services offered to the City of London by the Channel and British Virgin islands. The dependency of London's international art trade on Hong Kong, Singapore and Dubai is perhaps even more marked than the reliance of its financial services on offshore jurisdictions. Sotheby's, Christie's and Bonham's make a considerable proportion of their revenue at the Hong Kong sales and are developing their positions within the Dubai and Qatar markets. London's international art dealers also conduct significant amounts of their business at the art fairs of all three offshore jurisdictions, and some choose to open a second business in one of those territories.

London itself offers a benign tax environment for its international art collectors and one that makes full use of offshore jurisdictions. The UK has, for starters, no wealth tax,[12] and a benign inheritance tax.[13] But London's art market is also extremely vulnerable to changes in the tax status of the UK's non-domiciled residents (non-doms). If, for example, barriers are erected to prevent non-doms from bringing their works of art into the UK from abroad or the Treasury were to crack down on Capital Gains Tax (CGT) avoidance, many wealthy collectors may well decide to live elsewhere.

Hong Kong is already a hub of Chinese art market intelligence, and the centre best equipped to authenticate and sell Chinese

brush painting in particular. In time the Gulf states may play a similarly prominent role in the Islamic art market. Once the economic conditions for cultural expertise and research have been established in a particular place, and this involves massive and continued investment in the cultural and intellectual infrastructure, the slightest change to that city's competiveness leads to its rapid decline. The Paris market, which endured a long period of unhelpful state intervention and punitive taxation, has seen its market decline to a fraction of its pre-war size. If Paris had an intention to steer its market strategically down the road to cultural nationalism then it soon encountered two insurmountable hurdles: European economic harmonisation[14] and the limitations of its medium sized national art market.

Certain European Union countries, such as Italy, have adopted cultural protectionism with enthusiasm, particularly in respect of offshore jurisdictions. It is tempting to think that an agreement between Switzerland and Italy to combat the illicit trade in cultural property[15] was on China's mind, when on 14 January 2009, the People's Republic and the United States concluded a bilateral agreement under the Cultural Property Implementation Act (CPIA) restricting, as Bresler and Khalifa explain (autumn 2009, p.3), import into the United States of certain categories of undocumented archaeological materials.[16] The great advantage that China has over the culturally rich European Union States is the scale of its internal market, which is, potentially, the size of the entire European Union. It can, therefore, uniquely adopt protectionism without damaging its commercial self-interest. Whether China views the accession and disbursement of art in commercial terms is another matter altogether (see chapter 3).

There is a difference between the use of a tax haven as a store for wealth and the dynamic advantages that apply to offshore jurisdictions that act as wealth generators. Hong Kong is the most energetic of the offshore wealth generators. It offers arbitrage opportunities for sellers across a number of art market categories, most notably in the field of Chinese art and antiques. In addition to the advantages enjoyed by other sanctuaries, it has low business/corporation and income taxes and, crucially, and in common with Singapore and Dubai, the international art world is welcomed. Its currency is international, exchangeable, not subject to currency control and pegged to the United States dollar. It is for these fiscal reasons that Hong Kong attracts the world's wealthiest collectors. Foreign-owned art businesses in China transact a great proportion

of their sales under a licensed company in Hong Kong in order to avoid Chinese tax, taking advantage of a ruling which allows for profits to arise where the taxpayer's contracts of purchase and sale are effected.

Singapore's free port is an important part of its claim to be a vital offshore art centre. The most important function of a free port is the time it gives buyers and sellers to complete a transaction. Free ports are, as Bruno Muheim (2006) explains, 'extremely convenient during negotiations in which the seller does not know at the outset where his work of art will eventually end up'. Singapore's free port is by no means the only one in the world – Switzerland has 16[17] – but it does provide the South East Asian and Indian art market with a convenient storage facility and is particularly helpful to Art Funds. Singapore also offers tax incentives to those who make cash donations to museums and towards the creation of public sculpture. According to Lindy Poh Singapore has also added to its art skills sector and now 'leads one of the foremost conservation and care storage spaces in Asia' (2008, p.273).

Dubai's tax advantages are similar to Hong Kong's. Galleries are, however, liable to a 5% import duty which undercuts most of the Middle East. Antonia Carver (2006) explains that collectors and dealers alike either bring in works of art as hand luggage or pay on their declared purchase price. Wealth, Value Added Tax (VAT), Capital gains and inheritance tax are all set at zero. Export tax is also 0%, but there is a 5% import tax. Importantly, import tax can be avoided if the business is set up in a 'free zone'. In April 2005, Christie's opened its first office in the region in the Dubai Multi Commodities Centre (DMCC). The zone offers: 'One hundred per cent business ownership, a guaranteed 50 years tax holiday and freehold property options' (Carver, 2006). Even for non-residents or those without offshore trusts, no VAT or *droit de suite*[18] is payable on the transaction.

The offshore jurisdictions have to make their tax regimes more appealing to collectors and the art trade than they are in other states. They face particularly strong competition from Asian countries, most of which are low tax societies. Mainland China is the exception to the rule. But China does operate Special Economic Zones (SPZ) and Free Trade Zones (FTZ) in which certain taxes are not applicable or else significantly lower. There are 16 FTZs in China that are exempt from sales and import taxes. If a work of art is imported into a FTZ as bonded material, it is exempt from capital gains tax and VAT, but both are triggered if the object is sold

outside the FTZ. Taiwan's import and export duties are much lower than China's and its hundreds of foundations act as efficient ways to exempt an art collection from income and inheritance tax. Japan and Korea operate very similar tax regimes to Taiwan although, unlike the United States and the UK, few if any tax benefits accrue to Japanese who donate work to a public collection. Compared to even the most competitive tax regimens in Asia, Hong Kong in particular stands above its rivals. Dubai is also well insulated and Singapore more attractive than its South East Asian neighbours. A final and perhaps overlooked advantage of the three territories is their relative security.

Both Singapore and Hong Kong are safe places to store physical assets. The region in which Dubai operates is much less secure and, despite the Emirates' efforts to comply with international standards, its position as a free port storage facility for works of art is hampered by fears over the region's safety.

How will indigenous cultures re-shape the international art market?

The vital role that Hong Kong, Singapore and Dubai will play as market players in international contemporary art from emerging markets is quite clear. But the ability of the international art market, through its city-states, to reach into national markets and influence the direction, shape and form of indigenous culture is much less sure.

There will come a time when emerging markets will detach themselves from the value system operated by the international art market. Until that time, the city-states will continue to add value to select work from emerging markets and lubricate the international trade in art. The international exchanges will exist for as long as they provide financial benefits that outweigh those of traditional states.

The paradigm shift in the system from international to national market valuation is hardly evident in any of the city-states, despite solitary outposts such as the Sin Hua and Yisulang Art Galleries in Singapore and Hanart TZ in Hong Kong that do show art that reflects tradition. Asia Auction week in Hong Kong, which attracts K Auction from Korea, Larasati from Jakarta, Shinwa from Tokyo and Ravenel from Taipei fails to add anything extra to the international cultural diet. To all intent and purpose, Asia's

regional houses do not reflect the development of a new art from emerging markets.

The multi-national model that has operated in China and East Asia from the 1990s (and in a limited way a decade earlier), in which international dealers based in Hong Kong, Europe and the United States foraged for work in mainland China, is exhausted. The other model, in which pioneering international dealers domiciled themselves in China at the beginning of that country's transition from a state-run to a free enterprise economy, and set benchmark values for the 'new' Chinese international art, has also run its course. The Ullens Center for Contemporary Art (UCCA) in Beijing's 798 gallery district hoped to become the gold standard by which international Chinese contemporary art would be judged. By validating the art of Western galleries, it also sought to add lasting value to the Ullens collection. The swathes of dealers from the West, South Korea and Japan that have since set up outposts in Beijing and Shanghai mark the highpoint of this adventure.

The ambitious cultural building programmes in Hong Kong and Abu Dhabi in particular, but also the new museums that have sprouted in China, suggest that the cultural establishment in those states still adheres to the notion of internationalism, However there is a strong indication that many of the new museums will show a different kind of art. It is to be expected that the city-states will take this path, but there are signs that the emerging world's core source markets will adopt a different framework altogether. This new framework will still employ the services and infrastructures of the city-states, but the international outposts will find themselves dealing in a new art, one without Western characteristics.

The type of art sold in the three important offshore art market centres will increasingly reflect the 'taste' of the source markets of the emerging world. The 'East Asian Tigers' will play a significant role in determining the nature of this taste. There will be a tipping point when the art markets of Hong Kong, Singapore and Dubai will derive more benefit from their respective regions than from the international market. Major civilisations like Greater China, the Persianate realm and Hindustan will determine the future pattern of the art and culture of their region to the exclusion of the West. In the final analysis the core will extend its influence absolutely over its rim, at which point the evolutionary cycle will be complete.

Notes

1. Works of art commissioned by the emperor (royal household) in the Ming (1368–1644) dynasty, beginning with the triumphant return of native rule under Hong Wu (1368–1398) and the establishment of Beijing as the capital inheriting the palace sites of the Jin and Yuan. In the Ming Dynasty which has 16 reigns, the reign title was often inscribed on ceramics or lacquer to identify and date the piece.

2. *Liz* (1963), 101 x 101 cm, sold at Christie's in November 2007 for $21 million and *Silver Liz* (1963), 101 x 203 cm, sold for $6.3 million in May 2010.

3. The fact that Hong Kong Island needed 'New Territories' in order to survive – it being the only source of water amongst other necessities – made the fact that 'technically' Hong Kong itself could have been retained by Britain in 1997 just that; a point of academic interest.

4. Oakley & Tett (*Financial Times*, March 25 2010). Abu Dhabi runs a string of smaller funds in addition to the ADIA.

5. Abu Dhabi is the wealthiest of the emirates and holds the UAE's oil reserves.

6. Cultural in its broadest sense, from museums to food.

7. See UNESCO's Intergovernmental Committee for safe-guarding Intangible Cultural Heritage.

8. Ansarinia painted the intricate design onto paper before giving it to traditional carpet weavers to make into a hand woven, wool, silk and cotton rug, 360 x 250 cm.

9. Havens, most of which are under present or former British jurisdiction and relics of empire, exist because larger states allow them to exist. They are an integral part of the world economy (Kay, J, 21 -22 March 2009, *Financial Times*).

10. A free port is a tax-free zone where goods may be stored free of tax. A newly opened state-of-the-art free port in Singapore looks set to create competition for the Swiss free ports (Valentin & Stripp, autumn 2008).

11. Both Hong Kong and Singapore announced in 2009 that they would endorse OECD standards for transparency and exchange of information, in line with Switzerland's decision to ease its laws on banking secrecy. These decisions do not compromise the special and advantageous services that both dominions are able to offer the art industry.

12. Wealth tax systems essentially tax net worth on an annual basis and tend to be applied against a percentage (typically 0.8% and 2.5%) of net worth in excess of a certain level (Groves & Monroe, spring 2009, p.2).

13. UK Inheritance Tax (IHT) applies to the worldwide assets of individuals domiciled in the UK but only to the UK assets of non-domiciled individuals. UK residents face one of the world's lowest capital gains (CGT) rates of 18% and under the remittance basis of taxation non-domiciled individuals are only subject to UK tax on foreign income and gains remitted (i.e. brought into) to the UK.

14. The protectionist approach adopted by the French art market contravened the EU's laws on free trade and harmonisation.

15. A new bilateral treaty (April 2008) between Switzerland and Italy provides that the two countries will cooperate to combat the illicit trade in cultural property (Valentin, autumn 2008, p.7).

16. The agreement is designed to limit entry into the United States of archaeological material illegally excavated and exported from China, thereby discouraging trafficking in China's cultural patrimony (Valentin, autumn 2009, p.4).

17. The fact that the largest of Switzerland's free ports, Geneva, has given up its special status gives further advantage to Hong Kong, Singapore and Dubai.

Bibliography

Chapter 1.

Books

Acharya, A., 'Democracy and disorder: will democratization bring greater regional instability to East Asia?' in Chu Yin-wah and Wong Siu-lun, *East Asia's New Democracies*, Routledge, 2010

Bary de, W.T., *Sources of East Asian Tradition*, vol 1, Columbia University Press, 2008

Carino, L.V. 'Devolution and democracy: a fragile connection' in Chu Yin-wah and Wong Siu-lun, *East Asia's New Democracies*, Routledge, 2010

Chu Yin-wah and Wong Siu-lun, ibid

Doniger, W.,*The Hindus. An Alternative History*, Oxford University Press, 2009

Fuller, P., *Images of God. The Consolations of Lost Illusions*, Chatto, 1985

Howell, J., 'Social and political developments in China: Challenges for democratization', in Chu Yin-wah and Wong Siu-lun, *East Asia's New Democracies*, Routledge, 2010

Hewison, K., 'Thailand's conservative democratization', ibid

Hsiao, M and Ming Sho-ho, 'Civil Society and democracy-making in Taiwan: re-examining the link', ibid

Im Hyug-Baeg, 'Development and change in Korean democracy since the democratic transition in 1987: the Three Kims' politics and after', ibid

Peerenboom, R., 'Rule of law and democracy: lessons for China from Asian experiences', ibid

Thompson, M. R., 'Modernization theory's last redoubt: democratization in East and Southeast Asia, ibid

Articles

Hao Sheng, 'Keeping company with the past: "fresh ink" at the Museum of Fine Arts, Boston', *Orientations*, October 2010

Hao Sheng, 'Liu Xiaodong', ibid

Hao Sheng, 'Xu Bing', ibid

Scheier-Dolberg, 'Li Jin', ibid

Chapter 2.

Books

Albritton, K., *Evolution of the Japanese contemporary art market: From Eastern to Western practices*, SIAL unpublished M.A. dissertation, 2008

Baum, R., *Hiroshi Senju's Alternative Materialism. The Waterfall Paintings in Contemporary Art Historical Context*, Sundaram Tagore Inc, 2007

Chang Tsong-zung et al, *A Translucent Dawn. Ink Paintings by Hsu Yu-jen*, Hanart TZ Gallery, 2007

Chang Tsong-zung et al, *Man and Earth, Contemporary Paintings from Taiwan*, The Asian Art Coordinating Council, 1994

Chang Tsong-zung, *The Sky in the Landscape, Qiu Shi-hua, Landscape Painting*, Galerie Rudolfinum, 2000

Choi Sunhee and Choi Byongsik, *South Korea, The International Art Markets*, the essential guide of collectors and investors, Kogan Page, 2008

Choi Taeman, 2007, *Reconciliation between Material and Shape*. Return to Nature, Lee Jaehyo, Touch Art, 2007

Faulkner, R., *Japanese Studio Crafts. Tradition and the Avant-Garde*, Laurence King, 1995

Jiang Hsun, *Return to the Native Soil – Directions in Taiwanese Art in the 1970s,* Taiwan Art (1945–1993), Taipei Fine Arts Museum, 1993

Harris, V. (ed), *Shintō. The Sacred Art of Ancient Japan*, British Museum Press, 2001

Kenji, K, *Crafting Beauty in Modern Japan*, British Museum Press, 2007

Lai Chi-tim, *The Nature of Dao*. Qiu Shi-hua, Landscape Painting, Galerie Rudolfinum, 2000

Liu, C.,*Place/Displace: Three Generations of Taiwanese Art*, Taiwan Fine Arts Museum, 2003

Lin Hsing-Yueh, *Setting the Historical Stage for the Taiwan Art Exhibition* Taiwan Art (1945–1993), Taipei Fine Arts Museum, 1993

Lu, V.,The New Wave of Contemporary Taiwan Art 1983–1993: A Decade of Metamorphosis. Taiwan Art (1945–1993), Taipei Fine Arts Museum, 1993

Lu, V., *New Art, New Tribes – Taiwan Art in the Nineties*, Hanart, Taipei Gallery, 1993

Lu, V. et al, *Visions of Pluralism. Contemporary Art in Taiwan, 1988–1999*, Council for Cultural Affairs and Council for Mainland Affairs, 1999

Park, Myung-ja, *Park Soo Keun*, Gallery Hyundai, 2002

Portal, J., *Korea Art and Archaeology*, British Museum Press, 2000

Robertson, I.A., *Taiwan*, The International Art Markets, the essential guide of collectors and investors, Kogan Page, 2008

Ropner, R. and Hirakawa, K., *Japan*, ibid

Lee, Dong-suk, *Park, Seo-bo Ecriture 1967–2001*, Gallery Hyundai, 2002

Watkins, J., *Facts of Life, Contemporary Japanese Art*, Hayward Gallery, 2001

Yamaguchi, Y., *The Power of Japanese Contemporary Art*, ASCII, 2008

Yamaguchi, Y., *Warriors of Art. A Guide to Contemporary Artists*, Kodansha International Ltd, 2007

Articles

Downer, L., 'Shogun time' in the *Financial Times*, 14–15 August 2010

Duffles, M., 'An elegant dedication to ancient crafts' in the *Financial Times*, 20–21 August 2005

Fakhr, L., 'Rhyme and reason' in *Abraaj Capital Prize*, 2009

Garnham, P., 'Beijing seeks an escape from the dollar trap' in the *Financial Times*, 31 July 2009

King, S., 'China takes small steps towards breaking the sway of the US dollar' in the *Independent*, 13 July 2009

Kwong, R., 'A delicate détente' in the *Financial Times*, 7 May 2009

Nakamoto, M., 'Bizarre world of the collectors' in the *Financial Times*, 12 October 2004

Oliver, C., *Young Kim no guarantor of long-term stability* in the *Financial Times*, 2–3 October 2010

Radlauer, S., 'Universal waterfalls' in *Asian Art News*, November-December 2008

Chapter 3.

Books

Aldrich, M. & Wallis, R.J. (ed.), *Antiquaries & Archaists, The Past in the Past, The Past in The Present*, Spire Books Ltd, 2009

Barrass, G., *The Art of Calligraphy in Modern China*, British Museum Press, 2002

Boers-Li Gallery, *Qiu Anxiong: About – New Classic of Mountains and Seas II*, 2009

Bonhams, *Contemporary Asian Art Hong Kong*, Bonhams, May 2007

Clements, J., *Confucius A Biography*, Sutton Publishing, 2004

Colman, J., *Chinese Contemporary. Year 10*, Chinese Contemporary Ltd, Beijing, 2006

Chang, J and Halliday, J., *Mao the Unknown Story*, Vintage, 2005

Chang Tsong-zung et al, *Half a century of Chinese Woodblock Prints*, The Museum of Art Ein Harod, 1999

Chang Tsong-zung et al., *Power of the Word*, International Curators International, NY, 2002

Chang Tsong-zung, *The Sky in the Landscape,* Qiu Shi-hua Landscape Painting, Galerie Rudolfinum, 2000

Chun-Yi-lee, *Liu Kuo-sung, Universe in My Mind*, Michael Goedhuis, 2010

Cooper, R., *The Paintings of Yang Yanping*, Michael Goedhuis, 1999

Duff, S., *Ren Zhitian Script & View*, Art Labor, 2008

Fan Jingzhou, Wang Dong-ling, *Calligraphy and Painting*, Machteld Stikroort, 1994

Fairbank, J.K. and Goldman, M., *China A New History*, The Belknap Press of Harvard University Press, Second Enlarged Edition, 2006

Fenby, J., *Generalissimo Chiang Kai-shek and the China he lost*, Free Press, 2005

Fenby, J., *The Penguin History of Modern China. The Fall and Rise of a Great Power 1850–2008*, Penguin Books, 2008

Gao Minglu, *Thirty Years of Chinese Contemporary Art 1979–2009*, Minsheng Museum, 2010

Gill, C., *Shanghai Expo Censorship Rows*, *Art Newspaper*, July-August 2010

Goedhuis, M., *Yang Yanping*, Beadleston Gallery NY, 1998

Hao Jing, *An Overview of Contemporary Chinese Antique Market*, SIAL unpublished MA dissertation, 2007

He Xu, *Contemporary Chinese ink Painting – Marginalised or the Next Boom*, SIAL unpublished MA dissertation, 2009

Huang Bingyi, *Unbounded You Si*, Art Labor, 2007

Hutton, W., *The Writing on the wall. China and the West in the 21st Century*, Abacus, 2007

Kemble, M., *No Show Ying Yefu*, Art Labor, 2009

Kemble, M., *Ren Zhitian – Everywhere is Here*, Art Labor, ibid

Kuo, J.C., *Chinese Ink Painting Now*, Art Publishers Inc NY, 2010

Leonard, M., *What does China Think?*, Fourth Estate, London, 2008

Linebarger, P.M.A., *The Political Doctrines of Sun Yat-Sen*, Baltimore, The John Hopkins Press, 1937

Lu Datong, *The Pond, Jiang Shanqing*, Culture & Art Publishing House, 2010

Miller, E., *Lo Shang Tang, Contemporary Chinese Paintings II: An Exploration*, Roberts Hall and Edwin Miller, 1989

Saatchi, C., *The Revolution Continues: New art from China. Picture by Picture Guide*, The Saatchi Gallery in partnership with Phillips de Pury & Company, 2008

Salisbury, H.E., *Tiananmen Diary. Thirteen Days in June*, Unwin Paperbacks, 1989

Snow, E., *Red Star Over China*, Victor Gollancz, 1937

Sotheby's, Contemporary Art Day Sale, Hong Kong, Sotheby's, 5 October 2008

Sullivan, M., *Art and Artists of Twentieth Century China*, Berkeley: University of California Press, 1998

Sullivan, M., *Paintings by Yan Yanping*, Michael Goedhuis, 1997

Sullivan, M., *Luo Kuo-sung*, National History Museum, Taiwan, 1990

Sullivan, M., *The Meeting of Eastern and Western Art, From the Sixteenth Century to the Present Day*, Thames and Hudson, London, 1973

Terrill, R., *The New Chinese Empire and what it means for the United States*, A Cornelia and Michael Bessie Book, 2003

Wu Chao-jan, Two Worlds in the Paintings of Yu Peng, Hanart (Taipei) Gallery, 2001

Zhang Xin, Suzhou Museum, Great Wall Publishers, 2007

Articles and Reports

Ahmad, S., 'China goes shopping' in the *Financial Times Magazine*, 22–23 August 2009

Anderlini, J., 'China set for Renminbi policy shift' in the *Financial Times* 7 April 2010

Blas, J., 'A market re-emerges' in the *Financial Times*, 14 April 2010

Dinmore, G. and Dyer G., 'China "increasingly hostile" to foreign groups, says GE chief' in the *Financial Times*, 2 July 2010

Dyer, G., 'The Beijing Bronzes expose a faultline with the West' in the *Financial Times*, 7–8 March 2009

Hille, K., 'File not found' in the *Financial Times*, 5–6 Sept 2009

Hille, K., 'Inside China's censorship machine' in the *Financial Times*, 18–19 July 2009

Hille, K., 'Showing the strain' in the *Financial Times*, 29–30 May 2010

Hille, K., Mitchell, T and Dyer, G., 'Striking out' in the *Financial Times Magazine*, 17–18 July 2010

Huang Ching-Yi, 'Chinese art market' in *Art Market Report*, 3rd quarter 2009, spring 2009

Melikan, S., 'New Chinese buyers redefine the market' in *International Herald Tribune*, 26–27 September 2009

Mitchell, T., 'Invisible "fetters" cling to migrants' in the *Financial Times*, 16 April 2010

Pilling, D., 'I don't think anybody can protect me' in the *Financial Times*, 24–25 April 2010

Rachman, G., 'America is losing the free world' in the *Financial Times*, 5 January 2010

Sotheby's, 'Contemporary Chinese Art Part I', Hong Kong, 7 April 2007

Sotheby's, 'Contemporary Chinese Art Part II', ibid

Waldmeir, P., 'Bund Bull signals Shanghai's charge against Wall St dominance' in the *Financial Times*, 24–25th April 2010

Wilson, E., 'The power of Poly' in the *Financial Times*, 29 May 2010

Winchester, S., 'Cultural capital' in the *Financial Times*, 20 -21 June 2009

Chapter 4.

Books

Alizadeh, S. et al, *Iran, A chronological history. History, Culture, Architecture*, Iran-history, 2002

Amirsadeghi, H., *Different Sames: New perspectives in contemporary Iranian art*, Thames & Hudson, 2009

Asher, C.B. & Talbot, C., *India before Europe*, Cambridge University Press, 2006

Axworthy, M., *Iran, Empire of the Mind. A history from Zoroaster to the present day*, Penguin, 2007

Borchardt-Hume, A., *In Search of the Miraculous, Walid Raad: Miraculous Beginnings*, Whitechapel Art Gallery, 2010

Brotton, J., *The Renaissance Bazaar. From the Silk Road to Michelangelo*, Oxford University Press, 2002

Canby, S.R., *Shah 'Abbas: The remaking of Iran*, British Museum Press, 2009

Curtis, J & Tallis, N., *Forgotten Empire. The World of Ancient Persia*, British Museum Press, 2005

Diamond, D. et al, *Garden & Cosmos. The Royal Paintings of Jodhpur*, British Museum Press, 2009

Eigner, S., *Art of the Middle East. Modern and Contemporary Art of the Arab World and Iran*, Merrell, 2010

Goodwin, J., *The International Art Markets, The essential guide for collectors and investors*. Lawrie, W. *The Middle East and North Africa*, Kogan Page, 2008

Holland, T., *Persian Fire*, Abacus, 2005

Holm, A., *The History of Greece Volume I. From its commencement to the close of the independence of the Greek nation*, MacMillan and Co Ltd, 1899

Holm, A., *The History of Greece Volume II. From its commencement to the close of the independence of the Greek nation*, MacMillan and Co Ltd, 1902

Madani, A., *Thinking Inside the Box: 6 Notes on Rashid Rana,* Rashid Rana, Chatterjee & Lal Chemould Prescott Road, 2010

Mirza, Q., et al, *A World Apart*, Rashid Rana, Chatterjee & Lal Chemould Prescott Road, 2010

Muller, N., et al, *Contemporary Art in the Middle East*, Art World Black Dog publishing, 2009 (?)

Nanji. A., et al, *Spirit & Life. Masterpieces of Islamic Art from the Aga Khan Museum Collection,* The Aga Khan Trust for Culture, 2007

Porter, V., *Word into Art. Artists of the Modern Middle East*, British Museum Press, 2006

Saatchi, C., *Unveiled New Art from the Middle East. Picture by Picture Guide*, The Saatchi Gallery in partnership with Phillips de Pury & Company, 2009

Articles and Reports
ArtTactic, 'Turkish Modern and contemporary art market', February 2009

ArtTactic, 'Middle East Modern and contemporary art market overview', October 2007

Atwood, R. & McCord, A., 'Recovering Iraq's past', *Art News*, November 2003

Atwood, R., 'Restoring Iraq's cultural legacy', *Art News*, summer 2004

Axworthy, M., 'Crisis of legitimacy leaves reformers few choices' in the *Independent*, 15 June 2009

Axworthy, M., 'This inauguration did little to hide the scars that still divide Iran' in *The Independent*, 6 August 2009

Bonham's, 'Modern and contemporary Arab, Iranian, Indian and Pakistani art', Bonham's Dubai, 3 March 2008

Bonham's, 'Modern & contemporary Middle Eastern & South East Asian art', Bonham's London, 3 June 2009

Bozorgmehr, N., 'Police clash with mourners of Iran protesters' in the *Financial Times*, 31 July 2009

Bozorgmehr, N., 'Pressure on Khatami to run again' in the *Financial Times*, 29 December 2008

Butler, K., 'As Ahmadinejad is anointed, his victims pay the price of dissent' in *The Independent*, 3 August 2009

Butler, K., 'TV blackout and boycott mar Ahmadinejad's swearing-in' in *The Independent*, 6 August 2009

Cockburn, P., 'History suggests the coup will fail' in *The Independent*, 19 June 2009

Fifield, A., 'Iranians mix fervour with fever' in the *Financial Times*, 10 June 2009

Fisk, R., 'Ahmadinejad whips crowd to frenzy as opposition muzzled' in *The Independent*, 15 June 2009

Khalaf, R., 'Decoding the leader's message' in the *Financial Times*, July 2009

Khalaf, R., 'Iran's anti-reform cleric' in the *Financial Times*, 27 July 2009

Khalaf, R. and Bozorgmehr, N., 'At a turning point' in the *Financial Times*, 20 July 2009

Khalaf, R. and Bozorgmehr, N., 'Risks growing for opposition's reluctant leader' in the *Financial Times*, 22 June 2009

Moore, S., 'The collection is a symphony', in the *Financial Times*, 15 March 2008

Sami-Azar, A., 'Poetry in bronze', *Canvas*, March/April 2008

Slackman, M., 'Amid Iran's unrest, a battle for the state' in *International Herald Tribune*, 9 July 2009

Somers Cocks, A., 'Are we colonialising Middle Eastern art?' in *The Art Newspaper*, July/August 2009

Sotheby's, 'Contemporary art, Arab & Iranian', London, 20 October 2010

Sotheby's, 'Contemporary art, Doha', 18 March 2009

Thomas, K., 'The mission of Mathew Bogdanos', *Art News*, April 2006

Thomas, K.D., 'A bit of a hiccup', *Art News*, November 2005

Chapter 5.

Books
Asher, C. B & Talbot, C., *India before Europe*, Cambridge University Press, 2006

Blurton, T.R., *Hindu Art*, British Museum Press, 1992

Dalrymple, W., *Nine Lives. In Search of the Sacred in Modern India*, Bloomsbury, 2009

Essl, K. et al., *Chalo! India. A New Era of Indian Art*, Prestel, 2008

Fernandes, E., *Holy Warriors, A Journey into the heart of Indian fundamentalism*, Portobello Books, 2007

Fisher, R.E., *Buddhist Art and Architecture*, Thames & Hudson, 1993

Goodwin, J., *The International art markets. The essential guide for collectors and investors. Singh. S. India*, Kogan Page, 2008

Guy, J et al., *Chola. Sacred bronzes of Southern India*, The Royal Academy of Arts, London, 2006

Imbert, M., *Sayed Haider Raza. The Five Rays of Raza*, Kings Road Gallery, 2010

Jackson A. and Jaffer A. (ed.), *Encounters. The Meeting of Asia and Europe 1500–1800,* Victoria and Albert Museum, London, 2004

Jackson A. and Jaffer A. (ed.), *Maharaja. The Splendour of India's Royal Courts*, Victoria and Albert Museum, London, 2009

Luce, E., *In spite of the gods. The strange rise of Modern India*, Abacus, 2006

Mitter, P., *Indian Art*, Oxford University Press, 2001

National Portrait Gallery, *Contemporary Connections, The Singh Twins*, National Portrait Gallery, London, 2010

Saatchi Gallery, *The Empire Strikes Back: Indian Art Today*, Saatchi Gallery in partnership with Phillips de Pury & Company, 2010

Tunzelmann, von, A., *Indian Summer: The Secret History of the End of an Empire*, Pocket Books, 2007

Wood, M., *The story of India*, BBC Books, 2007

Articles and Reports

ArtTactic, *Indian Modern and Contemporary Art Market*, March 2008

ArtTactic, *Emerging Art Markets: India*, July 2007

Art India, vol XII, issue IV, *Changing languages of place*, Burte, H., *Hyphenated worlds*, Gupta, L., 2007

Art India, vol XIII, issue I: *Feeding the very hungry god*, Harris. L., *Looking for value*, Williams, L., *Better late than never*, Chari, A., *The Bubble*, Bordewekar, S., *Show me the money*, Mirza, Q., *High flyers*, Grewal, G., *The craft of art*, Maitra, R, 2008

The Economist, 'India's jumbo election', 18–24 April 2009

Holmes, P., 'Is art having an Indian summer?' in the *Financial Times* magazine, *Spend it*, 2 August 2008

Kazmin, A., 'Palaces of the Untouchables' in the *Financial Times* magazine, 23 May 2009

Lamont, J., 'Obituary: Indian queen who epitomised glamour of the Raj' in the *Financial Times*, 8 August 2009

Pilling, D., *Progress and democracy collide in India* in the *Financial Times*, 8 April 2010

Robertson, I., *All the Raj* in *The Australian Art Market Report*, winter 2008

Chapter 6.

Books

Akira, T., *Art as Criticism. Asian Modernism. Diverse development in Indonesia, the Philippines and Thailand,* The Japan Foundation, 1995

Becker, J., *Rogue regime, Kim Jong II and the looming threat of North Korea*, Oxford University Press, 2005

Binks,H., *Bui Huu Hung*, Kings Road Gallery, 2000

Chu, M., *Understanding contemporary Southeast Asian art*, Art Forum Pte Ltd, Singapore, 2003

Crump, T., *Asia-Pacific. A History of Empire and Conflict*, Hambledon continuum, 2007

Fisher, R., *Buddhist Art and Architecture*, Thames & Hudson, 1993

Guillermo, A.G., *The History of Modern Art in the Philippines, Asian Modernism: Diverse development in Indonesia, the Philippines and Thailand,* The Japan Foundation, 1995

Junichi, S., *Bangkok and Chiang Mai: Ways of Modernity Asian Modernism. Diverse development in Indonesia, the Philippines, and Thailand*, ibid

Kerlogue, F., *Arts of Southeast Asia*, Thames & Hudson World of Art, 2004

Lane, M., *Unfinished nation. Indonesia before and after Suharto*, Verso Books, 2008

Nguyen Ngoc Dung., *Bui Huu Hung*, Art House Consultancy

Rodboon, S., *History of Modern Art in Thailand, Asian Modernism: Diverse development in Indonesia, the Philippines and Thailand*, The Japan Foundation

Stevenson, W., 2001. *The Revolutionary King. The True-life sequel to the King and I*, Robinson, 1995

Short, P., *Pol Pot. The history of a nightmare*, John Murray, 2004

Supangkat, J., *The Emergence of Indonesian Modernism and its background Asian Modernism. Diverse development in Indonesia, the Philippines and Thailand*, The Japan Foundation, 1995

Takashi, S., *The Modern in South East Asia, Asian Modernism: Diverse development in Indonesia, the Philippines and Thailand*, The Japan Foundation, 1995

Tran Luu Hau and Hoang Duc Dung, vol 2, Contemporary Vietnamese Art, *Poetry of the Motherland*, Apricot Gallery, 2010

Tran Tuy et al, *Bui Xuan Phai (1920–1988)*, Hanoi Fine Arts Collectors' Club, 1993

Tsutomu, M., *Whispers of a lost child: The heritage of Realism Asian Modernism*. Diverse development in Indonesia, the Philippines, and Thailand, The Japan Foundation, 1995

Zandvliet, K., *The Dutch encounter with Asia*, Rijksmuseum, Amsterdam, 2002

Articles

Aglionby, J., 'Economists split on Jakarta's Komodo power' in the *Financial Times*, 10 September 2009

Borobudur Auction, 'Southeast Asian contemporary', 28 October 2007

Christie's, 'South East Asian pictures and Straits Chinese ceramics, gold and silver', 27 March 1994

Guillermo, A.G., 'A harvest of paintings' in *Asian Art News*, Nov/Dec 2008

Kazmin, A., 'Vietnam's inflation rate surges above 25%' in the *Financial Times*, 28 May 2008

Larasati, 'Pictures of Asia modern and contemporary art', 21 October 2007

Lombardo, F., 'Vietnam builds a future for itself' in the *Financial Times*, 8–9 March 2008

Sotheby's, 'An important collection of Vietnamese paintings featuring the Philip Ng collection', Hong Kong, 8 April 2008

Sotheby's, 'Modern and contemporary South East Asian paintings', Hong Kong, 8 April 2008

Sotheby's, 'Modern and contemporary South East Asian paintings', Hong Kong, 6 October 2008

Sotheby's, 'Modern and contemporary Southeast Asian paintings', Hong Kong, 5 April 2010

Sotheby's, 'South East Asian Paintings', Singapore, 4 April 2004

Sotheby's, 'South East Asian paintings', Singapore, 10 October, 2004

Sotheby's, 'South East Asian Paintings', Singapore, 10 April, 2005

Chapter 7.

Books

Au-yeung, H., 'Design, landscape and modernity: reflections on the paintings of Wucius Wong and the role of design in modern Hong Kong art', Wucius Wong, *Visions of a Wanderer*, Plum Blossoms, 1997

Christian, J., *Singapore's role in the development of South East Asian art markets*, unpublished MA dissertation SIA, 2007

Desjardins, T., *The Guggenheim/Abu Dhabi*, unpublished MA dissertation SIA, 2007

Peerenboom, R. 'Rule of law and democracy: lessons for China from Asian experiences' in Chu Yin-wah and Wong Siu-lun, *East Asia's New Democracies*, Routledge, 2010

Tregear, M., *Chinese Art*, Thames & Hudson, 1997

Articles

Adam, G., 'Fireworks as Qatar Steals the Show' in the *Financial Times*, 29 November 2008

Bresler J. & Khalifa, S., 'US import restrictions imposed on certain archaeological material from the People's Republic of China', Withersworldwide, October 2009

Canvas Supplement, 'The Creative City', ArtParis, 2007

Carver, A., 'Dubai, An art scene in the making, out of the desert' in *The Art Newspaper*, Allemandi Publishing, September 2006

England, A & Khalaf, R., 'Abu Dhabi multiplies investment arms' in the *Financial Times*, 6 May 2009

Groves, C & Munro, P., 'The UK as a jurisdiction for the international art collector', Withersworldwide, March 2009

Heathcote, E., 'A monument to the possible' in the *Financial Times*, 17–18 May 2008

Houlder, V., 'Fears over CGT crackdown' in the *Financial Times*, 26 November 2007

Houlder, V., 'London fears fall from arts pedestal' in the *Financial Times*, 23–24 February 2008

Houlder, V., 'Tax havens in retreat as Swiss capitulate' in the *Financial Times*, 14–15 March 2009

Itoi, K., 'Japan, a low rate of sales tax, but little incentive for art collectors to add to public collections or protect the national heritage' in *The Art Newspaper*, Allemandi Publishing, September 2006

Kay, J., 'Tax havens exist because of the hypocrisy of larger states' in the *Financial Times*, 21–22 March 2009

Muheim, B., 'The most inaccessible museum in the world' in *The Art Newspaper*, September 2006

Oakley, D. & Tett, G., 'Sovereign wealth funds courted in debt sales' in the *Financial Times*, 25 March 2010

Robertson, I., 'Taiwan', *The Art Newspaper*, Allemandi Publishing, September 2006

Robertson, I., 'China', ibid

Valentin, P., 'Illicit trade in cultural property: Switzerland and Italy agree to cooperate', Withersworldwide, November 2008

Valentin, P. & Stripp, C., 'Free ports in the UK, Switzerland and Singapore', Withersworldwide, spring 2010

West, B., 'Wealthy isolation' in the *Financial Times*, 10 October 2009

Index